Fragments of Infinity

A Kaleidoscope of Math and Art

IVARS PETERSON

John Wiley & Sons, Inc.

New York Chichester Weinheim Brisbane Singapore Toronto

Published by John Wiley & Sons, Inc.
Published simultaneously in Canada

Design and production by Navta Associates, Inc.

This publication is designed to provide accurate and authoritative information in regard to the subject matter covered. It is sold with the understanding that the publisher is not engaged in rendering professional services. If professional advice or other expert assistance is required, the services of a competent professional person should be sought.

Library of Congress Cataloging-in-Publication Data

Peterson, Ivars
 Fragments of infinity : a kaleidoscope of math and art / Ivars Peterson.
 p. cm.
 Includes bibliographical references and index.
 ISBN 0-471-16558-1 (cloth : alk. paper)
 1. Mathematics in art. 2. Visual perception. I. Title.

N72.M3 P48 2001
701'.05—dc21 2001024026

Printed in the United States of America

10 9 8 7 6 5 4 3 2 1

Contents

Preface v

1. Gallery Visits 1

2. Theorems in Stone 11

3. A Place in Space 35

4. Plane Folds 61

5. Grid Fields 85

6. Crystal Visions 111

7. Strange Sides 135

8. Minimal Snow 159

9. Points of View 179

10. Fragments 207

Further Readings 219

Credits 225

Index 227

Preface

THIS BOOK IS ABOUT CREATIVITY and imagination at the intersection of mathematics and art. It portrays the work of several contemporary mathematicians who are also artists or whose mathematical thoughts have inspired others to create. It provides glimpses of artists enthralled by the unlimited possibilities offered by mathematically guided explorations of space and time. It delves into the endlessly fascinating mysteries of one-sided surfaces, four-dimensional spaces, self-similar structures, and other seemingly bizarre features of modern mathematics.

In 1992 I was invited to present the opening address at a remarkable meeting devoted to mathematics and art, organized by mathematician and sculptor Nat Friedman of the State University of New York at Albany. My invitation to the pathbreaking meeting came about because of articles I had written for *Science News* highlighting the increasing use of visualization in mathematics, particularly the burgeoning role of computer graphics in illuminating and exploring mathematical ideas, from soap-film surfaces, fractals, and knots to chaos, hyperbolic space, and topological transformations. One of my articles had focused on Helaman Ferguson, a sculptor and mathematician who not only works with computers but also carves marble and molds bronze into graceful, sensuous, mathematically inspired artworks.

Friedman's lively gathering introduced me to many more people who are fascinated by interactions between art and mathematics, and with them, I have attended and participated in subsequent meetings. Many of the artists and mathematicians mentioned in this book belong to this peripatetic tribe of math and art enthusiasts. The tribe's diversity of thought and custom, however, also brings to mind difficult questions of what constitutes mathematical

art, what beauty means in that context, and what explicit role, if any, mathematics ought to play in the visual arts.

The following chapters offer a glimpse of the ways in which we can stretch our minds to imagine and explore exotic geometric realms. They highlight the processes of creativity, invention, and discovery intrinsic to mathematical research and to artistic endeavor.

The book's title echoes thoughts of the Dutch graphic artist M. C. Escher, who sought to capture the notion of infinity in visual images. In 1959, in his essay "Approaches to Infinity," Escher described the reasoning behind one of his intricately repeating designs, which featured a parade of reptiles, as follows: "Not yet true infinity but nevertheless a fragment of it; a piece of 'the universe of reptiles.'

"If only the plane on which [the tiles] fit into one another were infinitely large, then it would be possible to represent an infinite number of them," he continued. "However, we aren't playing an intellectual game here; we are aware that we live in a material, three-dimensional reality, and we cannot manufacture a plane that extends infinitely in all directions."

Escher's solution to his immediate artistic dilemma was to "bend the piece of paper on which this world of reptiles is represented fragmentarily and make a paper cylinder in such a way that the animal figures on its surface continue to fit together without interruptions while the tube revolves around its lengthwise axis." It was just one of many highly original schemes that Escher devised in his attempts to capture infinity visually. Other artists share this passion (or perhaps obsession) for visualizing creations of the mind, whether theorem or dream, and rendering them in concrete form, and they, too, must overcome limitations of their tools and their place in the natural world to present glimpses or fragments of these conceivable yet elusive realms.

Special thanks go to Helaman Ferguson and Nat Friedman, who introduced me to many of the people who and the ideas that inspired and encouraged my travels in the surprisingly wide and diverse world of mathematical art.

I also wish to thank the following persons for their help in explaining ideas, providing illustrations, or supplying other material for this book: Don Albers, Tom Banchoff, Bob Brill, Harriet Brisson, John Bruning, Donald Caspar, Davide Cervone, Benigna Chilla, Barry Cipra, Brent Collins, John Conway, H. S. M. Coxeter, Erik Demaine, Ben Dickins, Stewart Dickson, Doug Dunham, Claire Ferguson, Mike Field, Eric Fontano, George Francis, Martin Gardner, Bathsheba Grossman, George Hart, Linda

Henderson, Paul Hildebrandt, Tom Hull, Robert Krawczyk, Robert Lang, Howard Levine, Cliff Long, Robert Longhurst, Shiela Morgan, Eleni Mylonas, Chris K. Palmer, Doug Peden, Roger Penrose, Charles Perry, Cliff Pickover, Tony Robbin, John Robinson, Carlo Roselli, John Safer, Reza Sarhangi, Doris Schattschneider, Dan Schwalbe, Marjorie Senechal, Carlo Séquin, John Sharp, Rhonda Roland Shearer, Arthur Silverman, John Sims, Clifford Singer, Arlene Stamp, Paul Steinhardt, John Sullivan, Keizo Ushio, Helena Verrill, Stan Wagon, William Webber, Jeff Weeks, and Elizabeth Whiteley. My apologies to anyone I have inadvertently failed to include in the list.

I am grateful to my editors at *Science News,* Joel Greenberg, Pat Young, and Julie Ann Miller, for allowing me to venture occasionally into topics that didn't always fit comfortably within the purview of newsworthy scientific and mathematical research advances. Some of the material in this book has appeared in a somewhat different form in *Science News.*

I wish to thank my wife, Nancy, for many helpful suggestions while reviewing the original manuscript. I greatly appreciate the efforts of everyone at Wiley who worked so hard to transform an unwieldy stack of manuscript pages and numerous illustrations in a wide variety of formats into the finished book.

1 Gallery Visits

Few of us expect to encounter mathematics on a visit to an art gallery. At first (or even second) glance, art and mathematics appear to have very little in common, although both are products of the human intellect.

Walking up to the buildings of the National Gallery of Art in Washington, D.C., and strolling through its rooms, however, can be immensely illuminating when the viewing is done with a

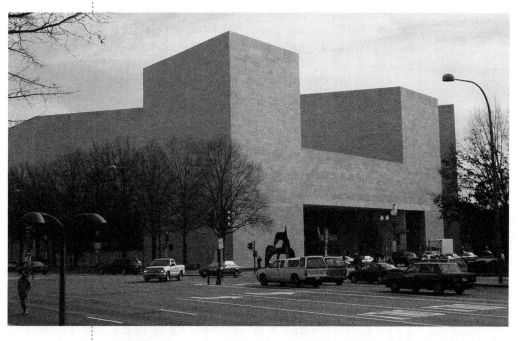

In Washington, D.C., the National Gallery of Art's East Building, which opened to the public in 1978, features a facade that teases the eye—where walls unexpectedly meet at acute and obtuse angles rather than commonplace right angles.

mathematical eye. The gallery's East Building, designed by the architect I. M. Pei, is an eye-teasing festival of vast walls, sharp edges, odd angles, and unexpected shapes. A playful visual illusion writ large, it is itself a work of mathematical art.

Such a close connection between architecture and mathematics shouldn't be surprising. Geometry has long occupied a prime position in the architect's and builder's toolbox. In commenting on the inspiration for his East Building design, Pei noted in a 1978 article in *National Geographic,* "I sketched a trapezoid on the back of an envelope. I drew a diagonal line across the trapezoid and produced two triangles. That was the beginning."

Conceived as explorations of form, space, light, and color, sculptures and paintings can themselves embody a variety of mathematical principles, expressed not only in such obviously geometric objects as triangles, spheres, and cones, but also through depictions

To fit the National Gallery's East Building on a trapezoid-shaped site, architect I. M. Pei based his design on a division of the trapezoid into an isosceles triangle and a smaller right triangle.

of motion and metamorphosis. Renaissance painting of the fifteenth century celebrated the precisely mathematical use of proportion and perspective to achieve startlingly natural images of the visual world. Centuries later, artists such as Pablo Picasso (1881–1973), Salvador Dali (1904–1989), and René Magritte (1898–1967) could play with those conventions and illusions to nudge the mind in new and unexpected directions.

To capture the vitality of everyday life, Impressionist painters of the nineteenth century used bold strokes and splashes of color to evoke motion and change, reflecting the natural state of an observer's perpetually restless eye. In more recent times, Alexander Calder (1898–1976) fabricated giant, delicately balanced mobiles that perform subtly chaotic dances in the air, displaying ever-shifting relations between or among forms in space.

Motion, change, and unpredictability also intrigued, and perhaps haunted, Jules Henri Poincaré (1854–1912) and other nineteenth-century mathematicians, whether they were tangling with the mathematics of planetary orbits and molecular motion, reflecting upon the existence of higher dimensions and non-Euclidean geometries, pondering the nature of randomness, or probing the meaning of infinity.

There is more mathematics to be seen in the fractal splashes of Jackson Pollock's action paintings, in sculptor Henry Moore's fascination with holes and topological transformations of space, in a Dutch master's exquisitely rendered minimal-surface soap

bubbles, in Georges Braque's fractured windows into fictional four-dimensional space, and in Piet Mondrian's expression of an ideal, universal order in the form of rigorously precise compositions made up of straight lines and primary colors.

Indeed, the creativity on display at the National Gallery of Art and in many other galleries throughout the world embraces a wide swath of human expression and experience. The artworks are remarkably varied in appearance, type, and style. In one way or another, however, they are all concerned with the visual presentation of abstract concepts.

Interestingly, the impulse among mathematicians to strip mathematics to its essence, to eliminate the inessential and the redundant, and to construct an elegant, austere edifice out of pure thought has a counterpart among artists. In the early part of the twentieth century, abstract painters such as Wassily Kandinsky (1866–1944) emphasized how form is the external expression of inner meaning. Focused on the intuitive and the spiritual, they developed a spare, pictorial language to represent those feelings. The resulting art, with its simplified shapes, brilliant colors, and thick, black outlines, attempted to depict the world as it appears in its essence rather than just to copy it.

That's not unlike what mathematicians try to do in their proofs and theorems, though the rules and conventions under which they operate are somewhat different. They, too, start with

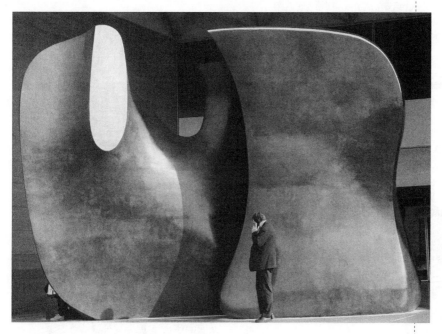

Knife Edge Mirror Two Piece, a massive bronze sculpture by Henry Moore, guards the main entrance to the National Gallery's East Building.

experience in the everyday world and rely heavily on intuition to carry them deep into abstract realms. Developing new ways of seeing along the way, they venture into visualization to understand better the patterns and relationships they discover in the course of their mathematical investigations.

The mathematician and philosopher Bertrand Russell (1872–1970) expressed one viewpoint when he remarked, "Mathematics, rightly viewed, possesses not only truth, but supreme beauty—a beauty cold and austere, like that of sculpture, without appeal to any part of our weaker nature, without the trappings of paintings or music, yet sublimely pure, and capable of stern perfection such as only the greatest art can show."

This sense of mathematical beauty remains foreign to most nonmathematicians. Without a highly trained eye or mind, it's difficult to appreciate the bare-bones beauty of an equation, a theorem, or a proof. Artists have helped bring some of that beauty out of its cerebral closet. The intriguing drawings of the Dutch graphic artist M. C. Escher (1898–1972), for instance, skillfully convey the illusion of infinitely repeating forms and the strange, counterintuitive properties of the hyperbolic plane. Other artists have tangled with representations of four-dimensional forms. A growing number of them now use computers and mathematical recipes as tools for creating art.

In the late spring of 1992, an unusual gathering occurred on the campus of the State University of New York at Albany. Organized and hosted by Nat Friedman, a member of the university's mathematics department, the meeting brought together about 150 mathematicians, artists, and educators, along with a smattering of engineers, computer scientists, architects, crystal polishers, toymakers, and assorted others.

Friedman had been a math professor at Albany since 1968. After taking an evening class in sculpting, he had become an avid wood and stone carver. At that time, his artistic endeavors represented a break from his mathematical work. Over the years,

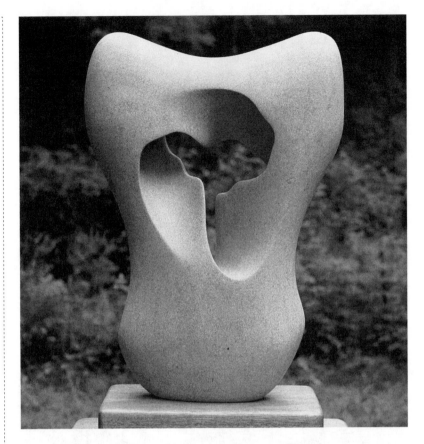

Carved from limestone, this sculpture by Nat Friedman has a torso form with a trefoil opening, whose rippled edges perturb the opening's threefold symmetry. This piece is one of a series in which Friedman explored the "combination of form, space, and light" that results when a solid shape is opened up.

however, he began to see connections between art and mathematics. As a mathematician, he was continually fascinated by repeating structures; as a sculptor, he sometimes worked with the natural surfaces of roughly split marble or granite, which form patterns described mathematically as fractals. By 1980 Friedman had set up and was teaching a course devoted to the creative process in mathematics and art.

"Art and mathematics are both about seeing relationships," Friedman maintains. "Creativity is about seeing from a new viewpoint."

A sprightly, gregarious, oversized leprechaun of a fellow, Friedman also felt isolated. The 1992 meeting represented his attempt to find people with whom he could share his deep interest in visual mathematics. First he invited a handful of people, mainly stone carvers, whose work he knew and admired, just as a way to get to meet them. One connection led to another, and the list of invitees grew to include many artists and others who were previously unknown to Friedman but passionately caught up in one form of mathematical art or another.

The Albany campus itself is an intriguing experience in mathematical art. It features an "academic podium" of thirteen buildings on a common platform, all connected by a continuous roof and long colonnades. Designed by Edward Durrell Stone and completed in the mid-1960s, the campus complex's stark symmetries reveal it as an example of structure as mathematical sculpture. In brilliant sunlight, however, the glaring whiteness and disorienting sameness of the buildings make it exceedingly difficult to navigate from place to place.

Nested inside that austere structure, a mad, friendly jumble of artists and mathematicians took over a block of classrooms and open areas to display their wares and explain their personal visions to anyone who would listen. For four unruly days, it became a veritable marketplace of the mind and the eye.

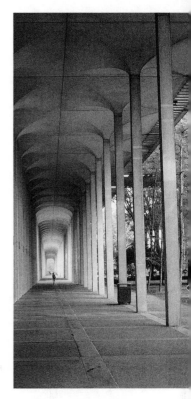

The colonnades and buildings that make up the "academic podium" complex at the State University of New York at Albany have such a relentless symmetry that someone strolling among the buildings can become quite disoriented.

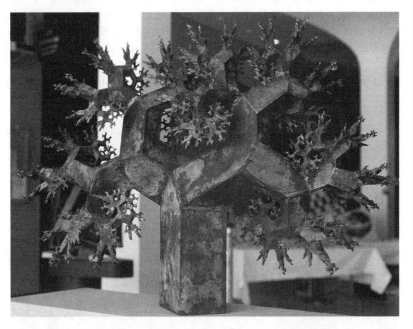

Pythagorean Fractal Tree was designed by Koos Verhoeff, cast in bronze by Anton Bakker and Kevin Gallup, and displayed at the first art and mathematics conference in Albany, New York. Born in Holland in 1927, Verhoeff studied mathematics and computer science. He worked for a time at the Mathematical Center in Amsterdam, where he encountered the Dutch artist M. C. Escher, who often came to the center to research the mathematical ideas he applied in his artworks. Inspired by Escher, Verhoeff ended up pursuing the application of mathematics and computers to art. One of his main interests after his retirement in 1988 was the discovery and development of artistic structures based on geometric principles. Fractal formations, in which small pieces of a structure echo the appearance of the entire structure, inspired the branched sculpture seen here.

Casual, '60s mellow, yet endlessly energetic, Friedman oversaw a dazzling visual feast of geometric surprises. Participants found the meeting exhilarating, stimulating, and exhausting, and most were ready to come back for more the following year. Indeed, Friedman's art and math meeting became an annual event for several years, until others who shared the same interests took over some of the work to bring such gatherings to California, Kansas, Seattle, Italy, Spain, and elsewhere.

These meetings have catalyzed the coming together of a diverse band of art and math enthusiasts who are eager to share their own discoveries and creations yet wonderfully open to and appreciative of the compelling (and sometimes quirky) visions of others. They contend that mathematics can and should play an important role in the visual arts.

One can argue that because mathematics is embedded in our schooling, professions, and culture, it influences all of art. Contemporary multimedia artist Anna Campbell Bliss has noted, "Being part of our general knowledge, mathematics may reinforce observations of patterns and transformations in nature, provide a sense of structure, whether explicit or implied, or serve as a resource to use at will."

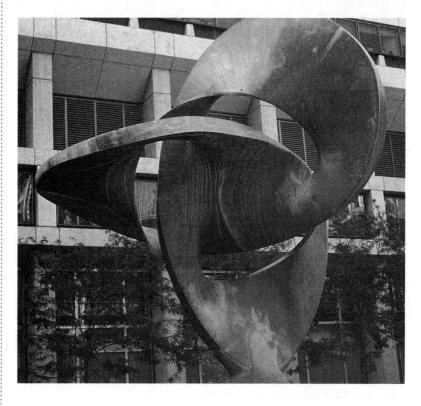

The Triune is one of a number of sculptures by Robert Engman that are on public display in Philadelphia. Long a professor of sculpture at the University of Pennsylvania, Engman inspired many artists to work with mathematical forms and ideas, as he himself did in this large, propellerlike artwork fabricated from bronze.

8

The French sculptor François Auguste René Rodin (1840–1917) emphasized geometry. "I have come to realize that geometry is at the bottom of sentiment or rather that each expression of sentiment is made by a movement governed by geometry," he commented. "Geometry is everywhere present in nature. A woman combing her hair goes through a series of rhythmic movements that constitute a beautiful harmony. The entire rhythm of the body is governed by law."

Mathematics can serve as a framework for artistic expression, as seen in the magnificent perspective art of fifteenth-century Renaissance painters, the mind-jangling explorations of time and space in the early-twentieth-century works of Picasso and other artists, and the visual conundrums and mischievous graphic excursions across ingeniously tiled planes by Escher. Conversely, art can awaken mathematical intuition, revealing otherwise hidden aspects of starkly abstract formulations.

Both mathematicians and visual artists are observers of their environment. Both experience the joy of creation and the feeling of rapture that come with making something that has never been made before—be it sculpture or theorem. They imagine new worlds, and they give us new eyes with which to view the old.

Indeed, passion is no more a stranger to mathematicians than it is to artists. Mathematicians derive enormous personal satisfaction from doing mathematics successfully, even as they trek a daunting landscape of abstraction, axiom, theorem, and proof, where genuine mathematical discoveries are rare occurrences. They wonder at the astonishing ties their spirited and inspired efforts reveal between or among objects and theories that at first glance seem disconnected and far apart.

Math as art (or art as math) can take on an incredible variety of forms. It can appear as a huge, geometric framework built of steel plates; a prismatic glass sculpture that refracts light into a shower of miniature rainbows; a painting of brightly colored squares, rectangles, and lines that serves as a window into the fourth dimension; or a vivid landscape of ragged peaks and valleys on a computer screen. These manifestations and many others illustrate that at least some of the creativity of mathematics is not so different from the creativity of art.

Such art also can arise from everyday objects and simple tasks: folding a sheet of paper, looking into a mirror, blowing a bubble, painting a wall, tying a knot, or laying tiles. At the same time, profound mathematical concepts underlie these seemingly mundane activities, demonstrating how mathematicians

The Geometry Lesson by Clifford Singer. See plate 1.

can extract the geometric essence of everyday forms and extend these notions into the unphysical realms of the infinite and the infinitesimal.

In commenting on the immense scope of mathematics, the British mathematician James Joseph Sylvester (1814–1897) once remarked, "Its possibilities are as infinite as the worlds which are forever crowding in and multiplying upon the astronomer's gaze." The same can be said of the unlimited scope of imagination, whether in mathematics, art, or everyday life.

2 Theorems in Stone

From the outside, Helaman Ferguson's modest, two-car garage resembles just about any other garage in his suburban Maryland neighborhood. Inside, it has the look of an industrial site.

Ropes, cables, pipes, and hoses twist through the cluttered space. A steel framework juts down from the ceiling. A hefty drilling machine hangs nearby, next to a huge, industrial-strength vacuum cleaner. An ancient Macintosh-II computer in a

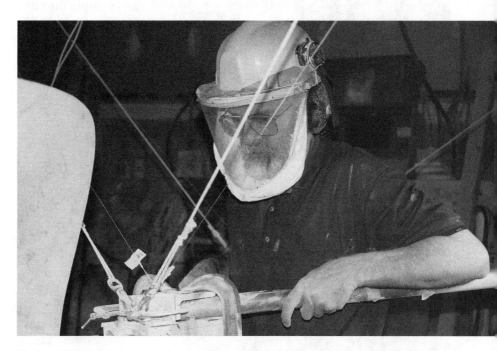

His face hidden behind a protective faceplate, sculptor Helaman Ferguson guides an air-powered tool to carve a piece of white Carrara marble.

dustproof case sits atop a high shelf. Blocks of stone occupy odd corners. Thick padding covers the walls.

Shaping stone is a gritty, noisy, physically demanding process. Ferguson's wiry, six-foot, three-inch frame flexes and strains as his bare, muscular arms wield an air-powered tool to chip away at a large chunk of gleaming marble. A protective faceplate masks his bearded face.

Carving stone is a destructive process—the subtraction of material to reveal the hidden form envisioned by the artist. Therein lies the challenge. Each stroke flakes off a fragment that the sculptor can never put back. Each sweep of a surface-smoothing diamond wheel creates a fleeting shower of dust. There is no going back. Sculpting stone firms muscle and tests courage, Ferguson insists.

At the same time, amid the roar and the dust, artist and stone engage in an intimate conversation—one that can readily break into song. With every stroke, the stone vibrates in response. When all goes well, its tones ring pure and sweet to both ear and hand. Sometimes, however, the song of the stone can crumble into discord.

Raw stone doesn't always reveal its character on its surface. Carving can uncover deep-seated flaws—mysterious fissures along which the stone may split or shatter, laying to waste all the time and energy put in by the artist. A change in tune can warn the wary sculptor of such impending losses of integrity or strength.

"With a stone, you really don't know what's in there until you get into it, particularly if it has a lot of grain or texture or different colors," Ferguson says. "These are all accidental things that you can't do anything about but which you can make use of in the process of creating a work of art. Part of the direct-carving-in-stone adventure is to make appropriate use of what you find."

Ferguson's fascination with stone marks him as an unfashionable figure

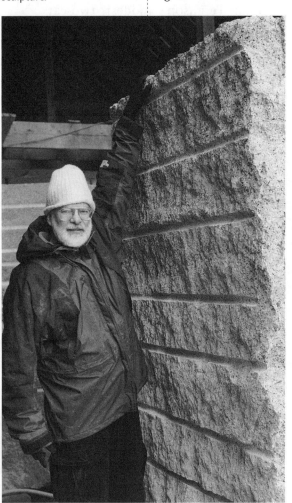

Ferguson barely reaches to the top of a thirteen-ton column of granite destined to become a mathematical sculpture.

among today's sculptors, who generally favor working with metal, glass, ceramic, and plastic rather than stone. Ferguson is highly unusual in another respect. As a professor, he spent seventeen years in the mathematics department at Brigham Young University in Provo, Utah. He still commits a significant portion of his time to mathematical research.

To many people, art and mathematics appear to have very little in common. The rigid rules and cold, detached rationality of mathematics lie far removed from the intuition, spontaneity, passion, and even ambiguity associated with art. Yet the wall between intellect and emotion is not as solid and impenetrable as it might appear. The practice of both mathematics and art requires a blend of discipline and vision—a delicate balancing of constraint and freedom.

Aesthetic considerations have long played a role in the development of mathematics. Mathematicians strive not just to construct irrefutable proofs but also to present their ideas in a clear and compelling fashion, driven more by a quest for elegance than dictated solely by the needs of logic. They are concerned not merely with formulating conjectures and proving theorems but also with arranging and assembling the theorems into an elegant, coherent edifice.

Mathematicians create in their minds what they believe to be beautiful, elegant, or sublime patterns of thought, and some of these patterns can be visualized as concrete forms. As a mathematician and sculptor, Ferguson uses mathematics as a sophisticated design language to suggest new forms. He relies on the precision of computer science and engineering to plan and execute his sculptures, which nonetheless are works of the hand.

The resulting forms are varied, provocative, and organic, belying their origins in mathematical abstraction. In one, a wild sphere flings its pale, slim arms into the sky. In others, a twisted ring pulls itself free from a slab of marble, a glistening, silky-smooth knot writhes across the ground, or a metallic eye blinks in harsh sunlight. Each of these creations, realized in stone or bronze by Ferguson, represents a concrete expression of a mathematical theorem. Each is an attempt to embody—in a form that anyone can see and touch—the special sense of beauty that mathematicians experience in their explorations of abstract realms.

"Aesthetic pleasures are a major motivation [in mathematical research], but we usually don't bring that out," Ferguson says. "I am interested in the adventure of affirming pure mathematical thought in unpredictable physical form."

> "With a stone, you really don't know what's in there until you get into it, particularly if it has a lot of grain or texture or different colors.
> —Helaman Ferguson

This polished bronze sculpture by Helaman Ferguson, *Torus with Cross-Cap*, contains the germ of a fundamental theorem concerning the classification of surfaces. A "standard" torus looks like an inner tube, but it can be deformed into a one-handled coffee mug or some other shape with a single hole and still have the same topology. A cross-cap is a special sort of twisting and pinching where a surface intersects itself. Topological surfaces are equivalent if they have the same number of boundaries, handles, and cross-caps.

□ □ □

Ferguson's path to his current status as an accomplished sculptor and a professional mathematician was not an easy one.

Helaman Rolfe Pratt was born on August 11, 1940, in a Salt Lake City hospital. His parents had met in art school in Los Angeles. His father was a commercial artist, bred in Utah. His mother was from an old Colorado pioneer family, which included a number of Rocky Mountain doctors and mathematicians.

Ferguson entered the world seriously disfigured with a cleft palate, profoundly shocking his parents. The break, running from the front to the back of the roof of his mouth, was severe enough that he had to be fed through a tube in his nose. A series of operations over the next few years corrected the problem. Anyone meeting Ferguson today would be surprised that he was once disfigured.

At age three, he suffered additional setbacks. While he and his sister watched their mother removing laundry from a clothesline, she was struck and killed by lightning. Two weeks later, his father was drafted for service in World War II. Ferguson's grandmother cared for the two children for the next two years.

It was a difficult time. Ferguson remembers having nightmares and grinding his teeth at night. Withdrawn and caught up

in his demons, he had a tough time in kindergarten. He was labeled as unteachable.

The picture brightened when Ferguson was six years old. A distant cousin and her Scotch Irish immigrant husband, who were childless, adopted Helaman and his sister. Bringing the children to Palmyra, New York, the Fergusons provided the welcome stability of orthodox Mormon family life.

Ferguson's foster father was a stonemason and a carpenter. He taught Ferguson how to work with his hands, how to build with fieldstone and mortar, and how to handle huge chunks of rock. That was the beginning of Ferguson's lifelong love affair with natural stone.

In elementary school, teachers remarked on and praised Ferguson's painting ability. An art teacher reported that he was a joy to have in class. At the same time, Ferguson demonstrated a facility with numbers and a keen appreciation of geometry.

A ninth-grade math teacher, Florence Deci, recognized and encouraged Ferguson's dual creativity. She allowed him the chance to do a wide range of mathematics projects that sometimes included an art component. One involved putting together a wire-frame model of a hyperbolic paraboloid— a fundamental shape of three-dimensional geometry.

A hyperbolic paraboloid has a characteristic saddle shape.

Ferguson won several scholarships when he completed high school, and he could have gone into engineering. Instead, he chose Hamilton College in Clinton, New York, for its congenial blend of the arts and the sciences. The artist in residence at the time, James Penny, introduced Ferguson to sculpting, though the college didn't have the specialized tools needed for carving stone.

On the mathematical side, Ferguson's work was good enough that he managed the relatively rare feat of having a research paper, on the Riemann zeta function, published while he was still an undergraduate. He received a National Science Foundation fellowship to do graduate work in mathematics at the University of Wisconsin in Madison after receiving his liberal arts degree from Hamilton in 1962.

It was a time of great turmoil and indecision for Ferguson. He had earned recognition as a mathematician, but he wanted to paint. After one semester, he made the considerable financial sacrifice of returning his math fellowship to devote himself to art. He also met Claire Eising, a first-year art student, and ended up proposing marriage. The newly wed couple moved to Salt Lake City, where they settled into their lives together as poor, starving artists. Luckily, Ferguson's aunt helped them out by buying some of their paintings. He ended up getting a job as a computer programmer. While working, Ferguson tidied up his academic record by completing a master's degree in mathematics at Brigham Young University. He also took graduate courses in sculpture and did a number of wood carvings.

That mixture of mathematics and art continued during the five years that Ferguson spent at the University of Washington in Seattle studying for his doctorate in mathematics, with a focus on a field known as harmonic analysis. By this time, he and Claire had four children. To help support his growing family, he did some commissioned paintings and, at one point, put on an art show that featured his landscapes and other creations. Making do with just a carpenter's hammer and a railroad spike, he also carved a piece of limestone, which he had picked up while camping, into a sculpture.

Stone carving began in earnest after Ferguson settled in as a math professor at BYU in 1972. Popular with students, he could write on the chalkboard with both hands simultaneously, building mathematical arguments and constructing sentences and descriptions in the way that one would put up a house, creating a framework, then filling in the details rather than proceeding in a strictly linear fashion. He showed his manual dexterity in other ways, making it into *The Guinness Book of World Records* for a 1987

feat of "joggling"—that is, juggling three balls while jogging fifty miles.

Joggling is good for developing and maintaining hand-eye coordination, Ferguson says, and it helps keep bodily joints limber that might otherwise suffer from the repetitive motions of sculpting. Setting the record, however, was his response to a neighbor, a sports physiologist and orthopedic surgeon who had insisted that it would be neurologically and physically impossible to sustain that sort of hand, eye, and foot coordination for so long.

Collaborating with fellow BYU mathematician Rodney Forcade, Ferguson pursued an interest in step-by-step procedures, or algorithms, for accomplishing mathematical operations. His enduring mathematical achievement involves what he describes as a "jazzed-up" version of an algorithm dating back more than two thousand years to the Greek geometer Euclid of Alexandria (365–300 B.C.).

The so-called Euclidean algorithm offers a recipe for finding the greatest common divisor of two whole numbers. Suppose the given numbers are 12 and 18. Twelve is evenly divisible by 1, 2, 3, 4, 6, and 12; 18 is evenly divisible by 1, 2, 3, 6, 9, and 18. By comparing the lists, you can see that both numbers are evenly divisible by 1, 2, 3, and 6. The largest common divisor is 6. That's easy to figure out just by trial and error when the given numbers are small. The Euclidean algorithm works with numbers of any size.

To find the greatest common divisor of 77 and 187 using the Euclidean algorithm involves the process of long division, which most of us first encounter in elementary school. Divide 77 into 187. The remainder is 33. Divide the remainder, 33, into the original divisor, 77. The new remainder is 11. Divide 11 into 33. The remainder is 0. The greatest common divisor must be 11.

Determining the greatest common divisor is an example of finding an integer relation between two numbers. Ferguson's discovery, in collaboration with Forcade, was a generalization of the Euclidean algorithm, which serves as a practical computational scheme for finding integer relations involving more than two numbers and for performing a process known as lattice reduction. Now recognized as one of the top ten algorithms of the twentieth century, Ferguson and Forcade's recipe has already been used by others to generate novel mathematical formulas and to uncover new results in theoretical physics.

Ferguson sees an intimate link between his mathematical algorithm and the art of carving. Both are subtractive processes.

In the Euclidean algorithm, the mathematician chips away at a pair of numbers until their greatest common divisor is finally revealed. In sculpture, the artist flakes away rock until the envisioned form appears—almost as if it were a painstakingly unearthed archaeological artifact.

Algorithms themselves have intrinsic shapes, Ferguson says. In effect, streams of data—digits—can be processed as geometric forms or pictures, and those shapes can be complex and beautiful. With computers and visualization software, mathematicians are now in the new position of being able to explore the vast, uncharted expanse of the geometry of algorithms.

Indeed, much of life is algorithmic as nature goes about its daily business according to its own rules and as our senses and minds process the information available to us. We see, smell, and hear in every face, flower, and tree the shape, fragrance, and sound of an algorithm.

Ferguson's dusty basement studio is crowded with the results of his dialogues between materials and mathematical theorems—sculpted geometric forms that go by exotic names: Klein bottles, trefoil knots, cross-caps, horned spheres, and tori. These figures play important roles in topology—the branch of mathematics dealing with the fundamental characteristics of geometric shapes that remain unchanged even when the shape itself is stretched, twisted, or otherwise distorted, as long as the transformation doesn't involve tearing or breaking.

In topology, the surface of a sphere and the surface of a bowl belong to the same category of geometric objects because it's possible to reshape a sphere's surface into a bowl's surface without tearing it apart, just by indenting it. In contrast, the surface of a doughnut, or torus, belongs to a different category because there's no way to turn a sphere's surface into a doughnut's surface without performing some sort of surgery.

To create *Eine Kleine Rock Musik III*, Ferguson quarried a sixty-pound piece of creamily streaked honey onyx in Utah, then carved it into a topological shape known as a Klein bottle. A Klein bottle has a curiously contorted surface that passes through itself and emerges again from the other side.

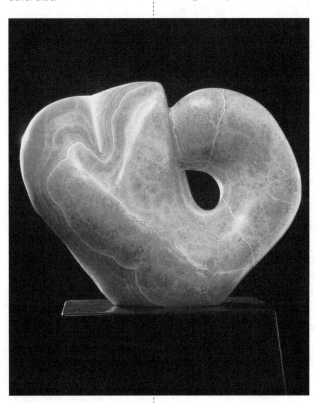

Such notions of topological transformation are captured in an artwork Ferguson calls *Double Torus Stonehenge*. It consists of twenty-eight individual bronzes arranged in a circle on an oak turntable about thirty-two inches wide. Each figure is a representation of a double torus and resembles a two-handled pitcher, like an ancient Greek amphora. The bronzes depict in twenty-eight stages how the two handles of a double torus can link and unlink without any tearing or breaking. In effect, *Double Torus Stonehenge* is both a theorem and its proof.

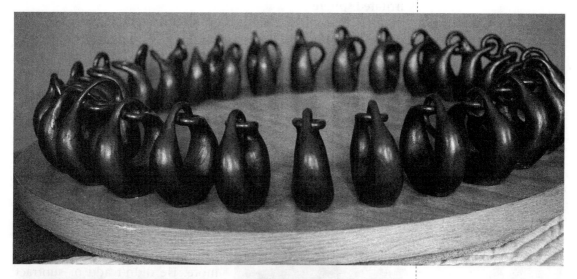

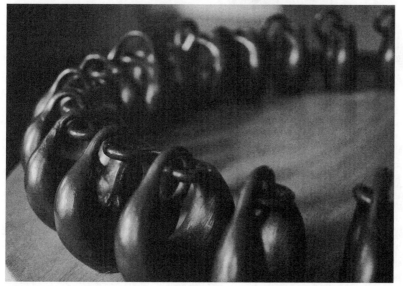

In *Double Torus Stonehenge: Continuous Linking and Unlinking*, Ferguson depicted in twenty-eight steps the gradual transformation of a double torus from a configuration in which its two handles are linked together to one in which they are unlinked, then linked again to continue the endlessly cycling dance.

At the same time, the collection of pieces echoes the twenty-eight days of the lunar month, suggesting a moonlit dance in the round. As the moon waxes and wanes by small changes from night to night, *Double Torus Stonehenge* undergoes its equally enchanting transformation from link to unlink over the same period.

One of Ferguson's favorite subjects has been Alexander's horned sphere, one of the more bizarre forms in the topologist's catalog of shapes. Named for the Princeton mathematician James W. Alexander (1888–1971), this strange object looks like a wildly irritated sphere.

Imagine a sphere that sprouts two arms that reach out to each other. Then imagine that the two arms each has a pair of fingers and that each of these fingers has a pair of smaller fingers, and so on. Now intertwine the fingers so that one arm appears inextricably linked to the other.

Ferguson has put a great deal of time and effort into taming this fearsome beast—creating several versions of the Alexander horned sphere in marble, bronze, and other materials. It started in 1986 with a ceramic pot borrowed from the kitchen and

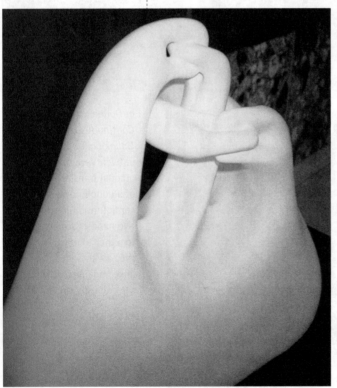

used to melt casting wax. Ferguson first formed the warm wax into a ball, then began squeezing out a pair of horns. He then squeezed two appendages from each horn; then from each appendage, two more. He didn't add or subtract wax; he just deformed it. At any stage, he could squash it all back into the wax ball, which in its physical way proves the theorem that the Alexander horned sphere is a topological variation on a sphere.

Ferguson's *Whaledream II* emerged from a large piece of Carrara marble. Though based on a fearsome mathematical shape known as Alexander's horned sphere, this rendering—pairs of arms entwined in a graceful ballet—inspires peace and harmony.

Whaledream II, carved out of white Carrara marble, is one of his more soothing realizations. This large sculpture, weighing about 550 pounds and standing about 15 inches high on a 30-inch base, represents the first 2¾ stages in the construction of the horned sphere, extending only to the first set of fingers, which appear clasped in an ethereal handshake. Ferguson's bronze casting of the same topological shape has a very different feel—of muscular, contorted arms trapped in an intense wrestling match. Another of his wild spheres has the look of a scaly, primeval creature clawing its way out of raw rock.

Though inspired by mathematics, Ferguson's sculptures are not precise mathematical models. "One most interesting and unnatural thing about modern mathematics is its preoccupation with infinite processes," Ferguson notes. Whereas equations may specify forms of infinite extent, the artist must decide where to truncate the structure to create a visually appealing form. No sculptor could ever fabricate the infinite sequence of successively tinier fingers that belong to a true horned sphere. Indeed, no artist, wielding brush, or chisel can venture into every infinitesimal nook and cranny created by the mathematical mind.

That's not the point, however. "We could just make a model . . . as exactly as physically possible," Ferguson remarks. "When we get done, we would have just that—a model. Nothing more, something less. A sculpture can have . . . nuance, timbre, mystery, warmth, history, numerous levels of meaning, and many references other than what its humble origins would hope or explain."

Ferguson's work has a warmth and softness that belies its cold, inorganic origins. The freely flowing lines, subdued details, and references to organic forms characteristic of his sculptures bring in a human element, imparting a familiar, tactile quality to esoteric mathematical ideas.

Photographs of Ferguson's pieces fail to capture many of the elements crucial to appreciating them. The textures and contours of his sculptures invite viewers to touch their surfaces and trace their designs. Only by walking around a piece to see it from different vantage points can a viewer sample its full spectrum of patterns. Each new look brings startling revelations.

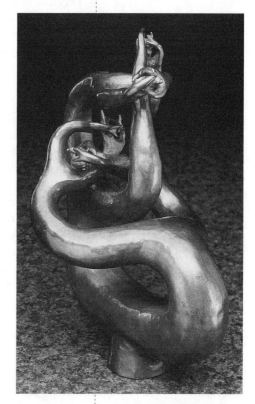

In Ferguson's alternative view of Alexander's horned sphere, *Wild Sphere I*, the polished bronze sculpture has the muscular look of a hero of ancient Greece straining to complete an impossibly tangled task.

□ □ □

Ferguson's *Umbilic Torus NC* looks like an artifact excavated from an ancient Mayan, or possibly Chinese, ruin. The sculpture's burnished edges and inscribed, weathered surface seem to carry an enigmatic message from bygone days.

Created in 1988, this textured, twisted bronze ring, which stands about twenty-seven inches high, actually represents a unique blend of the old and the new. Computer graphics allowed Ferguson to generate images of a mathematically defined form, and, from those images, he could select an aesthetically pleasing depiction. A specially programmed, numerically controlled milling machine produced the intricately inscribed surface, and an ancient bronze casting technique rendered the final object.

Looking at the equations that served as a starting point provides no visible hint, even to the mathematically trained eye, of the particular shape that Ferguson discovered encoded in the symbols. The basic underlying form is a torus, which resembles a bicycle tire's inner tube. In this case, however, a slice through the ring reveals not a circle, as you would see in an inner tube, but a triangular shape with inwardly curving sides. The three sides correspond to a curve called a hypocycloid, which is the path followed by a point on the circumference of a small circle that, in turn, is rolling inside the circumference of a larger circle. In this case, the large circle is three times wider than the small one. The result is a curve with three cusps.

Umbilic Torus NC by Helaman Ferguson. See plate 2.

The curve known as a hypocycloid of three cusps (curved triangle shape in center) represents the motion of a point on a small circle of radius one unit rolling inside a larger circle of radius three units.

Following a cusp around the ring unveils a little surprise. All three cusps, as seen in a cross section through the ring, lie on the same three-dimensional curve. In other words, a finger tracing the cusp-defined rim travels three times around the ring before ending up back at its starting point. The mathematical term "umbilic" refers to the particular way in which this torus is twisted to give it that property.

To convert his computer-generated drawings into a three-dimensional object, Ferguson turned to technology that is used to fabricate machine parts. He enlisted the aid of the BYU Robotics and Automated Manufacturing Laboratory and learned how components for jet engines are made. In return, he lectured for three semesters to a roomful of engineering faculty and graduate students on the computer-aided design and manufacturing approach he developed to automate the carving of a sculpture.

Direct carving, like machining, requires moving a cutting tool around on a surface so that, in effect, it visits every point. Like someone mowing a lawn or painting a large wall, manufacturing engineers usually have the cutter go back and forth, from one side to the other, or follow a spiral motion that produces a series of concentric rectangles.

Mathematically, there are other possibilities for curves that can visit one point at a time and cover the entire surface. One such surface-filling curve was discovered in 1890 by the Italian mathematician and logician Giuseppe Peano (1858–1932). He showed how a single point, moving continuously over a square, could, in principle, pass through every point on the square and its boundary. In effect, the curve would wind through an infinity of points, solidly painting in the entire square. A year later, the German mathematician David Hilbert (1862–1943) proposed a step-by-step method for drawing such an imagined curve.

After just a few steps, the resulting pattern begins to look like an intricate but highly regular maze. Each successive, increasingly folded path, however, remains just an approximation of the true Peano-Hilbert curve. The true curve is infinitely long and folded into infinitesimally small segments that no one could possibly picture in every detail. A

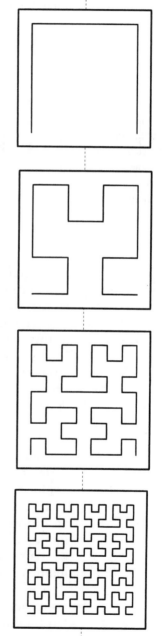

The first four stages in creating progressively more crinkled approximations of the space-filling Peano-Hilbert curve.

machinist or an artist, however, can take advantage of the fact that a real cutting tool has a finite width. Moreover, it can leave interesting marks and create a pleasing texture. Ferguson chose the fifth stage of the Peano-Hilbert curve as his surface-cutting pattern, giving his sculpture a distinctive surface relief pattern—a continuous trail that echoes Mayan pictographic writing or an ancient Chinese bronze.

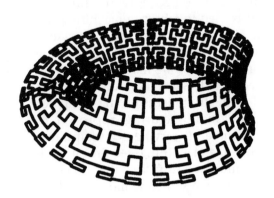

How an approximation of the Peano-Hilbert curve was adapted to fit the surface of Ferguson's umbilic torus sculpture.

Programming what was essentially a mindless robot to guide a powerful cutting tool flawlessly over a block of high-density Styrofoam and shape it into the complex, twisted form that Ferguson envisioned was no simple matter. "The tool path and trajectory have to be specified in complete detail in advance," Ferguson notes. "While [the milling machine] can do certain kinds of elegant, accurate, and reproducible work very well, it is very difficult to interrupt or reposition. After the programming is done, you hope you like what you see."

The final cutting took more than eight hours. The Styrofoam block emerged from under the knife looking like a weirdly twisted waffle. Ferguson then smoothed out and refined his design by hand, preparing his sculpture for a traditional bronze-casting technique rooted in ancient cultures.

In creating *Umbilic Torus NC,* Ferguson's choices added up to an evocative mingling of the old and the new—in art, mathematics, and technology. His finished sculpture, with its green patina redolent of silent waiting, celebrates the timelessness of mathematical ideas.

The year 1988 also saw Ferguson and his family, which by then included six sons and a daughter, move East to a Maryland suburb of Washington, D.C. He gave up the security of a

tenured professorship, but to maintain a steady income and support his burgeoning artistic endeavors (and growing family), he took a day job as a designer of computer algorithms for operating machinery and for visualizing scientific data. He became particularly interested in developing methods for "sculpting" data into forms that are meaningful and useful to researchers trying to cope with the overwhelming flood of information generated by frenetic, number-crunching supercomputers.

Ferguson's experience with BYU's numerically controlled milling machine had vividly illustrated both the benefits and the disadvantages of using such technology for creating a work of art. He could create an intricate, precisely defined object of great beauty, but the machine was expensive and unwieldy, and its reach and scale were strictly limited. Ferguson was now thinking bigger, cheaper, and more flexible.

Sculptors often make a small model, or maquette, of what they want to carve. Traditionally, they have used a contraption called a pointing machine to transfer measurements from the maquette to a block of stone to make an enlarged reproduction. Though effective, the process is cumbersome and time-consuming, and it's useless without a solid model to copy.

Ferguson pioneered an alternative approach. Using equipment developed by James Albus and his coworkers in the Robot Systems Group at the National Institute of Standards and Technology (NIST), he could translate geometric forms drawn on the computer screen directly into instructions on how much material to remove at any point on a stone's surface to reveal the carved object.

With the latest version of the NIST apparatus, the sculptor's task becomes that of chipping away the excess material to reveal a figure that, in some sense, already exists in the stone. The NIST virtual projector consists of two rigid, equilateral triangles: a large one fixed to the ceiling of Ferguson's garage, and a second, smaller triangle suspended from the first triangle by six cables. Attaching a high-speed water jet, air drill, or some other cutting tool to the lower triangle, the sculptor can move this triangle around to direct the carving process.

Sensors register the varying lengths of the six cables as the lower triangle moves about, and a computer program works out the tool's position and orientation at any moment. When the tool tip touches the stone, the computer also calculates the distance from that spot to the nearest point on the virtual image of the surface yet to be unearthed.

> "While [the milling machine] can do certain kinds of elegant, accurate, and reproducible work very well, it is very difficult to interrupt or reposition."
> —Helaman Ferguson

Ferguson's *Four Canoes* sculpture consists of two three-ton, interlocking rings of granite, one red and the other black, sitting on a pair of granite pedestals. Each ring represents a mathematical form called a Klein bottle and can be imagined as a pair of canoes, one inverted and placed atop the other, then sewn together at the gunnels and bent around until their front and back ends touch.

"Compared with the traditional pointing machine, you get a lot more flexibility," Ferguson says. "The process can also be more quantitative, down to a precision of a millimeter or so."

From certain angles, Ferguson's massive *Four Canoes* sculpture looks like two fat rings, each snugly looped through the other. Such a viewpoint, however, immediately poses a question: How did the granite rings, each one six feet wide and three tons in weight and each a different color, come to be inextricably linked?

A closer look reveals that each ring features a narrow gap where the ring tapers rapidly from each side into a sharp wedge. Even with the gaps, however, positioning and linking the rings to sit properly on a twin pedestal was no simple task when the sculpture was installed in 1997 at the University of St. Thomas in St. Paul, Minnesota.

Each ring represents a Klein bottle, one of Ferguson's favorite sculpting subjects from the realm of mathematics. Named for the German mathematician Felix Klein (1849–1925), this curious object has just one side. In effect, its "outside" blends into its "inside." One can imagine constructing a Klein bottle from a stretchable glass cylinder, narrowed at one end to form a neck

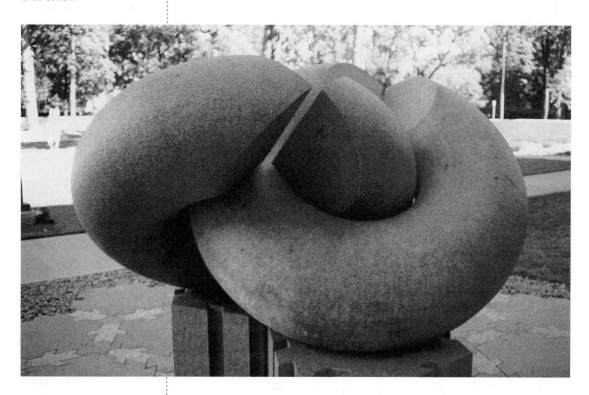

and wide at the other to serve as a base. The neck passes through the side of the bottle and then joins with the base, making the inside of the neck continuous with the outside of the base. The result is a weird, one-handled bottle that may or may not be able to hold a liquid.

However, the bottle surface is just one of many different ways of visually representing the mathematical form that Klein envisioned and defined. Indeed, the Klein surface can take on many shapes that don't look at all like bottles.

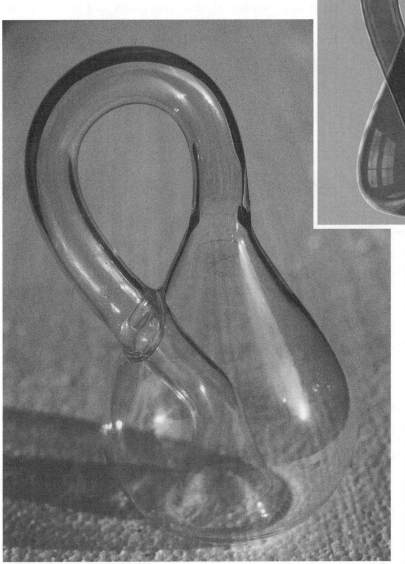

Computer-generated image of the "standard" Klein bottle (above). The challenge of fabricating a Klein bottle has long attracted the attention of glassblowers (left).

One particularly interesting version looks like a ring pinched so that it has a figure-eight cross section, but the orientation of the figure eight changes in going around the ring.

Ferguson discovered an equivalent, highly symmetrical form described topologically as a sphere with two cross-caps. It can be pictured as a ring that somewhere along its circumference gets pinched down to a line of infinitesimal thinness to produce a double cross-cap. In effect, a cross-cap is a sort of magic door that takes one from the inside to the outside, Ferguson says.

"A pair of these forms can physically pass through each other through their approximate double cross-caps and then, in this linked state, rotate around and through each other," Ferguson notes. "This is a very intimate piece, either as a handheld sculpture or in monumental size."

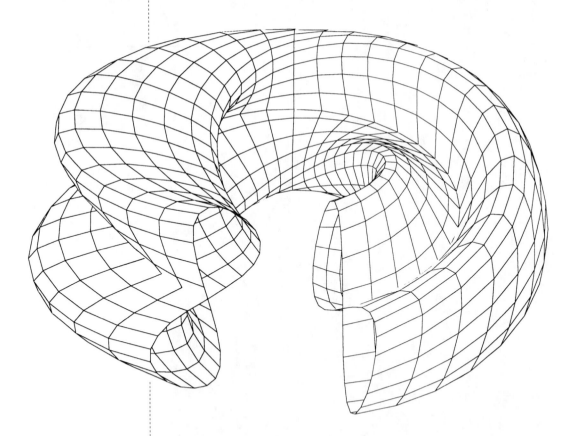

One of the many different ways of visualizing a Klein bottle looks like a ring pinched so that it has a figure-eight cross section. The orientation of the figure eight changes in going around the ring to give the shape an intriguing twist.

The technical *tour de force* is to carve the two pinched Klein bagels so that, when linked, they snuggle intimately into each other's orbits. "The pair together and apart offer a kind of parable of scientific technique," Ferguson suggests. "Together (synthesis)

A Klein bottle can be represented in terms of a torus, or bagel shape, with a pair of cross-caps. By putting in a small gap in a stone ring where the cross-caps meet, Ferguson can link two such Klein bagels to produce an intriguing sculptural combination.

they offer an immediate problem to be solved (analysis). On the other hand, a pair of these linking and unlinking Klein [bagels] are aesthetically symbolic of human relationships, a subject of enduring vitality, surely more ancient than going to sea in boats."

Ferguson's *Four Canoes* rests on two granite pedestals, which are surrounded by an array of twenty-eight hexagonal tiles, each three feet in diameter. The tiles represent a particular way of viewing a Klein bottle as the result of abstractly sewing together opposite sides of a tile so that serrated edges match. Curiously, mathematicians have yet to prove that it is possible to extend this particular hexagonal tiling to infinity so that it covers the entire plane. "This is an unsolved problem which intensifies the mystery of the sculpture," Ferguson comments.

Carving and installing *Four Canoes* presented significant technical challenges. It was fabricated under Ferguson's direction from a block of one-billion-year-old Texas red granite and a block of half-billion-year-old California black granite at the facilities of the Cold Spring Granite Company in Minnesota. To entwine the granite rings and install them on their pedestals, Ferguson carefully orchestrated the activities of two cranes, two crane operators, and two riggers. "Moving a three-ton object, which has a built-in tendency to roll, is no trivial matter," Ferguson says.

Ferguson is now scaling up his sculptural endeavors, breaking out of the confines of his cramped garage studio into a large, rustic barn to create sculptures of sufficient scale to populate the expansive spaces of a verdant research park and other settings.

"I find that sculpture is a very powerful way to convey mathematics, and mathematics is a very powerful design language for sculpture," Ferguson says.

In 1999, Ferguson began transforming a barn dating back more than 150 years into a spacious though somewhat drafty sculpture studio.

His sculptures allow nonmathematicians to experience some of the pleasure that mathematicians take in their work and to share in the wonder they feel. "I'm trying to express some of our culture's most beautiful achievements," Ferguson says. "They tend to be hidden knowledge, but they don't need to be." Strikingly, his creations convey not only the visual beauty, harmony, and symmetry of mathematics but also its sound and feel. These are edifying experiences for artist, mathematician, and onlooker.

In Ferguson's work, the symbolism inherent in mathematics collides and intertwines with the symbolism inherent in sculpture. His mathematical messages resonate in multiple ways. For one discerning viewer, a piece might encode the workings of a

This delicately shaped and grooved sculpture is a companion to *Torus with Cross-Cap and Vector Field*, created for the centennial in 1988 of the American Mathematical Society and now on display in contemplative serenity at the society's headquarters in Providence, Rhode Island.

mathematical theorem, a truth that holds now and forevermore. For another, it might open up a path to a new way of seeing the world—a new perspective, a new dimension.

"I'm drawing from mathematical resources that go back to the very beginnings of our culture," Ferguson says. "With my carving, I'm sending these mathematical messages into the future."

> "I'm drawing from mathematical resources that go back to the very beginnings of our culture. With my carving, I'm sending these mathematical messages into the future.
>
> *—Helaman Ferguson*

3 | A Place in Space

The bleak, checkered pavement fades rapidly into the gloom of a black sky. Two figures stand out in stark relief against this dismal backdrop, each caught in glaring light that casts sharp shadows and washes out natural colors into pallid ochers, ambers, and browns. The draped female figure in the foreground gazes up at the pristine, nearly naked body of Christ, suspended with outstretched arms in front of a cross floating in the air. The cross itself appears constructed from curiously stacked cubes.

Created in 1954, the painting is Salvador Dali's *The Crucifixion*, subtitled *Corpus Hypercubicus*. To represent the transcendental, the artist took advantage of the rich symbolism associated with the notion of the fourth dimension. He turned to a mathematical object to do it, depicting the cross as an unfolded hypercube—a mystical, unexpected intruder from a higher dimension.

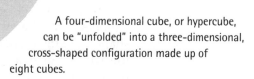

A four-dimensional cube, or hypercube, can be "unfolded" into a three-dimensional, cross-shaped configuration made up of eight cubes.

Dali's unfolded hypercube suggests access to dimensions beyond those to which our everyday senses of sight and touch seem to confine us. It takes us beyond descriptions of solid objects in terms of length, width, and breadth and beyond positions in space described in terms of left and right, up and down, front and back. It also reminds us of a recurrent theme in philosophy, theology, art, and mathematics: the ongoing struggle to grasp the ideal and the transcendental and to encompass the infinite and the infinitesimal. It forces us to confront the realm of the imagined but physically unrealizable.

The roots of this search for the transcendental go back to ancient times. Interest in the fourth dimension is much more recent, however. The late nineteenth and early twentieth centuries were a vibrant period of astonishing, dimension-bursting scientific and technological advances, from the discovery of X rays and the advent of powered flight to the unveiling of the atomic nucleus and Albert Einstein's formulations of the special and general theories of relativity.

It was also a time of great popular interest in visualizing a fourth spatial dimension—a concept that appeared to offer painters and sculptors, in particular, an avenue of escape from conventional representation. Moreover, the development of non-Euclidean geometries, which overturn Euclid's postulate that parallel lines never meet, provided alternative but perfectly consistent models of reality.

Obsessed with invisible worlds, the Russian spiritualist P. D. Ouspensky (1878–1947), an influential figure in the occult movement of the early twentieth century, wrote wildly popular books and articles about the fourth dimension. "Our basic conception of the world must be broadened," he argued. "Already we feel and know that we can no longer trust the eyes with which we see, or the hands with which we touch. . . . The ideas of the 'fourth dimension,' ideas of 'many dimensional space,' show the way by which we may arrive at the broadening of our conception of the world."

Even as the term "fourth dimension" became a metaphor for the mysterious, miraculous, supernatural, and incomprehensible, mathematicians were busy stretching their own concepts of dimension to include geometric forms such as the hypercube, or tesseract, within a logical framework.

An ordinary cube has six square faces. You can construct a model of a cube by drawing a template in the form of a cross-shaped arrangement of six squares on a sheet of paper, indicating which edges are to be attached to which, cutting out the pattern, and performing the appropriate folding and gluing.

The three-dimensional analog of the unfolded pattern of squares used for making a cube serves as a pattern for an unfolded hypercube. A hypercube would have eight cubical "faces." Construction begins by surrounding a cube with six additional cubes, one attached to each face of the central cube. An eighth cube added to one of the six arms completes the structure. How this form folds up into a hypercube, however, can't be directly visualized. Nonetheless, as depicted in Dali's painting, the unfolded hypercube can hint at the existence of an entrance to the fourth dimension.

For a number of years, a print of Dali's painting hung in the office of Thomas F. Banchoff, a mathematician at Brown University in Providence, Rhode Island. As a geometer fascinated with visualizing four-dimensional objects, Banchoff had collaborated with applied mathematician and Brown colleague Charles Strauss to generate startling graphic images of a hypercube in various guises. Banchoff often pointed out Dali's painting to visitors as an example of the way artists use higher-dimensional imagery in conscious ways in their creations.

In 1975, the *Washington Post* featured an article about the pioneering efforts of Banchoff and Strauss in using computer graphics to depict mathematical objects. The editors included a photograph of Banchoff with the Dali reproduction in the background. Shortly afterward, Banchoff received a telephone call inviting him to confer with Dali, who was at that time deeply immersed in studies of how to create and present stereoscopic oil paintings.

The artist and the mathematician met. Banchoff came away impressed with Dali's technical knowledge and facility. Dali evidently enjoyed the interaction and keenly appreciated hearing about a novel, foldable model of the hypercube that Banchoff had originally described in his 1964 doctoral thesis.

When Banchoff asked Dali what had inspired his *Corpus Hypercubicus* painting, Dali referred to the philosophy of Ramon Lull (1235–1316), a Catalan mystic, alchemist, and poet who had attempted to reduce all knowledge to first principles and establish its essential unity. Lull maintained that even the deepest mysteries of the Christian faith could be proved by logical argument. Geometrical objects such as circles often served as metaphors in his arguments.

A hollow, three-dimensional cube can be cut apart and unfolded into a flat, cross-shaped configuration made up of six squares, just as a hypercube can be unfolded into an array of three-dimensional cubes.

Coincidentally, Lull's work and philosophy were already familiar to Banchoff. This additional shared interest developed into a mutual respect that led to a series of meetings between Dali and Banchoff in Paris and Spain over the next few years. Banchoff would display the fruits of his research, in the form of slides, videotapes, films, and other visualizations, and he would get a peek at Dali's works in progress.

Unfortunately, the two never completed a project together. Dali died in 1989. The artwork of the last three decades of Dali's life reveled in symbolism suggested by atomic and nuclear theory and, just before his death, by quantum mechanics and genetics. In Dali's intensely spiritual visions, the material world shivers into disconnected fragments; atoms explode into cubes and spheres. With Dali's creations as intermediaries, the viewer can verily see through matter to glimpse a more elemental reality.

Banchoff's fascination with the fourth dimension and its connection with domains beyond everyday experience goes back to his childhood. He grew up in a Catholic household in Trenton, New Jersey. His mother was a kindergarten teacher and his father a payroll accountant.

Banchoff was an inquisitive, observant child and a voracious accumulator of facts. When he was ten years old, he won the "Quiz Kid of Trenton" contest, earning a chance to travel to Chicago to appear with other winners of city competitions in an exhibition match sponsored by the national *Quiz Kids* radio program. Banchoff's specialty then was astronomy.

At about this time in the early 1950s, Banchoff became curious about the fourth dimension, little realizing how much that nascent interest would later change his life. He remembers puzzling over the notion of "dimension" when he encountered the term in a futuristic comic book titled *Captain Marvel Visits the World of Your Tomorrow*. In the guise of blue-eyed, black-haired Billy Batson, boy reporter and radio personality, Captain Marvel is touring a laboratory. His guide, an Einstein-like figure, proudly proclaims, "This is where our scientists are working on the seventh, eighth, and ninth dimensions." A thought balloon bubbles up from Billy, "I wonder what ever happened to the fourth, fifth, and sixth dimensions?" Billy's unspoken question echoed Banchoff's own thoughts at that moment.

Shortly afterward, another comic book introduced Banchoff to the classic theme of a creature from a higher dimension intruding into our three-dimensional world in the same way that a

diver can intersect the flat world at the surface of a still pond. The same theme surfaced again a few years later when Banchoff discovered a remarkable book called *Flatland: A Romance of Many Dimensions,* written in 1884 by Edwin A. Abbott (1838–1926), an educator and headmaster of the City of London School in England.

Flatland's central figure and narrator, "A Square," brings visitors into a perfectly flat domain populated by a race of rigid geometric forms. An inflexible class structure rules: Flatland women are merely Straight Lines. Lower-Class men are Isosceles Triangles; Squares make up the professional class; Nobles are regular polygons with six or more sides; and Priests, the highest-ranking members, are Circles.

The cover of the 1884 first edition of *Flatland* invited readers into the two-dimensional, pentagonal house of the book's narrator, A Square.

All Flatland's inhabitants are trapped in their two-dimensional realm. Like shadows, they can freely skate about on the surface of their world but lack the power to rise above or sink below it

Toward the end of the book, A Square receives a visit from a ghostly three-dimensional sphere who tries to demonstrate to the bewildered Flatlander the existence of Spaceland and a higher dimension. The visiting sphere argues that he is a "Solid" made up of an infinite number of circles, varying in size from a point to a circle thirteen inches across, stacked one on top of the other. In Flatland only one of these circles would be visible at any given moment. To a Flatlander, each circle would look like a line. The length of the line would depend on the size of the circle, so to a Flatlander, a sphere rising through Flatland would look like a dot that grew longer and longer, then shorter and shorter, until it became a dot again and vanished.

When this vanishing trick fails to persuade A Square that the sphere is truly three-dimensional, the visiting sphere tries a more mathematical argument. A single point, being just a point, he insists, has only one terminal point. A moving point produces a straight line, which has two terminal points. A straight line moving at right angles to itself sweeps out a square with four terminal points.

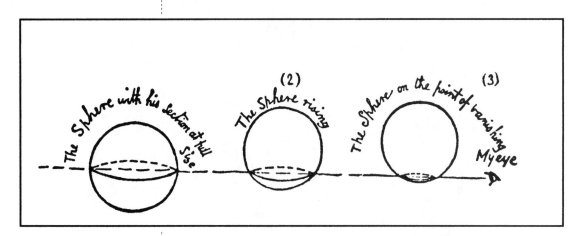

One can imagine a three-dimensional sphere as a stack of circles of differing diameter, and only one of these circles would intersect Flatland at any given moment. Such a circle would be visible to a Flatlander as a line segment, and the segment's length would depend on the circle's diameter. Hence, a sphere rising through Flatland would look like a dot that grows longer and longer, then shorter and shorter, until it becomes a dot again and vanishes.

These are all conceivable operations to a Flatlander. Inexorable mathematical logic forces the next step. If the numbers 1, 2, and 4 are in a geometric progression, then 8 follows. Lifting a square out of the plane of Flatland ought to produce something with eight corners. Spacelanders call it a cube. The argument reveals a path to even higher dimensions: a four-dimensional hypercube would have sixteen corners, for example. Tragically, A Square gets imprisoned for heresy when he later tries to persuade his fellow citizens of the existence of these other domains.

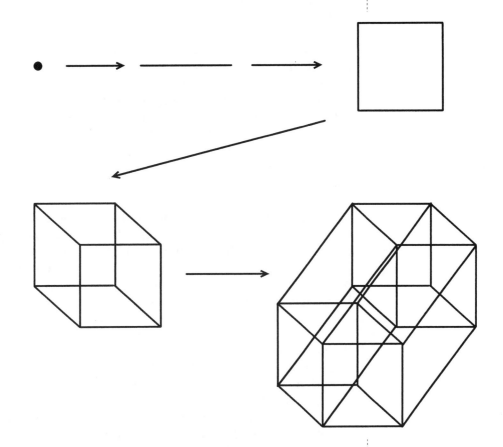

A mathematical point has no length or width, so it has zero dimension. Moving a point along a straight path to a new position traces out a line—a one-dimensional object. Shifting the line at right angles to its length produces a square—a two-dimensional object. Moving the square at right angles to its flat surface traces out a cube—a three-dimensional object. Moving the cube in a new, fourth direction at right angles to the three already used produces the mysterious hypercube, or tesseract. In general, the analog of a cube in any dimension can be generated by moving the preceding, lower-dimensional cube at right angles to itself.

When Banchoff was a student at Trenton Catholic Boys' High School, his speculations returned to some of the themes developed by Abbott in *Flatland*. In his junior year he presented to a sympathetic biology teacher, Father Roland Schultz, a theory relating the fourth dimension and the Trinity. In Christian theology, the Trinity represents the doctrine that God exists as three persons—Father, Son, and Holy Spirit—who are united as one being. Banchoff posited that if God, as a four-dimensional being, were to come into our three-dimensional world, all we would see is a particular "slice"—a person who would look like us. At the same time, there would be two other aspects of God that we couldn't see.

Admitted to the University of Notre Dame in Indiana, Banchoff focused on mathematics, though he maintained a lively interest and took classes in literature and philosophy. He received his bachelor's degree in 1960 and began graduate studies in mathematics at the University of California at Berkeley. Banchoff's specialty was in the field of mathematics known as differential geometry, which applies the techniques of calculus to problems in the geometry of curves and surfaces. His thesis concerned a particular mathematical feature of geometrical objects known as the "two-piece property."

If you use a long, straight knife to slice completely through an orange or a hard-boiled egg, the object falls apart into exactly two pieces. Hence, the shapes represented by the orange and the egg are said to have the two-piece property. On the other hand, objects such as a fork or a sufficiently curved banana would fall into three or more pieces when cut in certain directions. These objects do not have the two-piece property. In general, any convex geometrical object that (like a sphere or an egg-shaped form) has no indentations or crinkles has the two-piece property. However, certain nonconvex objects also have this property, including a bagel, a scooped-out half of a cantaloupe, and an apple (without the stem), but not a pear.

Banchoff's contribution was to look at what sorts of geometrical objects would have the two-piece property when the objects are polyhedra, which have flat faces, sharp edges, and corners rather than being smoothly rounded, as in a sphere or a torus. He looked for this property not only in two and three dimensions but also in higher dimensions. At one point in his work, it was the everyday task of folding his laundry that sparked a crucial insight, allowing Banchoff to imagine how to construct a polyhedral surface in six-dimensional space having the two-piece property. He quickly made a paper model that demonstrated the necessary folding technique.

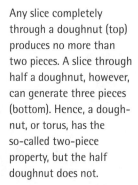

Any slice completely through a doughnut (top) produces no more than two pieces. A slice through half a doughnut, however, can generate three pieces (bottom). Hence, a doughnut, or torus, has the so-called two-piece property, but the half doughnut does not.

As one offshoot of this work, Banchoff constructed an ingenious folding model of the hypercube, an example of which he showed to Dali many years later. The model greatly impressed the artist, and a copy of it is now on exhibit at the Salvador Dali museum in Figueras, Spain, where Dali was born.

The model consists of six square cylinders, like cubes missing their tops and bottoms, each one attached to the others along their edges to define a new cube in the middle. Four edges of a seventh square cylinder are then attached to the bottom boundary of one of the six original square cylinders. Outwardly, the resulting shape resembles the three-dimensional cross of the unfolded hypercube that Dali depicted in *Corpus Hypercubicus*. Because the cubes are hollow and each one has two missing faces, however, the model readily folds flat.

The writer Robert A. Heinlein hinted at a similar structure in a 1940 tale called "—And He Built a Crooked House." In the story, the architect Quintus Teal designs an eight-room house, squeezing it onto land large enough for just a one-room building. He does it by constructing the house as an unfolded hypercube, with a cross-shaped second story and four projecting rooms. An earthquake, however, causes the house to collapse partially, leaving just a single cubical mass. Upon entering the apparently diminished house, the new owners are astonished to find that all the rooms are still there—but they discover they can't get back out in the usual way. Climbing the stairs to the roof, for example, puts them right back on the ground floor where they had entered! The bewildered occupants finally exit through a window and end up in an alien desert environment miles away from their weird residence. The house itself vanishes completely after a second earthquake.

Constructed from seven square cylinders, each made from a strip of four squares, this model of an unfolded hypercube collapses into a flat, two-dimensional configuration.

□ □ □

Whether encountered in a science-fiction story or glimpsed in a painting, a pile of neatly folded laundry, a pattern made by a brick wall, or a structure viewed from an odd, unexpected angle, Banchoff could see geometry everywhere. He brought this perspective and an accompanying joy of form with him when he joined the Brown University faculty in 1967. There Banchoff met an applied mathematician, Charles Strauss, who was looking for projects that would take advantage of a new, interactive "electronic blackboard."

Fed algebraic equations that describe three-dimensional geometrical figures symbolically, a computer could draw glowing, two-dimensional skeletons of the objects on a monitor. Additional instructions would rotate the resulting image to reveal the object in different poses or transform its appearance in various ways. Though painfully rudimentary, the ability to visualize

Looking for geometry: A sequence of rotated polygons made up the spectacular, soaring roof of the Man and His Community pavilion at Expo '67 in Montreal.

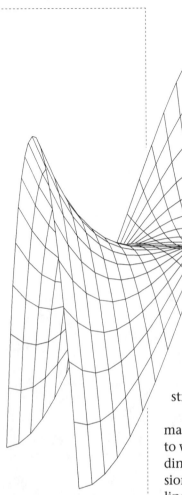

Skeleton of a mathematical surface that resembles a monkey saddle.

and manipulate complex three-dimensional forms proved irresistible to Banchoff, who could envision the computer as a versatile sketchpad for investigating the decidedly more complicated forms arising in four- and higher-dimensional geometry.

The word "dimension" has an aura of both the mundane and the exotic. In mathematics, the idea of dimension arose in close connection with the notion of measuring the world. The term itself stems from the Latin verb "to measure out," echoing the roots of the word "geometry" in the Greek words meaning "earth" and "to measure." By determining the length, width, and height of a rectangular brick, for example, we obtain three numbers, or dimensions, that completely specify the brick's shape. Given just those numbers, we can reconstruct the brick, picture it in our minds, or calculate its volume.

The Roman astronomer and mathematician Claudius Ptolemaeus (100–170), also known as Ptolemy, generalized this notion to what centuries later would become known as a system of coordinate axes. He advanced the fundamental idea that the "extension" of any body can be defined in terms of a set of straight lines, each one at right angles to the others, issuing like rigid rods from a point in the body. He claimed that such lines number no more than three.

That notion was formalized by the French mathematician and philosopher René Descartes (1596–1650). Linking algebra and geometry, Descartes developed a scheme in which equations represent curves, which in turn could be plotted point by point on a sheet of paper.

Starting with a straight line, for example, we can choose a point somewhere along the line as the origin and label it "0," then select another point a unit distance away and label it "1." Building on this foundation, we can identify each and every point on the line with a positive or a negative number—its "Cartesian" coordinate. In much the same way that a numerical address indicates the location of a house along a street, a single

number specifies the position of a particular point along a given line, even if the line is infinite.

On the flat geometric surface called the plane, we can apply Euclid's venerable rules to construct two lines at right angles. The lines intersect at a point, which serves as the origin for numerical coordinates along each of the two lines to define a grid. Just as we can determine a location in a town by specifying the intersection of two streets, so we can use an ordered pair of numbers to signify a particular point on an infinite plane. Hence, two numbers locate a spot in two dimensions, and x and y coordinates can be used to specify each corner of a square drawn on a sheet of graph paper.

To extend our coordinate system to three-dimensional space, we can construct a third line at right angles to a pair of perpendicular lines in the plane. In this case it takes three coordinates—an ordered set of three numbers—to give the location of a given point in space. To draw a cube, we specify the coordinates of the cube's eight corners and indicate which pairs of points are joined by straight lines.

In the construction of coordinate systems of successively higher dimension, it is logical to proceed to sets of four numbers,

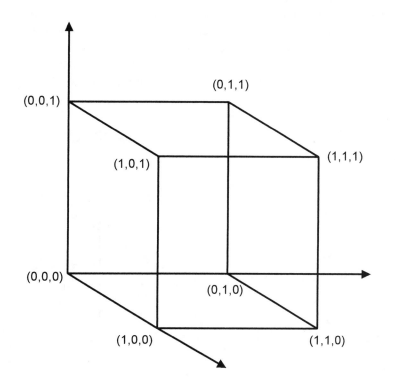

The unit cube in three-dimensional coordinate space.

which would represent points in four-dimensional space. Indeed, we can readily assign coordinates to each of the sixteen vertices of the four-dimensional analog of a cube to define a hypercube, so it's actually not difficult to provide a computer with a complete and accurate description of a hypercube in the language of symbolic algebra. A computer is then able to manipulate and plot the four numbers, or coordinates, that locate each point of the four-dimensional object.

The trouble arises in deciding how to visualize the object, given a two-dimensional drawing board—whether it's a sheet of paper, a canvas, or a computer screen. In effect, the viewer can see only two-dimensional shadows or slices of the object. Shadows and slices provide two distinct sets of views that reveal different kinds of information about a geometric object. "We learn to know a shape by seeing lots of different views and viewing them in our minds in some sort of network of associations," Banchoff says. "By that same sort of process of exploration, you can get to know a four-dimensional shape."

Consider the shadow cast by a three-dimensional chair. Although the shadow exhibits distorted lengths, skewed angles, and planes hidden by edges, it still preserves the connections and relationships among the chair's legs, back, and seat. In the same way, the purely mathematical operation of projection, which is akin to casting a shadow, preserves a figure's continuity, although the object's image may be distorted.

Slices through an object provide a sequence of cross sections that preserve the object's angles and lengths, although the rela-

Taking perspective into account, a wire-frame cube can look startlingly different when viewed from different angles.

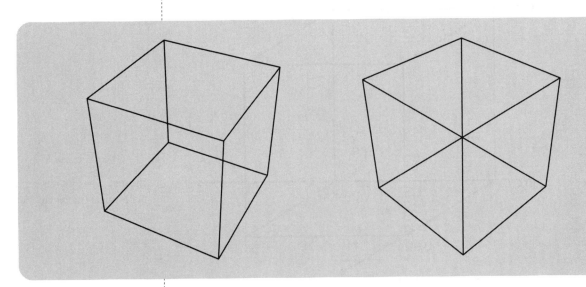

tionships among the parts of the object may be ambiguous. For example, cutting along different planes parallel to the floor gives a varying picture of a chair. Near the floor, a slice through the legs leaves four disconnected disks. Another slice may capture the square seat, and yet another, the thin rectangle of the back. The mind's eye can reassemble these images into a picture of a chair.

In 1978 Banchoff presented his animated film *The Hypercube: Projections and Slices* at the International Congress of Mathematicians in Helsinki, Finland. Scheduled as part of a 45-minute presentation, the film elicited such an enthusiastic response from the assembled mathematicians that an encore showing was required. The animated film, just 9½ minutes long, later won prizes at two international scientific film festivals.

The shadows cast by an ordinary, three-dimensional cube, transparent except at the edges, give some clues about what to expect from a hypercube. A cube's two-dimensional representation can resemble a square within a square. Rotating the cube produces a hypnotizing geometric minuet as the shadow's lines lengthen and contract and its squares diminish and expand.

So, too, a rotating hypercube springs to life in a movie pieced together from a sequence of computer-generated images. At first it may look like a square with four corners and four edges. That square turns out to be just one of the six faces of a cube, which appear as parallelograms, sharing a total of twelve edges and eight vertices. Further rotation reveals a starburst of lines—the eight ordinary cubic hyperfaces of a hypercube, which has twenty-four square faces, thirty-two edges, and sixteen vertices.

> **W**e learn to know a shape by seeing lots of different views and viewing them in our minds in some sort of network of associations.
> —*Thomas F. Banchoff*

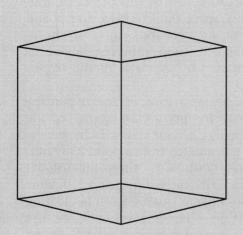

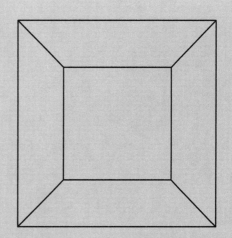

This view of a hypercube shows the figure's sixteen vertices and thirty-two edges.

In this artwork, David Brisson showed sixteen hypercubes that fit around a point in four-dimensional space.

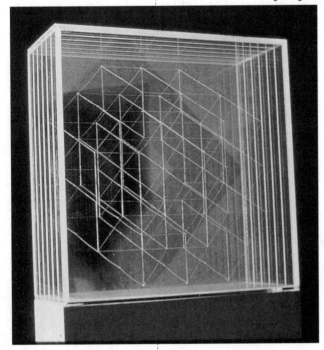

From certain perspectives, a stick representation of a hypercube would look like two three-dimensional cubes, with lines connecting corresponding corners of the two cubes. Indeed, it isn't especially difficult to construct this object in ordinary space out of sticks, straws and wire, or steel rods, then to photograph it from different angles to obtain various views of the hypercube.

A grand tour of the hypercube seen in perspective can provide equally dramatic views. If a hypercube is illuminated from a point lying outside ordinary three-dimensional space, its three-dimensional shadow looks like a small glass cube floating within a larger glass cube. As the hypercube rotates, the inner cube appears to shift, flatten, and turn

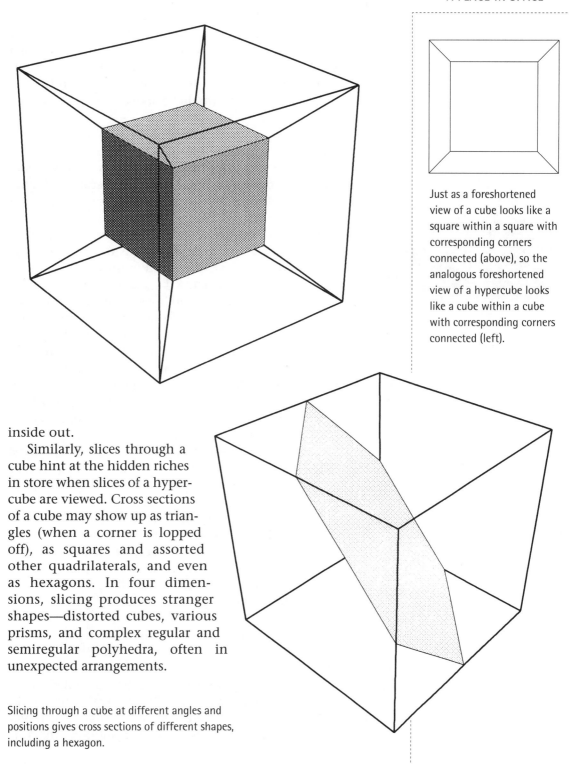

Just as a foreshortened view of a cube looks like a square within a square with corresponding corners connected (above), so the analogous foreshortened view of a hypercube looks like a cube within a cube with corresponding corners connected (left).

inside out.

Similarly, slices through a cube hint at the hidden riches in store when slices of a hypercube are viewed. Cross sections of a cube may show up as triangles (when a corner is lopped off), as squares and assorted other quadrilaterals, and even as hexagons. In four dimensions, slicing produces stranger shapes—distorted cubes, various prisms, and complex regular and semiregular polyhedra, often in unexpected arrangements.

Slicing through a cube at different angles and positions gives cross sections of different shapes, including a hexagon.

51

"When we saw the hypercube for the first time, we knew we were seeing something totally different," Banchoff recalls. "It moved in ways that were totally separate from anything we'd seen before. We were utterly taken by it. I realized I'd never completely understand it. The fourth dimension is beyond us, as much as the third dimension would be above people living on a two-dimensional plane."

The hypercube was just the starting point. With computer graphics, Banchoff and other research mathematicians turned the study of geometric phenomena into an observational science. In effect, a computer monitor became a highly interactive window by which a viewer could select and manipulate strings of images.

Shadows and slices of higher-dimensional objects provide a useful way for mathematicians to visualize these strange forms. Just as experienced musicians can look at a musical score and imagine the sounds, trained mathematicians accustomed to working with austere equations and stingy notations can read their ordered symbols and painstakingly construct a mental image of what they have composed. The mental image, however, isn't always enough. Vivid pictures, like brilliant musical performances in which the sonorous harmonies and subtle patterns written on paper spring to life, bring new richness and beauty to mathematics, which both mathematicians and nonmathematicians can appreciate.

To Banchoff, grand tours of visual images suggest relationships and conjectures that don't arise easily just from equations or lists of data points. In his words, "You can see things before you go ahead and prove them."

In October 1984, to celebrate the one-hundredth anniversary of the original publication of *Flatland,* Banchoff hosted a symposium that brought together many mathematicians, writers, artists, scientists, philosophers, historians, and other scholars to consider the question of "visualizing higher dimensions" and to pay tribute to Abbott and his playful, provocative, and inspiring fantasy.

An important component of that celebration was an art exhibit, *Hypergraphics 1984,* assembled at the Rhode Island School of Design by guest curator and artist Harriet E. Brisson of Rhode Island College. The two-week exhibition included works by twenty artists and was dedicated to Brisson's husband, David W. Brisson (1930–1984), who had died earlier that year. David Brisson had coined the word *hypergraphics,* combining *hyper* in

Math Horizon by Tom Banchoff. See plate 5.

the sense of "above" or "beyond" and *graphics* in the sense of "writing" or "drawing" to delineate a concept of art that extends beyond traditional means of imagemaking.

David Brisson had studied mathematics in the early 1960s, focusing on mathematical concepts of higher dimensions. Later, during his eighteen years as a member of the faculty at the Rhode Island School of Design, he devoted considerable effort to making such concepts accessible and comprehensible to those not trained in mathematics. Basing his techniques on mathematical formulations of higher dimensions, he sought through drawings, models, and various devices to extend the perceptual mechanisms that people normally employ to understand the world around them. He wanted to experience multiple dimensions fully, not abstractly through formulas but visually so that all could truly see this phenomenon even if not trained in mathematics. To that end he developed the "hyperstereogram" to provide unconventional, stereoscopic views of the hypercube and other mysterious, higher-dimensional figures. Another invention, the "hyperanaglyph," combined three-dimensional stick models, colors and filters, and a rotating turntable to present viewers with dynamic representations of such forms.

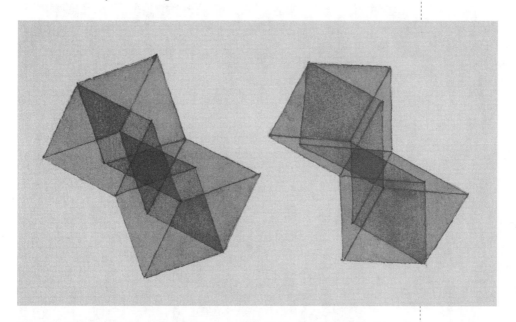

This pair of diagrams by David Brisson shows two views of a four-dimensional geometric figure. Together the diagrams form a "hyperstereogram." For a given stereoscopic vantage point, only a portion of the figures comes together to form a true image.

"This exploration began with drawings of the hypercube and extended to kinetic structures," Harriet Brisson observes. "The hyperstereograms and hyperanaglyphs . . . are but two examples of his continuing search for even better methods of perceiving and expressing these complex concepts that had been considered to be impossible to represent in any other form than mathematical formulae."

A strong proponent of the integration of art and science, Harriet Brisson herself took a somewhat different approach, creating intriguing artworks based on filling space with infinite structures. In both science and art, "the idea of linear and spatial extension without limits has fascinated many people throughout history," she remarks.

Because one can't literally build such structures, illusion plays an important role in Brisson's ingenious, geometrical assemblages of neon or fluorescent tubes and mirrors. In one of her reflecting sculptures, a viewer can actually enter the structure: a mirrored tetrahedron nine feet on a side and lined inside with twelve fluorescent tubes defining an octahedron. In smaller versions, a viewer can stick his or her head into the structure to experience

In Harriet Brisson's *Magic Box*, neon tubing formed the edges of a truncated octahedron. Placed inside a cubic box made of mirrored plexiglass, the glowing neon produced bright orange reflections that made it seem as if the network extended infinitely in all directions.

an overwhelmingly kaleidoscopic sensation of mathematical infinity.

"Much of my work has been based on mathematical principles, for I find them a rich source of form, both artistically and conceptually," Harriet Brisson noted in 1984. "Polyhedra may be interpreted through a variety of philosophical approaches, technical processes, and media. I have explored infinite structures of flat and curved clay tile tessellations, close-packing tensegrity structures, and neon infinity boxes.

"I am attempting to extend pure mathematical models beyond traditional means to a point where science and art intersect to create new forms," she affirms. "Light is my medium. Geometric forms are my inspiration."

The progression from one dimension to the next is an ancient idea. In the seventh book of his treatise *Republic,* the Greek philosopher Plato (427–347 B.C.) describes a conversation between Socrates and Glaucon concerning the education that ought to be

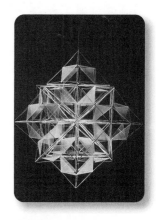

Great Rhombicuboctahedra and Octagonal Prisms by Harriet Brisson. See plate 3.

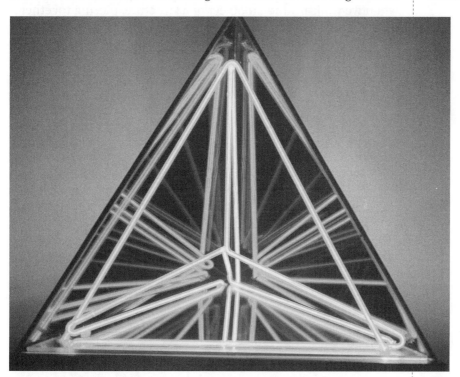

For *Pentahedroid,* Harriet Brisson placed blue neon tubes within a tetrahedron constructed from two-way mirrors. A viewer could see the form and, at the same time, its reflection in the surrounding space.

> **"W**e never see a three-dimensional object all at once.
>
> —*Tom Banchoff*

required of the guardians of the ideal state. Number, counting, arithmetic, and study of the number line serve as an essential foundation for every art and science, including the art of war, Socrates insists.

The study of geometry—specifically the investigation of plane surfaces—comes next, not only for city planning and in the conduct of war for dealing with encampments and army formations but also for its own sake as "knowledge of the eternally existent." Glaucon suggests astronomy as the next step, but Socrates argues that solid geometry should come before astronomy. "The right way is next in order after the second dimension to take the third," he contends. Astronomy, which deals with the movements of solids, becomes the fourth course of study.

By recognizing the progression of dimensions, Plato initiated an important thread of mathematical thought: the notion that we can take advantage of insights gained in one dimension to understand the next. Indeed, we use such a process instinctively when we walk around an object or a structure, piecing together a sequence of two-dimensional retinal images to infer properties of the full three-dimensional object. "We never see a three-dimensional object all at once," Ban-

Tom Banchoff s *Triple-Point Twist*
shows one result of deforming a plane
in three-dimensional space into a surface
containing one triple point and two
pinch points.

choff says. Sculptors can take advantage of this human limitation to present us with engaging structural puzzles and surprises.

Banchoff's own virtual travels have taken him far afield in the realm of four-dimensional visualization. He and his students have gazed upon shadows of hyperspheres, slices of strange bagels, images of mysterious triple-point twists, and many more never-before-seen wonders.

Banchoff's explorations emphasize spatial dimensions and coordinates. The term "dimension" also has a broader meaning, signifying an independent parameter, where a coordinate is not just a location in space but also a measurable quantity associated with an object or a phenomenon. A brass gong, for example, might be characterized by its weight, thickness, radius, and tone. Each of the four variables can be conceived as a dimension in the "space" representing all possible brass gongs, and the set of values for a particular gong as a point in that four-dimensional space.

Many problems in pure and applied mathematics involve formulas and expressions that contain four or more variables, each of which, independently of the others, may be positive or negative in value and lie between positive infinity and negative infinity. We can treat each dimension as a filing folder in a mathematical cabinet—one in which a given folder holds all the information about a particular variable. Problem-solving and theorem-proving are essentially manipulations, according to specified rules and equations, of the numbers stored in those folders.

Physicists often choose a set of dimensions in which the first three dimensions represent independent directions in physical space and the fourth is time. This model reflects the notion that three-dimensional space and time are intimately interconnected, as postulated in the special and general theories of relativity of Albert Einstein (1879–1955). Indeed, ever since the advent of

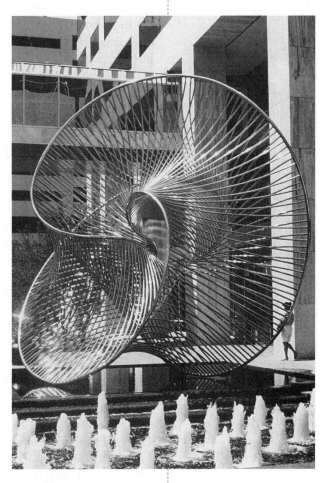

A model of *Solstice (2/3rd Twist Triangular Torus Moebius)* by sculptor Charles O. Perry was featured in the *Hypergraphics 1984* exhibition. A twenty-eight-foot-high, stainless-steel version of the sculpture (shown here) stands in Barnett Plaza, Tampa, Florida.

Einstein's relativity theory early in the twentieth century, many people have automatically assumed that time is *the* fourth dimension.

Such an assertion may be useful and valid in the context of describing the physical universe in cosmology and astrophysics, but time is just one of innumerable variables that can be associated with a fourth dimension. Depending on the context, the four dimensions could just as well be pressure, volume, temperature, and mass, or any other set of four parameters of interest. In general, any ordered set of four numbers, variables, or parameters can be considered either as a four-dimensional entity or as strings of numbers that can be filed and manipulated in certain ways.

Reasonable algebraic rules govern such manipulations, no matter how many dimensions may be involved. In some instances, however, mathematicians, scientists, and engineers would like to visualize what is going on. In effect, they want to convert numerical data into a geometric form—putting marks on a one-dimensional number line, plotting ordered pairs of numbers on a two-dimensional sheet of graph paper, or locating points in three-dimensional space.

As the pioneering efforts of Banchoff and Strauss and many others have vividly demonstrated, computation and computer graphics provide a wide range of colorful, exotic images to illuminate theories and highlight patterns hidden in data. When these data involve four or more variables, visualization techniques come into play to transcend the physical limitations of two-dimensional paper and screen. Banchoff and his collaborators have developed methods that involve shadows and slices, along with stereoscopy and animation.

Like the telescope, microscope, and X-ray machine, computer graphics represents an extension of human vision, making it possible to see new worlds, Banchoff says. At the same time, watching images on the computer screen presents the same sorts of challenges faced by the first scientists who looked at and had to interpret the shadowy, uncertain results of their forays into previously invisible realms. They had to interpret the squiggles of weird one-celled creatures seen through a microscope and the pinpricks of light from satellites of Jupiter. Despite the challenges, Banchoff contends, it *is* possible to have direct visual experience of objects that exist only in higher dimensions.

The combination of computer graphics and mathematics is not only challenging to the mind but also often pleasing to the eye. It helps bring mathematics out of its cerebral closet into the public arena. That accessibility has led to recognition for Ban-

choff's work among artists such as Dali, and in Banchoff's own local community. In 1996, the Providence Art Club in Rhode Island hosted an exhibition of computer-generated images created by Banchoff and his associates. Titled "Surfaces Beyond the Third Dimension," the exhibit featured twelve large photographic reproductions of computer-graphic images as well as two videos, each three minutes long. A guidebook explained some of the theory behind the illustrations and described details of how the images were generated and reproduced.

In some cases, elaborate theory accompanied the image in Banchoff's exhibition. In other instances, the mathematical phenomena on visual display were not yet well understood. Several illustrations required the development of new mathematics to create the resulting artwork.

Z-Squared Necklace by Tom Banchoff incorporates several views of the graph of a particular function of a complex variable.

Although the physical show was dismantled after two weeks, the exhibition lives on in virtual form on the Internet. Visitors to Banchoff's World Wide Web site can still tour the display to view the images. A viewer can even alter them interactively, obtain explanations of the underlying mathematics, watch electronic movies featuring some of these exotic forms, and add comments to an online guest book.

"This electronic gallery faithfully reproduces a great many aspects of the actual exhibit, while altering the experience in other ways," Banchoff notes. In some ways, the virtual edition contains more information than the original exhibit, particularly

to satisfy viewers who are curious about the mathematics or computer science behind the images.

The idea of an electronic gallery also plays with conventional notions of existence. We are used to thinking of a painting or a sculpture as a concrete object that we can see and touch. Banchoff's artful mathematical illustrations are more elusive. They exist as formulas and lines of computer code. Rendering them on a screen or printing them on photographic paper for display in an art gallery requires choosing color, orientation, and size—characteristics that are not intrinsic to the mathematical object itself. Which is the art object—the mathematics itself, or a particular, even arbitrary, depiction of that mathematics?

At a deeper level, we can ask in what sense a square, a circle, or any other geometric object exists. In his compendium of state-of-the-art geometry, Euclid dealt with ideals. No one has ever constructed a perfect circle or a perfectly straight, infinitesimally thin line, Banchoff remarks. Experience with diagrams drawn on a piece of a paper or on a blackboard can suggest facts about plane geometry. No line can intersect a perfect circle in more than two infinitesimally small points, for example. "But these are facts about ideal objects that no human being has seen directly," Banchoff contends.

Hypercubes and other four- and higher-dimensional objects belong to the same realm of mathematical ideals. Banchoff doesn't worry about whether there *really* is a fourth dimension. Using mathematics, he can describe what the fourth dimension would look like if it did exist.

"Thinking about different dimensions can make us more conscious of what it means to see an object . . . as a form or ideal object in the mind," Banchoff says. That's not a bad place to start for either a mathematician or an artist.

Truncated 600-Cell
by Harriet Brisson.
See plate 4.

4 Plane Folds

Much of the charm and attraction of origami lies in the extraordinary range of shapes that a skilled practitioner can fashion from a single square of unadorned paper. Flapping birds, graceful butterflies, fierce demons, delicate flowers, and many more fanciful forms and mechanical wonders spring magically from crisp, precise sequences of folds orchestrated by deft hands.

In recent decades, the art of origami has stretched beyond traditional, stylized models of birds, fish, and other creatures to encompass diverse geometric shapes and patterns. Simple folds

Folded into a sheet of silk, this intricate pattern, called *Whirl Spools—Pinwheel Path*, by Chris K. Palmer exemplifies recent trends in origami design from animal figures to spectacular geometric tapestries and in technique from folding paper to pleating textiles.

along unassuming lines transform sheets of paper into spectacular miniature sculptures. Woven together, they can become abstract tapestries or exotic crystals.

Given the geometry that underlies paper folding, it's not surprising that some mathematicians have over the years fallen under the spell of this whimsical art. The British mathematician Charles L. Dodgson (1832–1898), who wrote *Alice's Adventures in Wonderland* under the pen name of Lewis Carroll, was an ardent paper folder. In a diary entry dated January 26, 1887, Dodgson went to the trouble of recording how he folded a sheet into a fishing boat—with a seat at each end and a basket of fish in the middle. A few years later, another entry described an occasion when he taught some children how to make a paper pistol—a folded sheet that, when whipped through the air, would snap open with a loud pop. Folded paper hats appear in several illustrations that accompanied the original edition of Carroll's *Through the Looking-Glass* fantasy.

Architect, writer, and origami artist Peter Engel has noted that "to the mathematician, the beauty of origami is its simple geometry. Latent in every pristine piece of paper are undisclosed geometric patterns, combinations of angles, and ratios that permit the paper to assume interesting and symmetrical shapes."

Thomas C. Hull, a mathematician at Merrimack College in North Andover, Massachusetts, started making origami figures when he was eight years old. By the time he was in graduate school at the University of Rhode Island, Hull had found a way to combine his keen interest in origami with a career in mathematics. He is now a member of a small but growing community of origami enthusiasts intent on pursuing the mathematical intricacies of their craft.

> "To the mathematician, the beauty of origami is its simple geometry.
>
> —Peter Engel

In origami, there are two types of creases: mountain (top) and valley (bottom). A mountain crease is usually represented by a line made up of dots and dashes, whereas a valley crease is depicted as a dashed line.

Origami involves two types of folds: mountain and valley. A crease is the trace left on a square of paper by a fold that has been undone. One avenue for the exploration of the relation between origami and mathematics is to examine not the final object but the pattern of creases visible on a square of paper after the completed figure is unfolded. Origami models described as "flat" serve as good starting points. Although such models can be opened up into three-dimensional figures, they don't crumple but neatly collapse when pressed in a book after they are made.

The unfolded sheet of paper used to make the traditional Japanese crane, also known as the flapping bird, displays a distinctive crease pattern.

The collections of creases that belong to unfolded origami figures often exhibit striking symmetries and have interesting mathematical properties. "The patterns are marvelous," Hull says. "That has motivated me to want to know the relationship between what I folded and what I see in the crease pattern. How do I go from one to the other?"

Mathematically, origami creases are straight lines that divide a square into a finite set of polygon-shaped areas. It's possible to come up with simple theorems expressing some of the relationships among the lines, polygons, and vertices (points where lines intersect or meet inside the square) of a crease pattern. Japanese origami expert Jun Maekawa, for example,

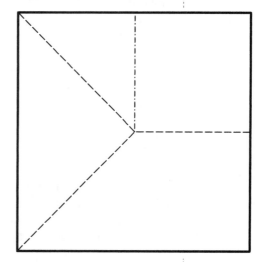

Three valley creases and one mountain crease meet at a vertex. In this case, the crease pattern obeys Maekawa's theorem, which specifies that for an origami model that folds flat, the number of valley creases minus the number of mountain creases meeting at a vertex equal two.

proved that the number of mountain creases subtracted from the number of valley creases surrounding an individual vertex in a flat origami must be precisely two or minus two. Moreover, the number of creases surrounding any vertex is always even.

Such theorems provide insights into the rules that govern the creation of origami objects. The practitioner begins to learn, in a more systematic fashion than by trial and error or intuition, what creases are needed to achieve certain results, for example, or what patterns are impossible to fold.

Hull has seen origami artists come up with elegant solutions to all sorts of tricky folding problems—such as making a little demon with fingers and a wagging tongue. He would often wonder what rules guided such flights of inspiration. "By understanding the rules, you can build better models," Hull insists.

Crease patterns by themselves, of course, are not the whole story. For instance, there's no information about the order in which folds should be made to achieve a desired result. Moreover, it's also useful to distinguish between creases that are necessary for the final folded model and those that are needed along the way just to make the necessary folds.

Hull's own approach primarily involves a branch of mathematics known as graph theory. Here, a graph consists of a collection of points connected by lines. "Thinking of the crease pattern as a graph—but with specific angles between the lines—turns out to be very useful in trying to create a mathematical model of origami," Hull says. "For example, by studying those properties, you can come up with conditions that origami needs in order to fold flat."

Using graph theory and other mathematical tools, Hull has proved a number of theorems, extending ideas developed by mathematicians in Japan and putting into mathematical form results well known to origamists. These and other findings have in turn inspired new origami creations. "There are lots of interesting problems here, with links to other kinds of mathematics," Hull notes. Indeed, origami has served as a source of ideas for his own mathematical research on planar graphs and for teaching his students mathematical concepts that underlie challenges such as routing cellular telephone calls over complex networks.

In creating or inventing origami models, artisans have traditionally relied on paper-folding rules learned and developed through years of practice. Step-by-step procedures called algorithms play a crucial role in these efforts. Lately, several origamists have sought

> There are lots of interesting problems here, with links to other kinds of mathematics.
>
> —Thomas C. Hull

to systematize at least some aspects of origami design, taking advantage of insights arising out of mathematics.

Physicist Robert J. Lang of Pleasanton, California, has been one of the leaders in this effort to formulate rules that, when given to a computer, would show what creases to make to produce a desired figure. Lang is famous for designs of great complexity, particularly multi-legged and winged insects, as well as elaborate humanmade objects, including his most famous work, a Black Forest cuckoo clock.

"The goal of many origami aficionados is to design new origami figures," Lang remarks. "For many, the pursuit of origami mathematics is a search for tools leading to ever more complex or sophisticated designs." In recent decades, as the complexity of origami models has increased dramatically, those designs have evolved from simple, stylized shapes to highly detailed representations of insects, crabs, sharks, dinosaurs, and other creatures with multiple appendages.

Robert Lang's elaborate origami model of a Black Forest cuckoo clock.

Lang's focus has been on generating crease patterns that fold flat into fundamental origami forms, or bases, with any desired number of flaps of arbitrary length, which can then become the arms, legs, or wings of the origami figure. Once a paper folder has a base with the right number of flaps, Lang notes, it is relatively easy to transform it into a recognizable representation of the subject.

One useful strategy is to represent each appendage of a desired figure by a circle. Each circle has a radius equal to the required length of the corresponding appendage. One then draws the circles on a square so that the centers of the circles all lie within the square and no two circles overlap. Such a circle arrangement can be turned into a crease pattern, which is folded into a base with the required number of appendages. Inside each circle, the creases fan outward like the struts of an umbrella. When collapsed, each of these umbrellas becomes a flap, ready to be shaped into an appendage.

An array of closely packed circles drawn on a square sheet guides the making of an origami model with a specified number of appendages (left). Such a crease pattern is turned into a three-dimensional starlike base for constructing the desired figure (right).

The circle method typically produces a three-dimensional base that resembles a star. It works well for models that have flaps emanating from nearly the same place. A model of an insect—with legs and wings sprouting from a single body segment—fits into this category. A lizard, however, would require a cluster of three flaps for its head and forelegs and another, separate cluster for its tail and hind legs.

Lang has developed what he calls the "tree method" as a tool for designing complicated forms, such as lizards, insects, and other animals. The first step is to represent the desired model by a stick-figure "tree" with a branch for each arm, leg, wing, or other appendage. Each branch has a certain length, equal to the length chosen for the corresponding appendage in the final model. A small number of rules then specify how to map the tree onto a square in such a way that the square can be creased and folded into the appropriate base while producing the largest possible sculpture from a given square of paper.

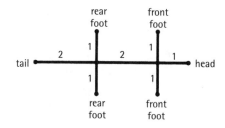

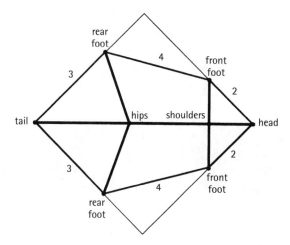

Generating a folding pattern (bottom) from a stick-figure tree (center) to create an origami model of a lizard (top).

"The great power of the tree method is that it can be implemented by a computer, thus permitting computer-designed origami models of great sophistication," Lang contends.

Lang has written a computer program, which he calls TreeMaker, that starts with the description of a tree, constructs the necessary equations, solves for the optimal arrangement, and displays the resulting crease pattern. In packing circles together as tightly as possible while respecting the overall geometry of the desired creature, the computer solves a mathematical problem known as "constrained optimization." It's the same sort of math that Lang often uses in designing optical systems—for finding efficient ways of guiding light rays through an appropriate selection of lenses, mirrors, gratings, and other devices to perform a desired function in a laser or some other instrument.

Based on a computer-generated base pattern (top), Lang's marvelously intricate lobster comes fully equipped with eight legs, a tail, a head, claws, and antennae (bottom).

"While simple models can be worked out entirely by hand, I have found that for complex subjects, the computer can find and evaluate efficient crease patterns much faster than I can by hand, including crease patterns that are not obvious to the unaided eye," Lang says.

One area of burgeoning interest is the creation of origami tessellations, where the crease patterns and folded objects look like mosaic tilings. Arrays of pleats folded into large sheets of translu-

cent paper produce regularly repeating patterns of considerable beauty. Held up to the light, these models betray breathtaking symmetries and startling intricacies among the layered folds of paper.

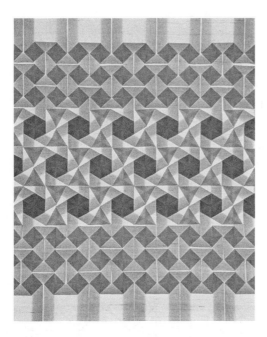

Basic folds involving hexagon, triangle, and square twists, originally folded in paper by Shuzo Fujimoto, form the basis for an elaborate tessellation by Chris K. Palmer.

Shuzo Fujimoto, a high school chemistry teacher and origami master in Japan, was probably the first person to experiment with origami tessellations, several decades ago. Since then, a number of practitioners have taken up the art, creating spectacular patterns based on squares, rectangles, hexagons, octagons, and combinations of these and many other angular figures. One attraction is the way in which repetitive patterns, created by simple folds, can lead to remarkably complex tapestries.

One of the most basic tessellation patterns consists of an array of squares—like a checkerboard. Origamists have discovered several different ways to make such an array, starting with some sort of basic unit, such as the so-called square twist unit. Because the crease pattern of this unit has the right symmetry, it's possible to repeat the pattern over and over again within a larger square.

Intriguingly, a variant of the square twist unit with a different sequence of valley and mountain folds collapses into a pair of rectangles instead of four squares. In this case, the folded object looks the same on both sides, although the pattern is rotated by 180 degrees. Repeated across a large sheet of paper, such units

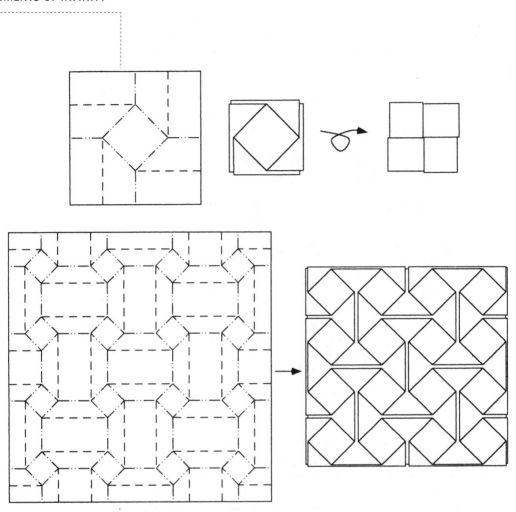

To make the basic unit of a checkerboard pattern (top), a square of paper is creased into quarters, vertically and horizontally. The vertical and horizontal creases are then used as guidelines for adding a set of four diagonal creases to define a new, diagonally oriented square in the middle. If the folding is done with the proper mix of valley and mountain folds and with sufficient care and precision, the entire sheet of paper can be twisted and collapsed along the creases in one final step into a two-by-two square lattice to produce the so-called square twist unit. Interestingly, the reverse side has its own diagonally oriented square pattern. Creasing a sufficiently large sheet of paper into sixteenths and adding diagonal creases in appropriate locations produces a four-by-four square lattice (bottom).

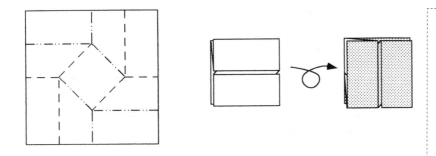

Crease pattern (left) for creating a "stretch wall" unit—shown front and back—that can be tiled into a brick wall arrangement.

become components of a pattern that resembles a wall made of staggered bricks.

An amazing number of variants is possible. While trying to find new ways to extract flaps, or appendages, from a square, Tom Hull stumbled upon an alternative way to produce a checkerboard tiling. His "woven squares" pattern involves a fundamental unit whose arrangement of creases differs from that of the square twist unit. On a larger scale, starting with an appropriate grid, adding diagonal creases in the right places, then twisting the paper along the creases collapses the entire sheet into a checkerboard pattern in one dramatic move.

"Making all the creases first and then collapsing everything as a last step is a rather unorthodox way to do origami," Hull

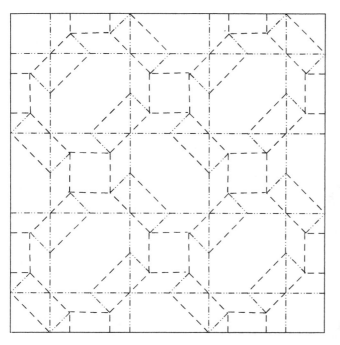

Crease pattern (left) for creating Tom Hull's woven-square pattern (right).

An origami tessellation involves four patterns: the crease pattern; the pattern of the front when folded; the pattern of the back when folded; and the light pattern, obtained by holding the origami up to the light and looking through it.

admits. Doing so, however, forces the practitioner to discover how the creases collapse and, in the process, learn much about the essential, repetitive elements of origami tessellations.

There are a remarkably large number of ways to fold paper into square grids. At the same time, a checkerboard pattern is just one of innumerable tessellations of the plane, many of which can be turned into origami patterns. Moreover, each origami tessellation exhibits four patterns: the crease pattern, the pattern on the front when the paper is completely folded, the pattern on the

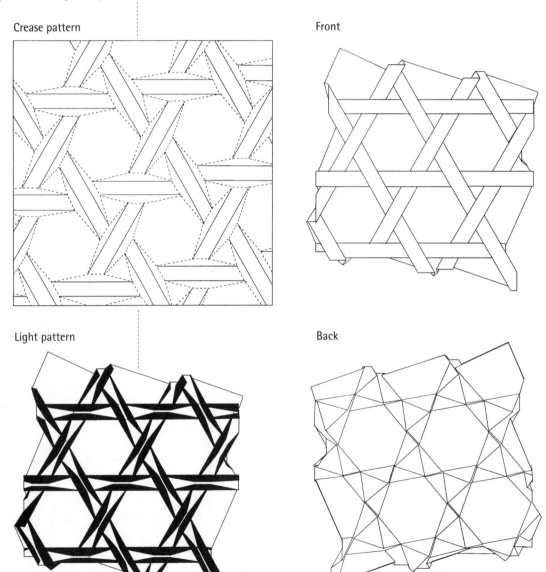

Crease pattern

Front

Light pattern

Back

back when it is folded, and the pattern that appears when the folded model is held up to strong light.

Nonetheless, says Helena A. Verrill, "the problem of finding tessellations which can be folded is difficult because the paper must not be stretched or cut and must end up as a flat sheet, so this imposes many conditions on the pattern to be folded." Verrill specializes professionally in a branch of mathematics known as algebraic geometry, but she has devoted considerable attention to the geometry and topology of origami tessellations.

Hull, Verrill, and others have worked out rules of thumb for converting fairly standard tilings into various types of crease patterns. The idea is to find a unit with a crease pattern that collapses into a polygon of the required geometry. If a unit's mountain and valley creases line up properly with an adjacent unit's pattern, many units can be joined to form a repeating pattern.

One of Tom Hull's origami tessellations, based on an Archimedean tiling of hexagons and triangles.

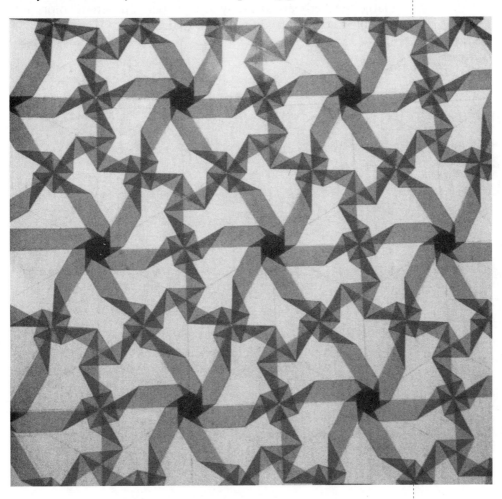

"There are a number of origami artists exploring this realm, really pushing its limits and seeing the kinds of patterns that can be made with that type of folding," Hull says. Artist Chris K. Palmer is perhaps the leading world expert on origami tilings. Often taking his inspiration from the mosaic designs of Arab mosques, such as the famous Alhambra in Granada, Spain, Palmer has developed techniques of considerable subtlety to produce beautiful patterns of startling intricacy. He also has made significant innovations in applying mathematics to create a new medium: textile pleating.

Another way to make an origami tessellation is to build it up from many pieces of paper. Verrill, for example, invented a way to fold a square sheet into a smaller square with two adjacent flaps protruding from one end and two pockets at the other. The flaps and pockets allow these modules to be locked together into a large checkerboard array. By using paper of different colors, it is possible to create striking quiltlike patterns.

Chris K. Palmer's *Shadowfold Whirl Spools—Dodecagon Twists*, made from pleated silk.

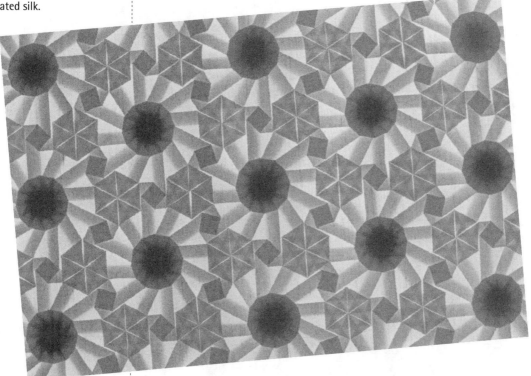

Copies of this folded module (top) can be fitted together to create a colorful paper quilt (bottom).

One particularly intriguing color scheme arises from the array of numbers known as Pascal's triangle, named for the French philosopher and mathematician Blaise Pascal (1623–1662). Pascal's triangle starts with a 1 at the vertex, has a 1 at each end of each subsequent line, and every other number in a given row is the sum of the two numbers immediately above it. Thus the

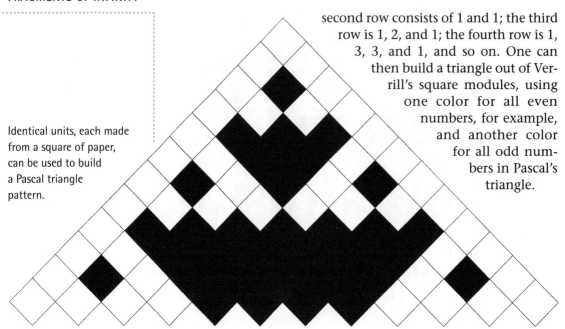

Identical units, each made from a square of paper, can be used to build a Pascal triangle pattern.

second row consists of 1 and 1; the third row is 1, 2, and 1; the fourth row is 1, 3, 3, and 1, and so on. One can then build a triangle out of Verrill's square modules, using one color for all even numbers, for example, and another color for all odd numbers in Pascal's triangle.

The distinctive pattern that emerges turns out to be an example of a geometric object called a fractal, in which each part is made up of scaled-down versions of the whole shape. Giving the even numbers in Pascal's triangle a distinctive color produces a pattern that resembles a special fractal known as a Sierpinski triangle. This fractal consists of triangles within triangles in a pattern such that smaller triangles contain the same pattern as the larger triangles.

One also can color Pascal's triangle in other ways. Suppose the colors available are red, blue, and yellow. All numbered squares that are multiples of 3 (3, 6, 9, 12, and so on) could be yellow, for instance. Those that leave a remainder of 1 when divided by 3 (1, 4, 7, 10, and so on) would be red, and the remaining squares would be blue. A somewhat different fractal pattern emerges. Indeed, fascinating patterns emerge from all sorts of simple

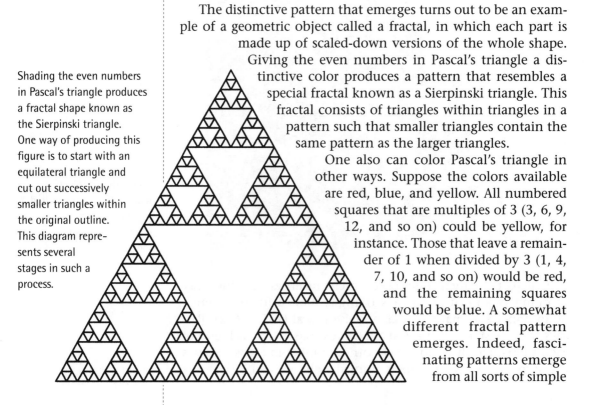

Shading the even numbers in Pascal's triangle produces a fractal shape known as the Sierpinski triangle. One way of producing this figure is to start with an equilateral triangle and cut out successively smaller triangles within the original outline. This diagram represents several stages in such a process.

rules applied to arrays of numbers that can then be transformed into origami quilts.

From devils and lobsters to quilts and tapestries, new methods, new materials, and new ideas—many of them mathematical—have transformed the art of origami over the past thirty years. That's a sharp contrast to the very slow evolution of origami design and technique in previous centuries. The current burst of creativity continues to push the frontiers of origami design in many directions.

Hull and others have been experimenting with elaborate fractal-like tessellations folded from single sheets of paper. Such designs may feature a whirlpool of diminishing shapes; a complex interplay of elaborate figures repeated on different scales; or a sequence of polygons, each one nestled within a larger one.

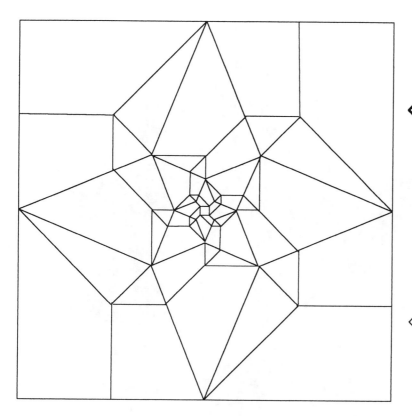

Unit

Tiling pattern

Tom Hull's self-similar bird base tiling (above) repeats the same basic pattern (top right) within smaller and smaller squares (bottom right).

> "The charm of such origami is that simple, easy-to-fold modules can lead to very complex, intricate structures.
>
> —Thomas C. Hull

Further complexity can arise when a designer finds it is necessary to use more than one sheet of paper to create a desired object. Nowadays, some intricate, three-dimensional models may require hundreds of pieces of paper, each folded the same way, then interlocked to form the structure. The use of modules also allows designers to experiment with myriad color patterns in their creations.

The individual units that make up such models are often themselves not particularly interesting to make. The thrill for the practitioner comes from assembling the modules into larger entities—taking advantage of ingenious systems of pockets and tabs to lock the whole contraption together without any glue and give the paper structure astonishing strength. Hull's visually stunning model of five intersecting tetrahedra is just one of many recently invented examples of such constructions. "The charm of such origami is that simple, easy-to-fold modules can lead to very complex, intricate structures," Hull says.

Tom Hull's visually stunning *Five Intersecting Tetrahedra*, constructed from copies of a single type of unit, represents the result of nesting five regular tetrahedra, each one having four corners, so they would fit snugly within a dodecahedron—a polyhedron with twelve pentagonal faces and twenty corners.

Traditional origami allows no cutting or gluing. If the rules are stretched a little, even more designs and sculptures can emerge from nimble fingers. In one pathbreaking effort, Erik D. Demaine, Martin L. Demaine, and Anna Lubiw of the University of Waterloo in Ontario have created polyhedral sculptures based on a geometric shape called a hyperbolic paraboloid, an infinite surface discovered in the seventeenth century.

The right sequence of folds turns a square of paper into the saddlelike form of a hyperbolic paraboloid.

The central portion of a hyperbolic paraboloid resembles a saddle shape. Demaine and his coworkers started with a traditional method of folding a hyperbolic paraboloid from a square sheet and showed how it is possible to glue these components edge to edge in different ways to form paper sculptures they describe as hyparhedra. Their algorithm allows one to construct the hyparhedron version of any given polyhedron. It typically takes several hours to complete a model.

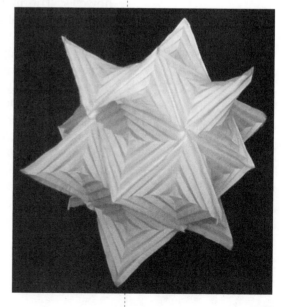

Gluing together partial hyperbolic paraboloids, or hypars, along their edges produces a cubic form—one of a number of closed, curved surfaces called hyparhedra that can be constructed from paper hypar units.

"The richness of these forms excites us visually and presents us with interesting mathematical problems," the team noted in a report presented at a 1998 meeting where they unveiled the new designs.

Allowing gluing and cutting opens up additional possibilities—and even suggests interesting questions involving faceted surfaces and the branch of mathematics known as topology. Consider the following conundrum: Why is a rectangle like an inner tube? Although this riddle may stump some people, a mathematician specializing in topology can answer immediately. Imagine the rectangle as a rubbery sheet. Glue together the two longer edges to create an open-ended, cylindrical tube. Then, pulling the tube into a ring, connect the open ends (in effect, gluing together the two shorter sides). *Voilà!*

That isn't the only way to turn a rectangle into an inner tube, or torus. William T. Webber, a mathematician in Bellingham, Washington, discovered that he could do it without stretching the material. He folds the sheet and tapes its edges together in just the right way to create a polyhedron that looks like a faceted, angular wreath or crown. As a result, he preserves the flatness of the original rectangle in the individual faces of his toroidal polyhedron. All the surface curvature of an ordinary torus is concentrated in the creases and corners of the polyhedron.

Webber now has a large collection of these intriguingly crinkled rings, made from paper, cardboard, and clear plastic. Their value as interesting offshoots of origami goes beyond aesthetics, however. The mathematics of these new objects constituted a significant part of Webber's doctoral thesis in mathematics at the University of Washington in Seattle.

Building things has long been part of Webber's life. At one time or another he has put together geodesic domes, fiddled with origami, and played with methods of folding sheets of paper to create unusual forms. "I was aware that the plane could be folded in some interesting ways," Webber says.

As a student of mathematician and tiling expert Branko Grünbaum at Washington, Webber began looking into tilings of the plane. He was intrigued by the possibility of folding along the lines of a section of a tiling—say, a grid of identical triangles—to create some sort of three-dimensional object. In one case he ended up with a folded shape resembling a hyperboloid—a cylinder with a gently curved waist. "It reminded me of a cooling tower at a nuclear plant," Webber remarks.

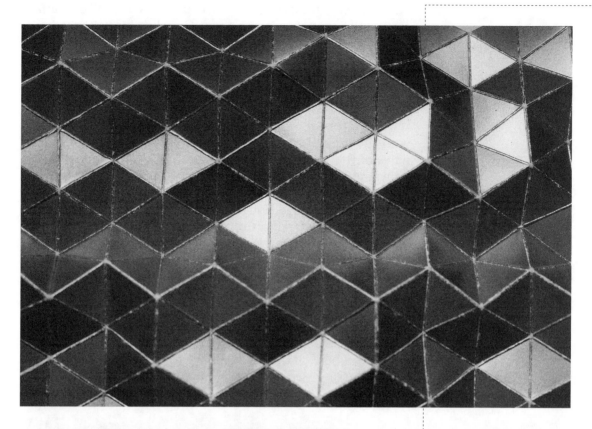

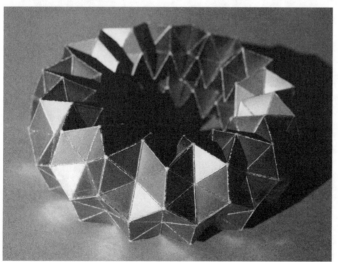

A creased, rectangular sheet (top) can be turned into a crinkled torus shape, viewed from the side (bottom left) and from the top (bottom right).

He quickly realized that this shape looks a lot like a surface around the central hole of a torus. He asked himself whether it would be possible to close up the folded hyperboloid into a full torus. Webber's initial evidence that it could be done came in the form of a model constructed from a piece of paper. But that wasn't the same thing as having a mathematical proof establishing the figure's legitimacy.

"Using paper, you can fudge it," Webber says. However, with the help of a computer program to calculate the coordinates of the vertices where triangles meet in his folded rings, he was able to prove that such figures qualify as true toroidal polyhedra.

Webber's crinkled doughnuts all share certain characteristics: The triangular faces of a given toroidal polyhedron are identical, and six triangles meet at each vertex. Hence, all faces and vertices are equivalent. This still leaves lots of room for variation, and Webber has expended a great deal of effort trying out different shapes of triangles and different folding patterns to see which ones work. "I can start with a fold pattern that looks promising and build a model showing that it fits together," Webber says. "Then I can go to the computer and calculate where all the vertices have to be for different triangle shapes."

Whirl Spools—Watering Fujimoto's Garden—Kites by Chris K. Palmer.

Over the past few years he has found infinite families of these crinkled crowns, each with distinctive symmetries and configurations. In some varieties, the top and the bottom look different. Others feature helical twists. More types probably remain to be discovered. "We haven't yet proved that we have found them all," Webber says.

The wonder of origami lies in the extraordinary range of models that one can fashion, always beginning with a single square of paper and a few simple folds. From spectacular polyhedra to intricate mosaics, mathematics offers a stimulating playing field for stretching the art of origami.

5 Grid Fields

T he entrance to the Downsview subway station in Toronto presents visitors with a striking vista. A vast mosaic of square tiles sweeps across a curved wall, inviting viewers to trace its lines and ponder intriguing irregularities in its color scheme of blues, greens, roses, and other hues.

Of the hordes of people who hurry through the station every day, only a few take a moment or two to contemplate the curious blend of pattern and seeming randomness in the bands of this cryptic spectrum. Far fewer even suspect that the artist responsible for the mosaic based her remarkable design on the decimal digits of the number pi (π), the ratio of a circle's circumference to its diameter.

The artist is Arlene Stamp, a resident of Calgary, Alberta, who was born in London, Ontario, in 1938. Her father was an accountant who was very interested in numbers, crosswords, and puzzles of all sorts. Her mother expressed her artistry through home decor, gardening, and fashion. Perhaps inevitably, Stamp found herself, as a child, attracted to both drawing and numbers.

Sliding Pi by Arlene Stamp. See plate 8.

Stamp showed proficiency in mathematics and, at the same time, could appreciate its aesthetic side. "I remember finding much beauty in mathematics," she says. "I enjoyed the economy, clarity, and balance of problem solving and the relationships that exist among numbers."

Because neither her family nor her teachers were willing to accept artistic training on a par with what they considered academic pursuits, Stamp was nudged into studying mathematics instead of art. She became a high school mathematics teacher.

I enjoyed the economy, clarity, and balance of problem solving and the relationships that exist among numbers.

—Arlene Stamp

Several years later, in her early thirties with two young children at home and still yearning for artistic development, Stamp began to take art courses at night. As the hours spent in class sped by, her confidence in her artistic abilities increased. Then, when Stamp noticed other class members preparing portfolios for admission to a day program at a local art college, she decided to do the same, just to see how her work measured up. Her portfolio was accepted, and she enrolled as a full-time art student in 1973 at age thirty-five.

Stamp's art training broadened her aesthetic sensibilities, while mathematics remained a major interest. "I think it is not surprising that I should want to somehow link these two sources of influence and inspiration or that I should use my art to explore mathematical relationships visually," Stamp says.

One important mathematical influence on Stamp's art came out of the work of Benoit B. Mandelbrot, an IBM fellow emeritus at the Thomas J. Watson Research Center in Yorktown Heights, New York, and a mathematics professor at Yale University. In the 1970s Mandelbrot had called attention to intriguingly complex mathematical forms he described as *fractals*. Based on the Latin adjective meaning "broken," the term fractal conveyed Mandelbrot's sense that the geometry of nature is not one of straight lines, circles, spheres, and cones, but of a rich blend of structure and irregularity.

Such a blend is evident in many natural forms. A jagged fragment of rock resembles the rugged mountain from which it came. Clouds keep their distinctive wispiness whether viewed distantly from the ground or close-up from an airplane window. A tree's twigs often have the same forking pattern seen among branches near the tree's trunk. Indeed, nature is full of irregular shapes that are also self-similar—repeating themselves on different scales within the same object. Mandelbrot pointed out the link between such natural forms and self-similar, geometric curves and surfaces that originally came out of a purely mathematical context.

During the late nineteenth and early twentieth centuries, mathematicians had constructed self-similar curves in the course of attempts to prove or disprove certain notions about space, dimension, and area (see also Chapters 1, 2, and 4). They described these perplexing geometric constructions, with their infinite lengths, extreme crinkliness, vanishingly small areas, and other weird characteristics, as "pathological." It was mathematics "skating on the edge of reason," Hans Sagan, a mathematician at North Carolina State University, has observed.

Rugged coastlines, ragged clouds, breaking waves, and fractured rocks are examples of natural forms that resemble self-similar mathematical objects called fractals.

Starting with a large equilateral triangle, you can add smaller triangles to the middle of each side to create a six-pointed star. Adding even smaller triangles to the middle of each of the star's twelve sides generates a crinkly shape. Continuing the process by adding increasingly smaller triangles produces the intricately frilled Koch snowflake, first investigated in 1904 by the Swedish mathematician Helge von Koch (1870–1924). The boundary of the Koch snowflake is continuous but certainly not smooth. It has an infinite number of zigzags between any two points on the curve, so the figure has an infinite perimeter but encloses a finite area.

Fractals are mathematical curves and shapes that look just as complicated when they're magnified as they do in their original form. These forms, like the two examples shown, can often be generated by a step-by-step procedure that takes a simple initial figure and turns it into an increasingly complex form. Applying the process an infinite number of times produces a figure for which no amount of enlargement can reach a stage where no further indentations or other structures are visible.

A century ago this mathematical byway was almost completely ignored by scientists, and it barely registered among mathematicians. Such curves didn't seem relevant to their main concerns.

One of the few scientists who appreciated early on the peculiar geometric complexity of natural phenomena was the French physicist Jean Baptiste Perrin (1870–1942), who studied the erratic movements of microscopic particles suspended in liquids and remarked on the self-similar structure of natural objects. "Consider, for instance, one of the white flakes that are obtained by salting a solution of soap," Perrin wrote in 1906. "At a distance, its contour may appear sharply defined, but as we draw nearer, its sharpness disappears. . . . The use of a magnifying glass . . . leaves us just as uncertain, for fresh irregularities appear every time we increase the magnification, and we never succeed in getting a sharp, smooth impression, as given, for example, by a steel ball."

Many decades later, when Mandelbrot conceived and developed fractal geometry, he made a connection between the types

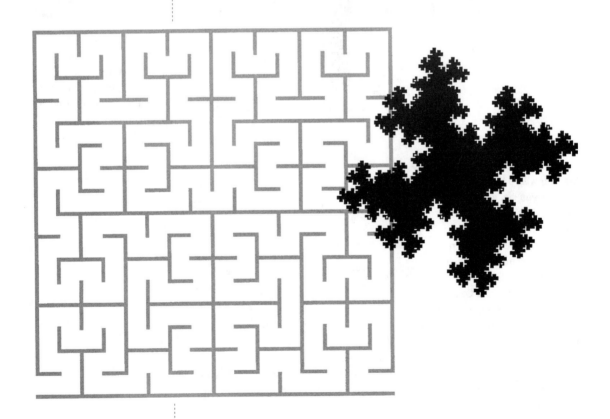

of natural shapes that Perrin had observed and the pathological curves and surfaces of the mathematicians. In general, fractal objects contain structures nested within one another. Each smaller structure is a miniature, though not necessarily identical, version of the larger form. The mathematics of fractals mirrors this relation between patterns seen in the whole and patterns seen in parts of the whole.

Mandelbrot had a great advantage over Perrin and other predecessors in that he could commandeer computers to calculate and display stunning images of these extraordinary mathematical forms. By the 1980s, what nineteenth-century mathematicians barely imagined could be speedily depicted and explored in three-dimensional, vividly hued splendor.

"Fractal art for the sake of science is indissolubly based on the use of computers," Mandelbrot argued in a 1989 essay published in the interdisciplinary journal *Leonardo*. "It could not possibly have arisen before the hardware was ready and the software was being developed."

These dramatic mathematical visualizations brought fractals to public attention and invaded the popular imagination. It wasn't long before books, postcards, calendars, posters, computer screens, and T-shirts flaunted garish, phantasmagorical images of weirdly branched, wildly swirling structures. These and other, more sedate examples of computer-generated graphics vividly illustrated how a computer could be used as a versatile tool for creating what Mandelbrot described as a new type of art.

Stamp was one of a number of artists captivated by computer-generated, self-similar mathematical forms. "I became interested in how these new developments in mathematical thinking might affect how we see and depict forms in space," Stamp says. Infinitely expandable in terms of complexity and scale, computer-generated fractal forms seemed to pose a challenge to works made by hand. Stamp wondered if there was a way in which an artist could impart a sense of the self-similarity inherent in mathematical fractals (and much of nature) without using the specific fractal imagery already generated by mathematicians.

In the course of her explorations, Stamp also found herself caught up in the representation of binary numbers—the basic elements of modern computation. A base 2, or binary, numbering system has only two digits: 0 and 1. In place of the 1s, 10s, 100s, and 1,000s columns (representing powers of 10), the columns of a binary number represent powers of 2. The right-hand binary digit is in the 1s column, the next digit to the left is in the 2s column, the next digit farther to the left is in the 4s column, and so

Filling in a strip of graph paper, using black squares to represent zero and white squares to represent one, with consecutive binary numbers results in a fingered pattern that resembles a fractal.

on. So the base-10 number 7 would be 111 in base 2; 20 would be 10100; and 255 would be 11111111.

Using black squares to represent 0s and white squares to represent 1s, Stamp filled in a strip of graph paper that was 8 squares wide and 256 squares long with the sequence of binary numbers from 00000000 to 11111111. To her amazement, the resulting pattern resembled a fractal, with each section branching into smaller and smaller fingers. "Suddenly I could see the inextricable link between pictures of fractals generated by computers and simple binary numbers, which underlie the structure of the computer itself," Stamp says.

This binary pattern became the basis for an artwork that stretches like a surreal piano keyboard in a narrow band high along the walls of the cavernous lobby of the Ernst & Young office building in

For the lobby of the Ernst & Young office building in Toronto, Arlene Stamp created a mosaic pattern out of sequences of binary digits. To introduce an element of unpredictability, she added a wave effect to parts of her design by tilting and overlapping some of the tiles.

Toronto. Stamp constructed her binary mosaic out of vinyl floor tiles, which were cut by hand, then assembled and glued onto aluminum supports. To perturb the relentless linearity of the fundamental binary number pattern, she also introduced a wave effect and an element of unpredictability by tilting and overlapping adjacent rectangles in certain sections of the mosaic.

Stamp became intrigued by the possibility of using designs with an element of unpredictability to enliven large areas in public spaces, such as floors and walls, which are usually covered with simple, repeating motifs. In 1993 she found an opportunity for just such a venture. To win the commission to decorate the newly built Downsview subway station, Stamp had to come up with an interesting design that would work equally well on various surfaces in different parts of a large station yet stay within a tight budget.

"It became clear that any kind of design based on . . . modules would be very repetitive within such a restrictive budget," Stamp says. "So I came up with a design that was rich in information but inexpensive in terms of its realization."

The basic unit in Stamp's design was a rectangle, ten units wide, made up of square tiles. Instead of placing these rectangles side by side along a baseline to create a regular, linear pattern, she overlapped adjoining rectangles. The amount of overlap was governed by successive decimal digits of pi. "I used pi as a source for a string of unpredictable digits because the circle and curved walls were a design feature in this station," Stamp remarks.

The nature and meaning of the number pi has intrigued and fascinated mathematicians for centuries. They know that pi is an irrational number. That means it can't be written out fully as a simple fraction. The fraction $22/7$, for instance, is merely a crude approximation of pi's actual value.

Pi is also what mathematicians term a transcendental number. It can't be the solution, or root, of an algebraic equation with integer coefficients. In other words, pi can never be evaluated exactly by any combination of simple operations involving addition, subtraction, multiplication, or division of positive integers, or the extraction of square roots. Nonetheless, pi can be expressed by formulas—for example, as the sum of an infinitely long series: $\pi = 4/1 - 4/3 + 4/5 - 4/7 + 4/9 - \ldots$. Using such a series, it is possible to calculate pi to as many decimal places as desired.

Over the centuries, many amateur and professional mathematicians have taken up the challenge of calculating pi to more and more decimal places. Much effort has gone into performing the tedious calculations and looking for series that reach the

> "Suddenly I could see the inextricable link between pictures of fractals generated by computers and simple binary numbers, which underlie the structure of the computer itself.
> —*Arlene Stamp*

The basic unit in Stamp's design is a rectangle, ten units wide, made up of square tiles. The amount of overlap between adjacent rectangles is governed by the decimal digits of pi. For example, the first digit of pi after the decimal is 1, so the first two rectangles from the left overlap by one unit, just as if the second rectangle were sliding over to the left to rest partly on top of the first. The second digit is 4, so the third rectangle overlaps those already in place by four units.

desired answer faster than ever before. The current world record was set in 1999 by Yasumasa Kanada of the University of Tokyo, who computed 206,158,430,000 decimal digits of pi.

One issue of interest to mathematicians is whether all the digits from 0 to 9 occur equally often. A number with such an even distribution of decimal digits is called "normal." At present, all the evidence available suggests that each decimal digit of pi occurs with roughly the same frequency, and the string of digits representing pi has no particular pattern that would make it possible to predict the next unknown digit in the sequence without actually computing it. Stamp figured that was enough to let her use the digits of pi to weave unpredictability into her mosaic.

Each digit determined the amount of overlap between a pair of adjacent rectangles in Stamp's design. The first digit of pi after the decimal is 1, so the first two rectangles overlap by one unit, just as if the second rectangle were sliding over a little bit to rest on top of the first. The second digit is 4, so the third rectangle overlaps those already in place by four units. As the process continues, some regions of overlap may end up as many as three or four layers thick.

Stamp used four sets of eight colors for the project, deploying them in different ways on surfaces in various parts of the station. Each set of colors had a different cast: yellowish green, bluish green, reddish blue, and bluish red. "I

By using several sets of colors, Stamp could vary the look of her *Sliding Pi* mosaic in interesting ways.

assigned colors by thinking of the first layer as the lightest, with the colors deepening according to the number of layers of overlap," she says. Because the number of overlapping rectangles in the pattern rarely exceeded four, Stamp had two colors available for each degree of overlap within each set.

"I actually had fun working out all the numbers for long strings of pattern and deciding how to use the four groups of color in different areas of the station," Stamp says. "It proved to be a very flexible way of generating pattern over great distances without resorting to repeating pattern."

Describing a nonrepeating design spread over a very large area presented an additional difficulty. "One of the biggest challenges of this commission was to find a way of encoding the color information for the tile installer in some kind of space-efficient way," Stamp notes. "With the help of an architect and a number-coded color system, we got all the information on a single sheet of the architect's plans." The tiler simply followed the installation chart to determine the number of columns and the number of the color to be used at any given point.

Stamp's design doesn't repeat itself anywhere in the station. Indeed, it's fun to look for all the different "pieces of pi" scattered throughout the structure. "It's true that few visitors to the station would have any idea that there is a connection between the patterns there and a math concept," Stamp says. "But surely some must wonder how such a seemingly random, ever-changing

Stamp's design for *Sliding Pi* doesn't repeat itself anywhere in the Downsview subway station, so it's interesting to look for different "pieces of pi" scattered throughout the structure.

pattern of color happened, because it is such a rarity in public design." Moreover, upon glimpsing the various manifestations of Stamp's pi-based mosaic, a few may even sense an underlying plan of some sort—that there is method to the randomness.

At the same time, Stamp's fascination with and explorations of nonperiodic patterns in general have given her a good sense of how the unfolding of myriad possibilities inherent in a particular scheme also reveals the confining limits of any such system. "This impression of expanded possibility within restrictive limits is not unlike the basic painting problem of finding space on a flat plane and may in fact be the new space I have been looking for ever since I first read about fractal geometry," Stamp says. "I am interested in the beauty of embedded possibility," she continues. "This is the way in which fractals have influenced my ideas of what is and can be."

Mandelbrot's work on fractals and related structures vividly illustrates how amazingly simple mathematical operations can lead to intriguingly complex results. Repeated operations, in particular, often produce surprising images. Consider, for instance, the iterative geometric process that resembles the making of flaky pastry dough. Flatten and stretch the dough, then fold it over on top of itself. Do this again and again and again. Repeating the pair of operations—stretch and fold—just ten times produces 1,024 layers; twenty times, more than 1 million layers.

In mathematics, the so-called baker's map, or transformation, does nearly the same thing. Here is one special case of this transformation. Start with a square. Stretch it to twice its original length while making it half as wide. Cut the result in half, and stack one half on top of the other to return the combination to the square's original dimensions. At each step the square's area is preserved, but its components are rearranged.

In effect, you can regard such a transformation as a way of scrambling an area or, in three dimensions, of mixing up a volume of space. Instead of focusing on the area or space, however, you also can pay attention to what happens to something embedded within the area or space. Just as you can glimpse the action of otherwise invisible, underlying currents by observing the movements of tiny specks suspended in water, so you can see transformed space in terms of the effect on inky tracers. In the case of the baker's map, applying the transformation repeatedly has the effect of jumbling whatever image may be drawn within the square. If that image happens to be a grinning feline, you end up with a madly scrambled cat.

> I am interested in the beauty of embedded possibility. This is the way in which fractals have influenced my ideas of what is and can be.
>
> —Arlene Stamp

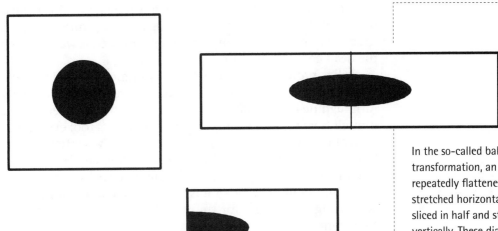

In the so-called baker's transformation, an image is repeatedly flattened and stretched horizontally, then sliced in half and stacked vertically. These diagrams show just the first stage in the mixing process.

During the mixing process it occasionally happens that some of the square's points come back close to their initial locations within the square. For an instant, some form of the original image would flash into view before vanishing again into a murky, nearly homogeneous sea. This surprising reappearance is an example of a phenomenon known as Poincaré recurrence, named for the French mathematician Henri Poincaré. In essence, if a transformation is applied repeatedly to a mathematical system and if the system cannot leave a bounded region, it must return infinitely often to states near its original state.

In their 1986 article "Chaos" in *Scientific American,* Bill Sanderson and James P. Crutchfield created a striking illustration of Poincaré recurrence. They applied a certain stretching operation, often called Arnold's cat map, to a digitized portrait of Poincaré. At each step a computer stretched the image diagonally, as if it were printed on a sheet of rubber. Any portion of the image that extended past the original border was chopped off and reinserted elsewhere. Most of the time, successive iterations of the stretching process produced diagonal streaks or seemingly random splotches of color. Once in a while, however, the original image reappeared.

When Bob Brill of Ann Arbor, Michigan, first saw this sequence of images, he was fascinated. "Stirring an image into a soup only to see that more of the same treatment restored it was like seeing the dead come to life," he observed.

Brill, a professional computer programmer, decided to explore this phenomenon for its potential in creating artful images. Although he hadn't started out as an artist, he had been teaching himself how to turn a computer into an artist's tool ever since he bought his first personal computer, in 1983. Two articles by A. K. Dewdney in *Scientific American*—one featuring vivid depictions of a mathematical object called the Mandelbrot set and another describing computer programs and mathematical formulas for generating "wallpaper for the mind"—ignited Brill's interest in algorithmic art.

The Mandelbrot set is another prime example of how simple mathematical operations can yield astonishingly complex geometric forms. Resembling a hairy snowman, this intricate mathematical shape has a convoluted border of loops and curlicues that calls to mind the extravagant ornamentation of baroque designs. Magnifying the Mandelbrot set's boundary reveals a never-ending array of successively tinier inlets and protrusions. At various positions the boundary twists itself into fuzzy, miniature copies of the full Mandelbrot set. In fact, the more you magnify the figure's border, the more complicated it gets.

Drawing the figure that corresponds to the Mandelbrot set requires computing the sequence of numbers c, $c^2 + c$, $(c^2 + c)^2 + c$, . . . and determining whether the numbers resulting from a particular choice for the initial value c steadily grow larger or instead are bounded, never rising above a certain value. The Mandelbrot set consists of all choices of c that stay bounded.

Any computer can perform the necessary operations: square the starting number, and add this product to the starting number to obtain the next number in the sequence. Then repeat the process by squaring the new number and again adding to it the original starting number, and so on. The only proviso is that the type of numbers used for c must be complex numbers. A complex number consists of two parts, which can be pictured as the coordinates of a point plotted on a flat surface, or plane. For example, the complex number $(3 + 4i)$ can be plotted as the point $(3, 4)$ on a sheet of graph paper.

The true complexity of the Mandelbrot set's border region is hard to discern without the use of computer graphics. A computer can create a colored halo around the figure, making the boundary visible, by tracking how rapidly the sequences of

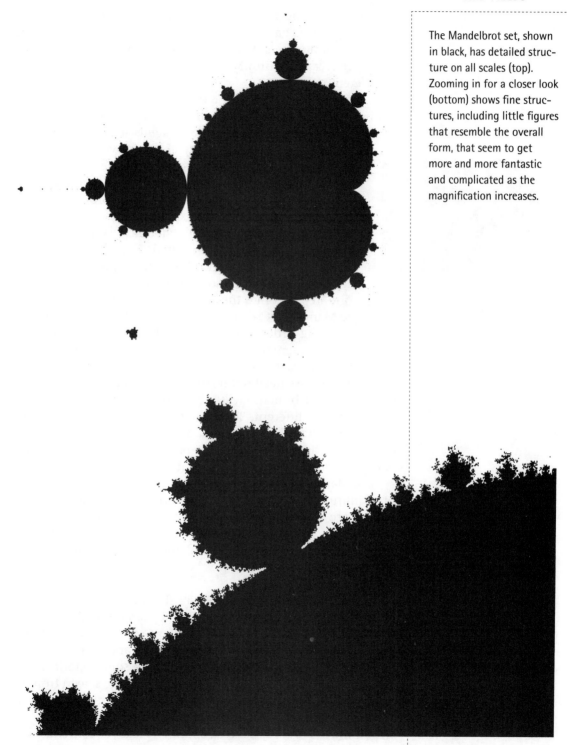

The Mandelbrot set, shown in black, has detailed structure on all scales (top). Zooming in for a closer look (bottom) shows fine structures, including little figures that resemble the overall form, that seem to get more and more fantastic and complicated as the magnification increases.

numbers resulting from different starting points grow in size. Starting points that lie within the Mandelbrot set produce sequences of numbers that stay bounded, whereas points outside the figure escape to infinity at varying rates, as shown by the use of different colors.

Discovered by Mandelbrot in 1980, the set is more than a mathematical or graphic plaything. It offers one way of exploring the behavior of dynamical systems in which equations express how some quantity changes over time or varies from place to place. Such equations arise in calculations of the orbit of a planet, the flow of heat in a liquid, and countless other situations. The Mandelbrot set in some sense encapsulates the unexpectedly bewildering behavior of the simplest possible dynamical system: the iteration of a quadratic polynomial. This process involves studying what happens when the expression $z^2 + c$ is repeatedly evaluated so that the numerical answer from one step becomes the starting point of the next.

Mandelbrot Madness by Cliff Pickover. See plate 10.

In the Mandelbrot set and other fractals "we see an interplay between strong order and just enough change and surprise," Mandelbrot has remarked. In effect, "the altogether new feature brought in by fractal art is that the proper interplay between order and surprise need not be the result either of the limitations of nature or of human creativity, and it can result from something entirely different. The source of fractal art resides in the recognition that very simple mathematical formulas that seem completely barren may in fact be pregnant, so to speak, with an enormous amount of graphic structure."

The Mandelbrot set also represents the output from just one of an infinite array of mathematical formulas. Innumerable other recipes are available for either mathematical study or artistic exploration. The artist's role becomes one of selecting the algorithm and the color scheme, and the computer calculates the color to be assigned to each pixel on a computer screen and presents the resulting image.

"Sometimes I consider myself a fisherman," computer graphics expert Clifford A. Pickover of IBM Research noted in his book *Computers, Patterns, Chaos and Beauty: Graphics from an Unseen World.* Instead of wielding brush or pencil and thinking shape, texture, and color, you bait your hook with some algorithm and cast in your line, he says. What comes up on the screen from the depths of some mysterious, virtual ocean is often surprising, sometimes beautiful. "The waters are vast and largely unknown, with infinities of undiscovered species," Pickover contends.

Such a vision of algorithmic art has had immense appeal for a number of artists, including Brill. To create an image, Brill writes a simple program in a special computer language he developed and named E in honor of M. C. Escher. Brill's DOS-based, menu-driven "E-Run" software executes the program and generates the picture.

One of Brill's favorite strategies involves applying area-preserving transformations to grids, where each box of the grid can be as small as a single pixel on a computer monitor. His algorithm specifies where all the boxes go with each application of a given transformation.

For example, suppose you decide to use a 4-by-3 grid, with its boxes numbered as follows:

1	2	3	4
5	6	7	8
9	10	11	12

One possible transformation shuffles the boxes so that the sequence of consecutive numbers starts in the lower right corner, and the numbers increase as you go up and to the left. So 1 goes to where 12 was, 2 goes to where 8 was, and so on, as shown in the table below.

1	2	3	4	5	6	7	8	9	10	11	12
12	8	4	11	7	3	10	6	2	9	5	1

Notice that boxes 1 and 12 simply exchange places with each application of the transformation. The remaining boxes each cycle through 2, 8, 6, 3, 4, 11, 5, 7, 10, and 9. In this particular instance, the original image reappears after ten iterations. Such a reappearance is a characteristic of the application of any area-preserving transformation to a finite grid. The idea is to color the boxes to create some sort of pattern, then apply the transformation again and again to see what happens.

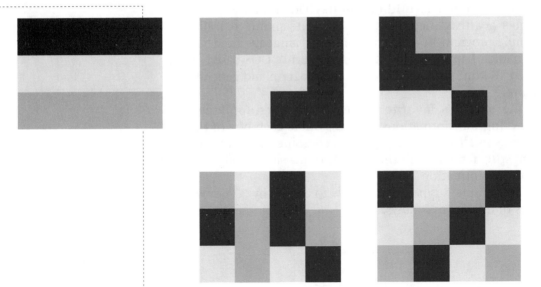

Suppose the starting pattern consists of three horizontal bars, each one colored a different shade. Successive applications of Brill's transformation to this four-by-three grid shuffle the boxes to create new patterns.

The majority of steps produce boring, soupy images. "To me, the images are interesting when they show structure, especially when there is some echo of the original image," Brill notes. Finding the interesting ones without having to check each of the thousands of possibilities, however, can be tricky and time-consuming. Indeed, there appears to be no recipe or shortcut for rapidly zeroing in on particularly pleasing designs. Nonetheless, "I still hold out hope that there are theorems or at least rules of thumb to be discovered that, when given the rules of a transformation and the rectangle size, will point to the iteration numbers where structure can be found," Brill says.

Brill has tried out a variety of grid-scrambling transformations to see what happens. Aesthetic sensibilities govern which transformation to use, what size the rectangular grid should be, and which iteration to look at. "Once a fruitful transformation, rectangle size, and iteration number have been found, the artist is in a position to create compelling imagery," Brill argues.

Applying a transformation to a bull's-eye pattern (top right) scrambles the original image more and more until the pattern becomes a sea of mush (top row right). However, distinctive patterns can suddenly appear amid the mush after enough applications of the transformation (middle and bottom rows). In this case the original bull's-eye reappears after 6,580 applications of the transformation. The number with each image indicates how many cycles were required to reach that stage.

0

1

2

3

15

47

516

772

833

Transformation by Bob Brill. See plate 9.

The choice of starting pattern and color scheme also can strongly influence the appeal of various gridscapes that arise. "Color is a particularly interesting problem," Brill says. When pixels of different colors appear side by side, especially when the combination occurs repeatedly over a region large enough to be visible to the eye, the eye averages them to generate a new color—an effect familiar to the French pointillist painter Georges Seurat (1859–1891) and other artists. In computer graphics, this visual effect is known as dithering. "With Poincaré recurrence, the dithering is done entirely by the transformation," Brill says. "You might think that the results would be muddy, but not so, if one selects colors with an eye toward their mixing potential and does not choose too many."

"The transformations are not random," he adds. "The dance of the pixels is quite orderly, so then is the appearance of new colors."

Going beyond area-preserving transformations, Brill has investigated a variety of other mathematical operations for their artistic potential. "There are worlds of order and beauty lying dormant in our various mathematical systems that these simple algorithmic processes are able to make visible," Brill concludes. "Mathematics, more than any other human activity, seems to offer connections to the underlying order of the world. This is a great inspiration for an artist and a great challenge."

A pursuit curve is the path an object takes when chasing another object. That simple process can lead to fascinating patterns, which Brill has explored in a variety of ways. Brill's *Vortex* represents the results of a twelve-point pursuit, where the twelve points start at the corners of three concentric squares.

□ □ □

Artist Douglas D. Peden of Essex, New York, has investigated his own sort of grid transformations, creating visually arresting paintings in which each gracefully distorted abstraction ripples its own subtly musical tale. Bands and splashes of color seep and shift along narrow passageways, like dyes spreading in irregular patches up soaked strips of porous filter paper.

Transfiguration by Douglas Peden. See plate 11.

Peden started out in nuclear engineering, but he left the field during the 1960s to become an artist. In 1970 he moved to the Adirondack region of New York State. "I found the combination of the natural beauty and solitude supportive of my creative needs," Peden says. "It also allowed me to pursue my own vision without the distraction and influence of the prevailing art fashions, styles, and market forces."

Peden's early paintings featured free-flowing amoebic forms radiating vibrant, contrasting colors. Later he turned to abstract landscapes—sky, water, land, trees, and structures presented symbolically and rhythmically in great horizontal swaths. His visual patterns, with their carefully manipulated thematic variations and modulated colors, reminded one of musical forms such as the classical sonata.

Peden then began to formalize his approach, developing a geometric language and framework that he could use to create his abstract narratives. Instead of working with a Cartesian grid represented by horizontal and vertical straight lines, Peden focused on coordinate systems based on wavy lines. He calls his scheme "wave space," or "gridfield," geometry. In effect, instead of moving around the squares of a grid, he focused on changing the squares themselves into other shapes.

The underlying idea of transferring information from one grid to another has a long history in both mathematics and art. When the blank grid differs from the original grid, for example, a drawing can suffer intriguing distortions. In art, the result is sometimes called an anamorphic picture. Mathematically, you're looking at the results of a type of transformation or mapping.

To create one sort of anamorphic picture, you start with a piece of paper ruled into square cells and another ruled with the same number of trapezoids. Draw your picture on the square grid. Then carefully copy the contents of each square of the original grid to the corresponding trapezoid of the other grid, stretching the lines of the drawing to make sure everything fits together.

You end up with a distorted version of the original picture. Interestingly, if you now look at the final drawing at the proper angle from the edge, it appears undistorted.

You've probably experienced the same effect while riding in a car and encountering the word "STOP" painted on the roadway just before an intersection. The white letters look normal from where you are sitting. If you were standing beside the sign instead of riding toward it, however, you would find that the letters are actually stretched out.

In this simple example of a grid transformation, copying a picture square by square to the corresponding cells of a trapezoidal grid produces a distorted image of the original drawing.

Artists have long used the same idea to create visual puzzles. In such examples, a viewer sees an object correctly only if he or she finds the right angle from which to look at the picture. It's possible, for example, to draw or paint a picture so that you can tell what it is only if you look at its reflection in a mirror shaped liked a cylinder or a cone. Other pictures must be reflected in shiny spheres, mirrored pyramids, or other reflecting surfaces to reveal their true identity.

Peden's scheme is more elaborate. He starts a painting by penciling in a Cartesian grid, using a straight edge. After specifying the wavelength and amplitude, he then draws freehand a set of wavy parallel lines oriented in the vertical direction. The corresponding set of lines in the horizontal direction is then chosen as a function of the vertical field. The combination produces what he calls a "gridfield" configuration. "If wave field amplitudes are reduced to zero, the gridfield becomes a Cartesian grid," Peden notes. "In other words, the commonly used Cartesian grid system is one of many grid/gridfield configurations."

One example of the sequence of steps that Doug Peden may follow to draw a wavy gridfield to serve as the basis for one of his paintings.

Peden then weaves in another meandering wave field to produce additional distortions, making the final grid look like a strangely crumpled piece of fabric. The choice of grid is up to the artist, as is the color of each of the grid's cells. "The shapes, themes, rhythms, and spatial textures are defined and influenced by the geometric configuration of the chosen space," Peden says.

In the early development of his gridfield technique, Peden adopted a trial-and-error approach. "It was a matter of deciding on some wave field parameters, drawing them out, and using various colors, color rhythms, shapes, and textures to see what happens," Peden says. "In other words, I had to experience the possibilities within different gridfield configurations to learn, to test—perhaps, in some sense, like Bach

A character drawn on a square grid can change shape drastically when transferred to different gridfields and to different positions within a given gridfield.

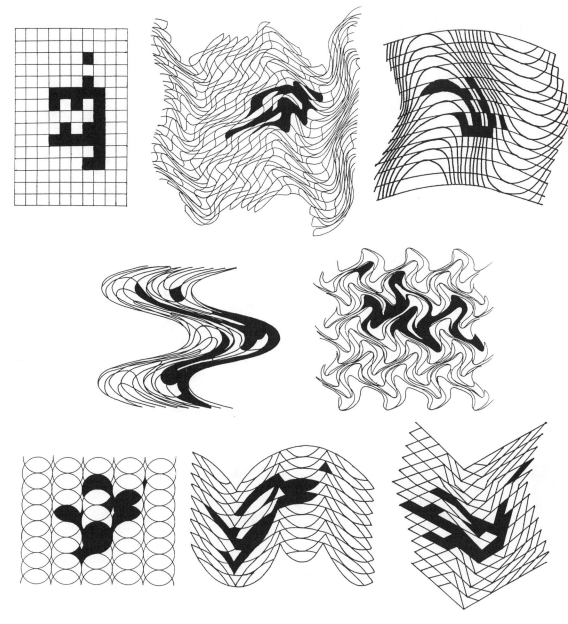

inventing pieces to see what the various organs were capable of doing."

For Peden, gridfield geometry is not only an exciting spatial environment to experience and learn about but also a new language with its own structure and symbolic meaning. "The gridfields themselves can be chosen to express rhythmic energy—in musical terms, allegro, andante, adagio, and so on," Peden remarks. With experience, he has found that different grids contain the possibility of forming different types of shapes—ones that may be dynamic, passive, hard, soft, cutting, ugly, or lovely. The use of color then either enhances or subdues the dynamics or mood suggested by the chosen grid.

Serenade for a Lone Figure by Douglas Peden. See plate 13.

In creating a painting, Peden may start by simply picking a gridfield, penciling it on canvas or paper, then shading in an image. "If the image expresses some sort of personal symbolism or has thematic appeal, I might tell a story," he says. "If the image is just a pleasing shape, I might explore its variations and morphological possibilities, perhaps by adding or subtracting parts or elements, thereby creating other shapes—much in the same manner as a composer develops and explores a musical theme."

Eventually the process evolves into an intimate conversation between artist and painting. At the same time, the painting style does not encourage trial and error. Perceived "mistakes" take a long time to correct. "This is a slow painting process," Peden says, with much time spent visualizing and thinking before committing to paint. Curiously, Peden has not used a computer to aid him in constructing his gridfields or to explore variations and plan his paintings. "The possibility of computer-sketched studies is a fascinating thought and intriguing solution," he admits. "It would certainly lead the way for quicker, more detailed, and more accurate studies and encourage the application of gridfield geometry in art and science." Others, including Bob Brill, are now trying to do this. They are looking into automating the process of creating gridfields.

Peden enjoys the fact that his art is inspired by music, literature, philosophy, mathematics, and physics. "I feel the most profound art is that which encompasses all life—at least as much as one can experience

Come Together by Douglas Peden. See plate 12.

within one's limited capacity for knowledge, understanding, and expression," he says.

Peden's work also helps shed light on the apparent tension between artistic freedom and mathematical constraint. Like Stamp, Brill, and many other artists, he has built a distinctive vision and style out of constraint—by exploring the seemingly unlimited, surprisingly rich possibilities offered by the set of rules he developed (and freely chose) as the framework for his art.

A similar combination of constraint and freedom pervades the natural world, with its subtle interplay of immutable physical law, random mutation, and infinite variation. "I find it interesting to contemplate where we find beauty and why it seems so to us," Arlene Stamp remarks. "I ultimately believe that it is when the systems we devise for ordering the world bear a relationship to our own physical systems that we find beauty."

6 Crystal Visions

The painted canvases and three-dimensional models of architectural structures displayed in artist Tony Robbin's spacious Manhattan studio present all sorts of visual surprises. Featuring brightly colored polygons and angular wire frames, Robbin's creations respond almost magically to changes in light and viewpoint.

Robbin's designs of domes and vaulted ceilings offer startling geometric perspectives. Constructed from networks of linked rods, with a sprinkling of tinted, transparent plates filling in diamond-shaped apertures, these structures reveal paradoxical patterns that combine orderliness and symmetry with an element of unpredictability.

The surprising visual effect becomes apparent when you imagine standing beneath one of Robbin's lacework canopies. Looking straight up, you would see a carousel of overlapping, five-pointed stars. The view slightly to one side reveals a dense thicket of squares and rectangles, whereas the view from another angle shows a network of triangles and hexagons.

Furthermore, as the sun moves across the sky, the shadows cast by such a web of rods suspended in the air shifts from one geometric pattern to another at different times during the day. It's as though three different structures lay hidden inside the same object.

Equally intriguing, the embedded patterns don't repeat themselves in the same way that a network consisting of rods linked to form squares or triangles would repeat itself. Every section of the dome looks a little different from every other section, yet the structure itself is clearly no crazy quilt of randomly placed polygons.

Quasicrystal Dome by Tony Robbin. See plate 14.

Computer plots of the same quasicrystal dome seen from different angles reveal a nonrepeating geometric pattern.

From the beginning of time, human beings all over the world have felt compelled to search for and make repeating patterns, Robbin contends, "so when you have a nonrepeating pattern, it's profoundly captivating."

Robbin's creations stem from his explorations of ways to depict four-dimensional objects and the discovery in the 1970s of a remarkable tiling pattern by the mathematical physicist Roger Penrose of Oxford University in England. Scientists' subsequent identification of a new class of crystalline materials—the so-called quasicrystals, which display evidence of an unconventional atomic arrangement—added another important element to Robbin's work. Indeed, the discovery of quasicrystals focused the attention of crystallographers, physicists, mathematicians, and many others on the occurrence of nonrepeating patterns in both nature and mathematics. It opened up the possibility of bringing a new kind of geometry with fascinating visual and structural characteristics into art and architecture.

Rooted in both natural philosophy and the practical arts, tiling theory is concerned with the ways in which copies of geometric shapes of a few kinds can fit together to cover a surface or fill

space without overlapping or leaving gaps. It's the sort of problem that you might encounter in assembling tiles for a bathroom wall or a kitchen floor.

Designers of mosaic patterns have known since antiquity that a flat surface can be paved with squares, equilateral triangles, or regular hexagons. They have also found ways to combine those shapes with other polygons to generate highly symmetric, perfectly regular patterns. On the other hand, tiles in the shape of regular pentagons, with five sides of equal length and equal interior angles, can't cover a flat surface completely. Attempts to lay pentagonal tiles out on a flat surface invariably leave gaps in the pattern or produce overlaps.

Interestingly, by allowing the use of pentagons with sides that differ in length and interior angles that vary in size, it is possible to create periodic tilings in which each tiling is comprised of tiles of a single, five-sided shape. For example, any pentagon having a pair of parallel sides can cover a flat surface in a periodic pattern.

Tiles in the shape of regular polygons such as equilateral triangles, squares, and hexagons can be laid down in symmetric arrangements that cover the plane without any gaps. Tiles in the shape of regular pentagons cannot.

Pentagonal tiles of the right shape can be laid down to cover the plane without leaving gaps or overlapping each other.

At the same time, tilings with a periodic or repeating pattern need not be limited to polygonal shapes. Many of the drawings, engravings, and prints made by M. C. Escher contain fascinating patterns made up of repeating and interlocking units in the shape of birds, fish, reptiles, and other creatures. Studies of Escher's

notebooks by Doris Schattschneider, a mathematics professor at Moravian College in Bethlehem, Pennsylvania, have shown that Escher had worked out his own mathematical system for classifying tilings and establishing color schemes for the resulting patterns. The symbols he used described how portions of the edges of a tile relate to each other and to edges of adjacent tiles. The system allowed him to find all the different ways in which he could interlock and color various shapes of identical tiles to create eye-catching, symmetrical patterns.

Although M. C. Escher's *Symmetry Drawing E137* looks complicated, it is based on a tiling of the plane by equilateral triangles. © 2001 Cordon Art B.V.—Baarn—Holland. All rights reserved.

Another interesting tiling problem concerns the possibility of devising suitably shaped tiles that cover the plane yet don't have translational symmetry. In other words, there's no unit that you could use like a rubber stamp to reproduce the entire pattern by placing units side by side in a regular array. For example, it's possible to arrange tiles of certain shapes into spirals. Another type of nonperiodic tiling occurs when tiles are grouped together to form successively larger replicas of themselves. Indeed, many tilings of the plane are not periodic.

In this example of a so-called substitution tiling, each L-shaped tile can be broken down into four, smaller L-shaped tiles, *ad infinitum.*

The astronomer and mathematician Johannes Kepler (1571–1630) encountered an especially intriguing route to nonperiodic tiling patterns in the early 1600s. In his characteristically obsessive and painstaking manner, Kepler was the first person to make a systematic study of the packing of polygons in the plane. Among his many discoveries, he identified the eight ways in which combinations of regular polygons, not necessarily all alike but with identical arrangements at each vertex, can be fitted together to create plane-filling patterns. Requiring various combinations of triangles, squares, hexagons, octagons, and dodecagons, these are now known as the semiregular, or Archimedean, tilings.

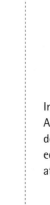

In this example of an Archimedean tiling, two dodecagons and one equilateral triangle meet at each vertex.

One of the other tilings that Kepler encountered was a curious pattern built from regular pentagons, decagons, and star-shaped polygons. In pondering this structure, Kepler wrote: "If you really wish to continue the pattern, certain irregularities must be admitted, two decagons must be combined, two sides being removed from each of them . . . as it progresses this five-cornered pattern continually introduces something new. The structure is very elaborate and intricate."

More than 350 years later, tilings similar to the one that had puzzled Kepler brought new attention to the issue of tiling the plane with a nonrepeating pattern. In 1973 Roger Penrose had a

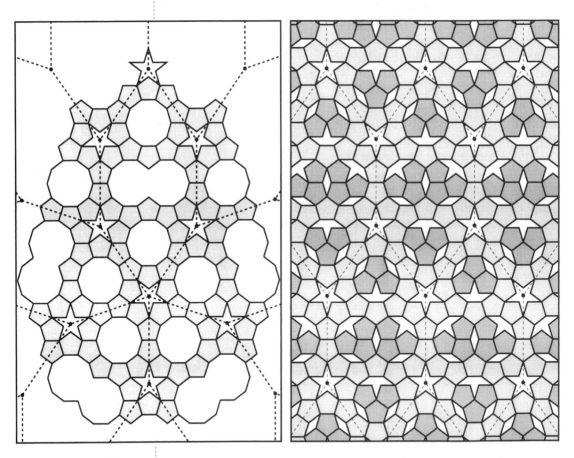

As Kepler discovered in the early 1600s, pentagons and decagons, together with star-shaped polygons, combine to form an intriguing tiling of the plane (left). The pattern formed by connecting the pentagrams in the original pattern can be continued indefinitely by putting three pentagons inside each decagon (right). Flipping some pentagons at random produces a nonperiodic tiling.

friend in the hospital, and he wanted to compose a picture that she would find interesting to ponder while confined to her bed. Creating interesting pictures was something with which Penrose had already had some experience. Fifteen years earlier, he and his father, L. S. Penrose, had introduced the intriguing, visually absurd "impossible" triangle, which came to be known as the tribar, in a paper published in a psychology journal. Roger Penrose's interest in such visual absurdities had been inspired by Escher's drawings of staircases that seem to go up but return to where they started.

The inspiration for Penrose's new picture came in the form of a letter on a sheet crowned with a pentagonal emblem: five identical regular pentagons enclosing another, inverted pentagon. Penrose noticed that the ring of five pentagons itself would fit neatly within a larger pentagonal border. He wondered what he would obtain if he used the inverted pentagon in the middle as a border for a smaller ring of pentagons, which would then leave another, smaller pentagon in the middle, to be filled anew. By repeatedly filling in the inner pentagon at each step, then enlarging the resulting pattern to the previous scale, he found that he ended up with a fascinating tiling pattern.

"If you keep on doing this, gaps will occur which have to be filled in some way," Penrose notes. "I worked out a scheme for filling the holes, and then I drew a picture based on this pattern, which I sent to my friend." Intriguingly similar to Kepler's elaborate pentagonal tiling, Penrose's pattern incorporated gap-filling

Roger Penrose and his father, L. S. Penrose, described the "impossible" triangle, or tribar, in a 1958 psychology journal (left). Later, a pentagonal emblem (right) inspired Roger Penrose to investigate tiling patterns involving pentagons.

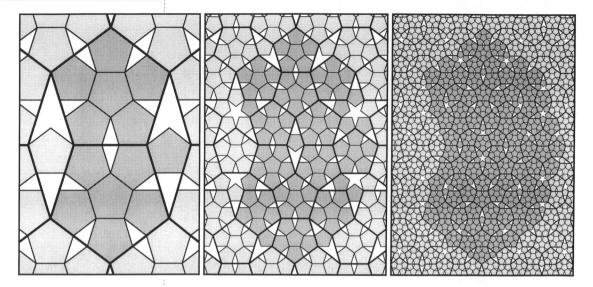

Penrose's original nonperiodic tiling pattern. In the initial step in generating an infinite tiling, six small pentagons fit together inside each of the larger pentagons, and a single small pentagon is fit into the lozenge gap (left). Continuing this process produces larger and larger tilings (middle, right).

polygons shaped like stars, diamonds, and paper boats among its rings of pentagons.

Penrose eventually found that the entire pattern could be put together from tiles of six different shapes. To create a valid tiling, however, the tiles had to be fitted together only in certain ways. In effect, you had to mark the tiles or shape them into units resembling jigsaw-puzzle pieces so that the correct edges ended up next to each other. Starting with a single unit, it would then be possible to keep adding tiles forever in any direction, and the tiling could grow to an infinite size.

The resulting pattern is also nonperiodic. There is no unit of the pattern that can be copied and, when superimposed on the original pattern, can always be slid to a new position, without rotating or reflecting it, where all the edges match the original tiling. Hence such a tiling pattern, when extended to infinity, consists of a huge number of different arrangements. In one of those curious paradoxes of infinite structures, however, no matter how large a finite portion you select from any such pattern, this finite portion will appear somewhere in every other complete pattern, and it will do so infinitely many times.

Penrose became interested in identifying the smallest possible set of different tiles that, when used together, would have the same property of covering a flat surface without forming a regularly repeating pattern. Is there, for instance, a single tile from which it is possible to construct only a nonperiodic tiling—a pattern enforced by matching rules that govern the ways in which tiles, or clusters of tiles, must be put together?

Over a period of about a week, Penrose was able, in his mind, to dissect the six different tiles in his original pentagonal pattern and glue the pieces back together in new ways so that he could assemble a nonperiodic pattern from just two types of tiles. Such a pair can be created by cutting a rhombus, a figure resembling a skewed square or a diamond, into two pieces in a special way. One piece of the rhombus resembles an arrowhead and is called a dart. The other piece, whose blunter end fits snugly into the arrowhead's notch, looks like a diamond with a foreshortened end and is known as a kite.

A Penrose tiling made from tiles in the shape of kites and darts.

Not surprisingly, when tiling the plane, it is possible to reassemble kites and darts into rhombuses and to arrange these forms in such a way as to create a periodic arrangement. However, by working out rules that specify which edges of one tile fit with which edges of another, you can force the tiles to fit together only in certain ways, generating a nonrepeating pattern. This can be done by decorating the appropriate sides or angles of each dart and kite with colored bands or using small, interlocking tabs like those on jigsaw-puzzle pieces. Such matching rules forbid juxtapositions that lead to periodic arrangements.

It turns out that you need about a hundred kites for every sixty darts to construct a correct pattern. More precisely, for an infinitely large pattern, the number of kites divided by the number of darts is exactly the golden ratio $(1 + \sqrt{5})/2$. As an irrational number, the ratio can't be expressed exactly as a fraction—that is, one whole number divided by another whole number. This irrationality is one manifestation of the pattern's nonperiodic structure. Were the arrangement regular, this ratio would have been a rational number, or a fraction. The reason the golden ratio arises rather than some other irrational number is intimately linked with the pattern's pentagonal, or fivefold, symmetry. In a regular pentagon, for example, the ratio of the shortest distance between two vertices to the next shortest distance is the golden ratio divided into 1.

As it happens, there are many different pairs of quadrilateral shapes that form a nonperiodic tiling pattern, although all are related in some way to the original kite-and-dart pair. One particularly useful set consists of a pair of diamond-shaped, or rhombic, figures—one fat and one skinny. As required for the kite and dart tiles, rules for matching specified sides—shown by markings, tabs, or decorations on the tiles—are critical for forcing the tiles into a nonrepeating pattern. Decorated tiles must be placed so the designs they form are continuous.

A Penrose tiling made from tiles in the shape of fat and skinny diamonds, or rhombs.

Plate 1 In *The Geometry Lesson* and other paintings, New York City artist Clifford Singer used the classical construction methods of the ancient Greek geometers as a language to engineer aesthetic expressions painstakingly arranged and precisely depicted in bold lines, sweeping curves, and pure colors. The result is geometric poetry.

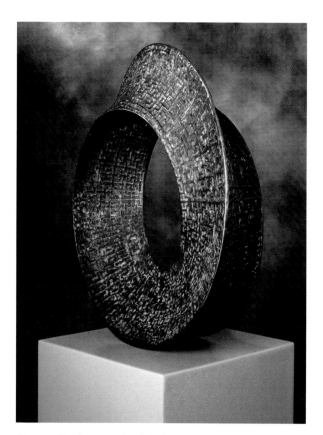

Plate 2 For the mysteriously incised and patinated *Umbilic Torus NC*, Helaman Ferguson used modern computer-controlled machinery to shape the sculpture's surface and an ancient process known as lost wax bronze casting to create the final piece.

Plate 3 Constructed from plexiglass, aluminum tubes, and nylon cord, Harriet Brisson's *Great Rhombicuboctahedra and Octagonal Prisms,* a space-filling, tensegrity structure, represents one way to divide space in half. Because the form and the space "outside" the form are geometrically identical, the sculpture highlights the impossibility of differentiating the form from the space between.

Plate 4 *Truncated 600-Cell* by Harriet Brisson features twelve fluorescent tubes in the shape of an octahedron placed within a mirrored tetrahedron to produce the four-dimensional analog of the regular icosahedron in three-dimensional space. By reflection, the sculpture shows six hundred regular tetrahedral cells, five of which fit around each individual cell.

Plate 6 *All Stars CMYK 295* by Eleni Mylonas emphasizes the complex grid of parallel lines that guides Mylonas in creating images based on Penrose tilings.

Plate 5 *Math Horizon* by Tom Banchoff represents a sphere that is twisted so it intersects itself in just a single point in four-dimensional space (in much the same way that a figure eight represents a twisted circle with a single intersection point in the plane). As viewed from inside the object, the colored bands correspond to different circles of latitude on the original two-dimensional sphere.

Plate 7 In recent years, Tony Robbin has returned to painting on canvas to continue his multidimensional explorations, as shown in *Untitled #6, 2000.*

Plate 8 The entrance to the Downsview subway station in Toronto features a striking mosaic by Arlene Stamp. Titled *Sliding Pi*, its bands of color reflect the seemingly random decimal digits of the number pi—the circumference of a circle divided by its diameter.

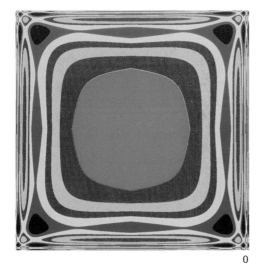

0

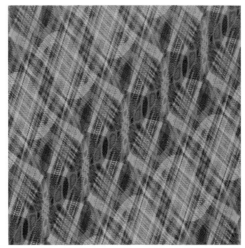

171

Plate 9 In the following sequence of images from *Transformation*, Bob Brill applied the same transformation repeatedly to a starting pattern (top left) in a 1,024-by-1,022 rectangle. Shown are images resulting from 171, 254, 256, 341, and 512 applications of the transformation. In this case the repeat cycle is 1,023.

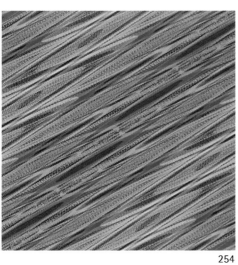

254

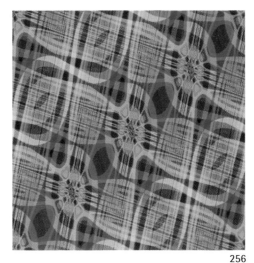

256

341

512

Plate 10 In *Mandelbrot Madness* by Cliff Pickover, a magnified portion of the Mandelbrot set's boundary reveals a chaotic world of winding tendrils, ragged shapes, and miniature copies of the snowmanlike Mandelbrot figure. Different shades show the rates at which various points near the boundary escape to infinity.

Plate 11 Douglas Peden painted *Transfiguration* as a memorial to his wife, Jan Peden. "It is basically a painting of hope and faith," Peden says. "The specific event in question is the pain and horror of my wife's cancer and the hope of a joyful conclusion, whether it be in the beauty of bodily healing or the painless union with God."

Plate 12 *Come Together* by Douglas Peden.

Plate 13 Detail from Douglas Peden's *Serenade for a Lone Figure*, painted in 1997.

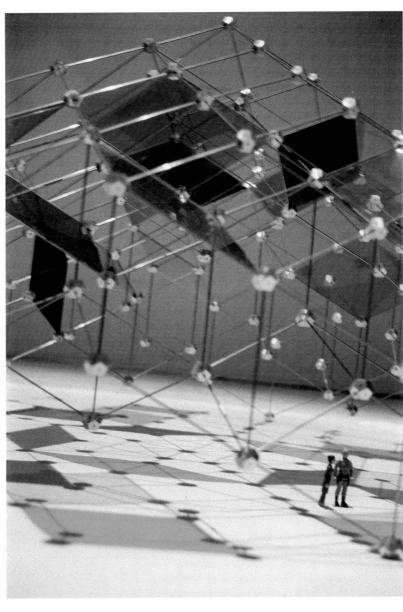

Plate 14 The discovery in the early 1980s of a new class of crystalline materials known as quasicrystals focused the attention of physicists and mathematicians on nonperiodic geometric patterns. The same patterns also inspired new designs in art and architecture, as shown in *Quasicrystal Dome* by New York City artist Tony Robbin.

Plate 15 In *Simplex #9, 1983,* Tony Robbin's use of wire frames protruding from a painted canvas offers a striking perspective on four-dimensional geometry. No single picture can do justice to the experience of viewing a composition like this one from different angles. As the viewer moves, the shadows of three-dimensional, wire-frame figures emerging from the canvas play against the two-dimensional acrylic painting.

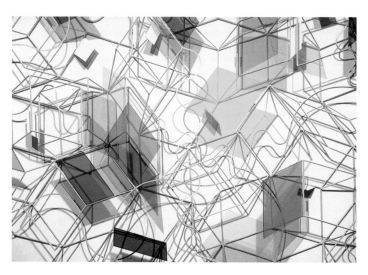

Plate 16 Welded steel frames, transparent plastic panels, and colored light add up to an intriguing artwork, *Untitled #3, 1987,* by Tony Robbin.

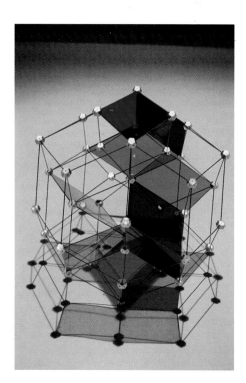

Plate 17 Tony Robbin's *Quasisphere.*

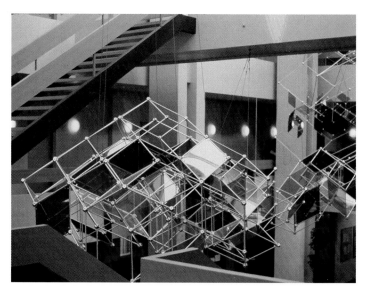

Plate 18 The completed quasicrystal *COAST* Canopy by Tony Robbin at the Center of Art, Science, and Technology (COAST) in Denmark.

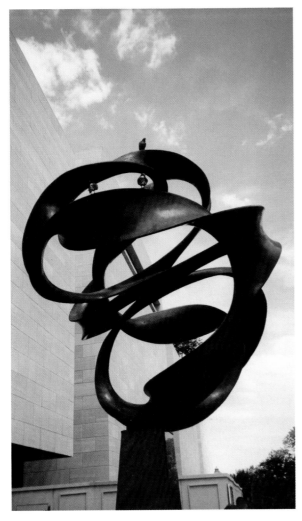

Plate 19 *Continuum* by Charles O. Perry is a Möbius surface of seven saddles designed to represent the continuum of the universe.

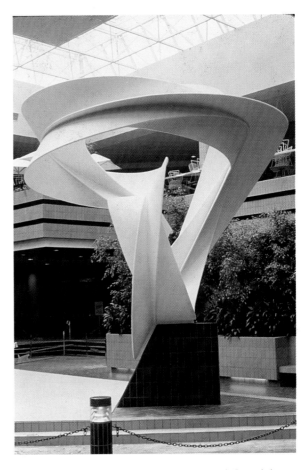

Plate 20 In sculptures like *Enigma* by Charles O. Perry, it is difficult to tell whether its surface can be considered equivalent to that of a Möbius strip.

Plate 21 *Invisible Handshake* is a Costa surface carved from packed snow.

Plate 22 *Arabesque XXIX* by Robert Longhurst.

Plate 23 *Music of the Spheres* by Brent Collins.

In her book *Quasicrystals and Geometry,* Marjorie Senechal of Smith College in Northampton, Massachusetts, recommends that "The best introduction to Penrose tilings is to play with the tiles. It is not difficult to make your own from cardboard or, even better, plexiglass." Swiss artist Caspar Schwabe carried this idea into a large, interactive artwork he created for a 1991 exhibition. It allowed visitors to move around colorfully decorated magnetic tiles on a wall to learn the rules for creating a Penrose tiling.

In practice, Penrose tilings are difficult to assemble even when you obey the tiling rules scrupulously. "It's very easy to go wrong, and you'll make worse and worse mistakes as it goes on," Penrose remarks. "It's not like a normal jigsaw puzzle, where if the piece fits you know it's right; here, if the piece fits, it may be a mistake, which you won't be able to detect until many moves later." When you end up constructing a region with a space that can't be filled in without disobeying the matching rules, all you can do is to unravel part of the tiling and try again.

Penrose's patterns quickly attracted attention, particularly after Martin Gardner wrote an article about the tilings for *Scientific American* in 1977. These nonperiodic patterns intrigued not only mathematicians and other researchers but also many artists and artisans. Creating such a nonperiodic pattern with its

> "The best introduction to Penrose tilings is to play with the tiles. It is not difficult to make your own from cardboard or, even better, plexiglass."
>
> —*Marjorie Senechal*

Matching rules specify how the two types of Penrose rhombs fit together. In this case, adjacent tiles sharing a side must have the same number of arrows going in the same direction. Following the rules, however, does not automatically lead to a "legal" tiling. It is possible to end up with tile arrangements that can't be continued, as shown in this example, without breaking the rules. Nonetheless, because many authors don't follow the rules scrupulously, it's not unusual to find diagrams of incorrect patterns in the published literature.

unexpected irregularities became an interesting challenge for quiltmakers, for instance, who were already familiar with the "reversing cubes" pattern made up of diamond shapes in a regular array. Tilemakers, painters, and others also got into the act, interpreting these patterns in a variety of formats. Interestingly, if you look closely at some of the resulting patterns, it's clear that the artist or craftsman did not always follow the matching rules, or perhaps was unaware of them, because the patterns contain "illegal" tile arrangements.

A Penrose tiling pattern (above) offers an intriguing alternative to traditional, periodic patterns based on rhombs that create an illusion of an array of cubes (right).

Early in the development of these nonperiodic tilings, even before Penrose got to the kite-and-dart stage, he realized that his pentagonal pattern must have a three-dimensional version. In this case, the basic building blocks are not tiles but polyhedra—three-dimensional figures bounded by flat, polygonal faces. In the periodic case it's easy to imagine how the array of squares of a checkerboard in two dimensions corresponds to stacked cubes in three dimensions. In three dimensions it's possible to build up a nonrepeating pattern by using two types of rhombohedra that resemble skewed cubes.

A few scientists also paid attention to these mathematical discoveries. In 1981 crystallographer Alan Mackay suggested that a three-dimensional variant of Penrose's tilings might appear in nature. Physicists Dov Levine and Paul Steinhardt, then at the University of Pennsylvania, provided a mathematical treatment of Penrose tilings generalized to three dimensions. Light projected at just the right angle through a framework model of one of these three-dimensional structures would create a shadow that replicates a Penrose diamond tiling.

Such research efforts were little more than theoretical musings until 1984, when Dan Shechtman, working at the National Institute of Standards and Technology, and his coworkers reported the discovery of an aluminum alloy that yielded a peculiar diffraction pattern. Electrons reflected from the material created an image consisting of concentric rings of well-defined spots arranged so the overall pattern had a fivefold symmetry. In other words, rotating the pattern through seventy-two degrees would bring it into a new position in which the pattern looked just as it did in the old position.

The sharpness of the spots indicated that the atoms in the material are organized in some orderly fashion rather than

A rhombic triacontahedron, which has thirty rhombic faces, can serve as a building block of a quasicrystal or the three-dimensional analog of a Penrose tiling.

123

randomly placed. But the pattern's unusual fivefold symmetry suggested that the atoms could not lie in one of the orderly arrangements of repeating units, or unit cells, conventionally assigned to crystals.

It was natural for physicists and others to turn to the Penrose tilings and their three-dimensional analogs as reasonable models of the basic units that might fit together to produce the unusual alloys. Steinhardt introduced the term "quasicrystal" as a label for these materials. Indeed, the Penrose tiling embodied several features characteristic of these natural quasicrystal structures. It suggested, for example, that the atoms of quasicrystals organize themselves into two types of clusters, which serve as building blocks, rather than into the single type of block typical of ordinary crystals.

Mathematicians and physicists were not the only ones to get caught up in the wonder of nonperiodic patterns. A handful of artists, architects, and tinkerers, often quite independently, explored the possibilities of using the flexibility afforded by such novel building-block schemes in their own designs.

In the early 1970s, inventor Steve Baer of Albuquerque, New Mexico, discovered that rods sprouting from nodes in the shape of dodecahedra—three-dimensional forms having twelve pentagonal faces—could be assembled into polyhedral building units, which in turn could be combined to create an array of larger structures displaying a fivefold symmetry. This idea became the basis of his patented "zome" building system. That endeavor, in turn, led to a book describing the system, a toy construction kit, and various structural designs. "We have playground climbers made with fivefold symmetry [at various locations] in Albuquerque," Baer says.

Somewhat later, architecture professor Koji Miyazaki of Kyoto University in Japan, working with assemblies of fat and skinny rhombohedral blocks, discovered that these assemblies could be stacked and fitted together to make perfect space-filling, three-dimensional structures—examples of the three-dimensional analogs of Penrose tilings applied to architecture.

Other designers took a more mathematical approach. Motivated by a fascination with projections—in effect, the two- or three-dimensional shadows—of higher-dimensional forms, Haresh Lalvani, a member of the architecture faculty at Pratt Institute in Brooklyn, New York, investigated the use of various mathematical procedures for transforming lattices in a particular dimension into new geometric patterns, including nonperiodic arrangements, in a lower dimension.

In the "zome" building system, the combination of special balls with polygonal apertures (left) and color-coded struts can be used to create a wide variety of geometric structures (below).

Using this approach, Lalvani not only created a variety of ingenious designs but also anticipated a number of mathematical discoveries concerning the intriguing properties of Penrose tilings. In some cases he even went beyond what mathematicians had succeeded in working out. Having no mathematical proofs,

however, the best he could do to establish that his ideas were credible was to perform computer simulations and build architectural models to demonstrate the concepts.

Because designers aim to create pleasing or provocative structures, their designs are governed by aesthetic considerations rather than by matching rules and other mathematical niceties. Nonperiodic structures built from just a few basic types of building blocks offer a number of striking features. In particular, such modular systems introduce the possibility of constructing truly unique structures that are both spatially and visually interesting.

"The same system allows many possibilities," Lalvani says. "It allows nonrepetitiveness. It also allows repetitiveness—if needed—because the same basic units can be laid out periodically." Lalvani holds several architectural-design patents based on these concepts.

With the discovery of quasicrystals and their apparent link to Penrose tilings in two dimensions and space-filling rhombohedra in three dimensions, interest in the subject soared during the 1980s. Numerous articles in newspapers and magazines brought these fascinating patterns to the public, and a number of artists began creating their own interpretations of these nonperiodic tilings and structures.

In 1989, a *New York Times* article about certain curious physical properties of quasicrystals alerted New York City artist Eleni Mylonas to the enigmatic intricacies of Penrose tilings. Mylonas was born in Greece into an intellectual family. Her father was a government official and her mother a sculptor. In school, Mylonas enjoyed mathematics, particularly geometry, but she pursued journalism at Columbia University in the late 1960s. As a photojournalist she often found herself highlighting textures and shadows, whether in the dreary abandonment of Ellis Island or the wilds of Afghanistan. She would find stark beauty in the rubble of empty lots and in the crunched remains of wrecked automobiles. At the same time, she was drawn to art—ceramics, painting, sculpture, and more recently, electronic or digital imaging.

All Stars CMYK 295 by Eleni Mylonas. See plate 6.

"As far back as I can remember, I was conscious of scale within scale," Mylonas remarks. "But the exploration has already become less of the visual and more of the conceptual and abstract."

Mylonas's visual explorations of quasiperiodic spaces represent one outcome of that transition. At the same time, her fascination with scale unwittingly echoes the way Penrose created his original nonperiodic pentagonal designs by a process of filling in and enlarging, then repeating the process. An equivalent process

Gray Bed Revisited by
Eleni Mylonas.

of inflation can be used to generate the kite-and-dart and diamond Penrose tilings.

On her own, Mylonas discovered how to use a complex web of sets of parallel lines running in different directions to create her distinctive nonperiodic patterns. Flavored strongly with pentagons and five-pointed stars, some of her designs are reminiscent of those that Kepler discovered centuries earlier. Other designs feature diamond shapes and play with illusions of depth to create intricate networks and structures on a computer screen or as part of a wall-filling collage. Still others capture the wonder of tilings with fivefold symmetry in colorful images that evoke mosaics of stained glass.

In another artistic foray into nonperiodic structure, Helaman Ferguson designed *Aperiodic Penrose Torus, Alpha* in collaboration with mathematician Marjorie Senechal. The completed sculpture now stands in the lobby of Burton Hall at Smith College, where

> As far back as I can remember, I was conscious of scale within scale.
>
> —*Eleni Mylonas*

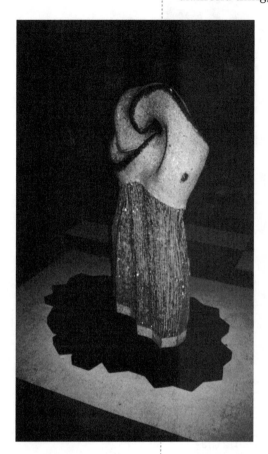

Aperiodic Penrose Torus, Alpha by Helaman Ferguson. A portion of a Penrose tiling, made from granite, surrounds the pedestal of this sculpture, which encodes mathematical properties of the tiling.

Senechal has been teaching for many years. A portion of a Penrose diamond tiling, fabricated from granite tiles, sits at the sculpture's base. The sculpture itself is a torus, with lines winding around the object to encode many of the mathematical properties of the tiling, including a symbolic proof of the tiling's nonperiodicity.

Tony Robbin came to Penrose tilings and quasi-crystal structures from a somewhat unusual perspective. He had started out as a painter, creating complex works filled with interwoven patterns and ambiguous figures to give the illusion of seeing more than one object in the same place at the same time. "I was interested in ways of experiencing and depicting space—complex spaces, multiple spaces, paradoxical spaces," Robbin recalls.

Some of Robbin's paintings from the early 1970s depict tiling patterns—but they show subtle irregularities and appear to be made up of crumbling tiles, almost as if order were slowly dissolving away or fading into another realm. Many of these artworks were created by spraying paint through patterned stencils to produce the impression of multiple, superimposed spaces.

Robbin's fascination with finding ways to look beyond our three-dimensional universe inexorably pulled him into the domain of four-dimensional geometry. "I think the main vehicle that artists use to communicate emotion is space," Robbin contends. "You can say the history of art is the history of different spaces, and these spaces are an embodiment of the mathematics of time, of the geometry of time. What four-dimensional geometry can do is give you a model of the complexity of the world we live in."

In a fashion that is typical for him, Robbin set out to learn everything he could about the fourth dimension, even hiring a tutor to introduce him to space-time and Einstein's general theory of relativity. But it was a visit in 1979 to Brown University in Providence, Rhode Island, that really persuaded him that mathematics could serve as his gateway to higher-dimensional spaces. During this visit he saw Tom Banchoff's computer-generated images of four-dimensional hypercubes (see Chapter 2).

"After years of hoping to visualize the four-dimensional cube,

Hints of regular tilings appeared in the early work of Tony Robbin.

there it was," Robbin writes in his book *Fourfield*. "By moving a joystick, I could turn the hypercube in my hand. The computer recalculated the position of the object thirty times a second, so the joystick was exquisitely sensitive to the touch, and the illusion of actually handling this beloved and mysterious object was very strong indeed.

"For three nights, I woke frequently from dreams of the images that I had seen on Banchoff's computer: the green screen, the quivering geometric figure," Robbin continues. "It seemed as if these images were imprinted on my mind. I had seen the fourth dimension directly."

Robbin also took away an appreciation of what a computer could do to help visualize complicated forms. "I realized that real mathematics was more liberating and richer, more complicated and more exhilarating, than my ignorant artist's fantasies about it," he says. "I was dissatisfied with using artists' tricks to depict spaces. I decided to take the plunge."

Robbin's immersion in mathematics led to the creation of a series of works in which welded steel frames protrude from painted canvas panels to represent sections of hypercubes.

Because the painted lines remain fixed and the relative positions of the rods change as a viewer walks past, such a work re-creates in a novel fashion the experience of seeing the multiple faces of a three-dimensional shadow cast by a rotating hypercube.

The computer proved to be a crucial tool to obtain the views that Robbin needed. He went back to school to learn enough mathematics and computer programming to write his own software for creating images of four-dimensional and quasicrystalline geometric structures. "The lens allowed us to see things that were far away up

Simplex #9, 1983 by Tony Robbin. See plate 15.

close, and allowed us to make recorded images of the things we saw," Robbin says. "The computer allows us to see things that we know are there but we can't see for ourselves. It creates a visual world of four-dimensional geometry, of hyperbolic geometry, of quasicrystal geometry, of fractal geometry. We know that these structures exist. The computer allows us to see them."

In later works Robbin explored the dimension-bursting and space-twisting interactions of sculpture, painting, and light more fully. In some pieces he took advantage of the shadows cast by steel-rod frameworks attached to canvas to complete four-dimensional geometric figures. In other cases Robbin shone red and blue light from different angles through wire frameworks, projecting red and blue shadows on a blank, white wall. He provided viewers with special glasses that would fuse the colored shadows to make the figures that complete the hypercubic forms depicted in his artwork.

Robbin became interested in quasicrystals and the mathematics associated with them when he learned that nonperiodic patterns can be understood mathematically as projections of periodic lattices in higher dimensions. In

Untitled #3, 1987 by Tony Robbin. See plate 16.

other words, regular patterns in six-dimensional space—when seen in three dimensions—could under certain circumstances appear as nonperiodic geometric structures. Lacking the

Projection of lattice points in a two-dimensional array onto a line generates a nonperiodic arrangement of points along the line. Similarly, the nonperiodic arrangement of quasi-crystals can be thought of as the result of a projection of a regular lattice of a higher dimension into three dimensions.

regular spatial repetitions associated with ordinary crystals, quasi-crystals could be understood as mathematical "shadows" in two and three dimensions of higher-dimensional geometric lattices.

With help from Paul Steinhardt, Robbin wrote a computer program that enabled him to generate three-dimensional quasi-crystalline lattices on a computer screen. That program was based on earlier work by the Dutch mathematician N. G. de Bruijn, who had discovered a way to generate Penrose tilings by drawing certain grids of intersecting lines and putting a tile at each point of intersection. Robbin also added features that enabled him to visually explore a variety of designs based on quasicrystal geometries. Without a computer to generate and manipulate those intricate, three-dimensional forms, Robbin says, "it is truly difficult to understand the aesthetic potential of quasicrystal structures."

In 1991, officials of the newly built Center of Art, Science, and Technology (COAST) at the Technical University of Denmark in Lyngby commissioned Robbin to construct a model and to conduct feasibility studies for erecting a large canopy and climbing structure based on his quasicrystal forms. The structure was originally meant to climb up a wall and overhang a roadway, where passersby could experience the changing patterns as they walked or drove under it.

The Denmark project raised a number of intriguing engineering issues—the kind that come up whenever a novel design

Quasisphere by Tony Robbin. See plate 17.

131

makes the transition from concept to real world. For instance, no one really knew how strong or stable a full-scale quasicrystal structure would be. "Because they are nonrepeating patterns, quasicrystals are structurally different from anything yet built," Robbin argues. From his experience with models, he suspected that quasicrystal structures might be somewhat spongy—able to absorb shock and spring back. But neither intuition nor tabletop models could substitute for a full engineering analysis of how such a structure would behave. The Denmark project provided the first opportunity to investigate the structural characteristics of a quasicrystal-based design.

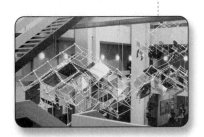

COAST Canopy by Tony Robbin. See plate 18.

With the grant to pay for the project about to expire and the approach of winter complicating construction, Robbin's quasicrystal canopy found a home as a suspended structure within the three-story atrium of the COAST building rather than on the outside. The resulting architectural sculpture, sixty feet long, twenty-five feet wide, and thirty feet high, was completed in 1994. Two bridges span the atrium, allowing visitors to pass under, over, around, and even through the sculpture to reflect upon its varied and many symmetries. "From above, the fivefold symmetry of this structure is apparent, but from below we see the near chaos inside," Robbin remarks.

Robbin provided details of his architectural designs based on quasicrystals in his 1996 book *Engineering a New Architecture,* which recounts how new engineering materials—including the use of exotic fabrics, tough cords, and flexible sheets—together with innovative fabrication techniques have influenced modern design to produce unconventional geometric structures. A year later, Robbin was particularly proud to receive a patent for his concept of an "architectural body having a quasicrystal structure."

Untitled #6, 2000 by Tony Robbin. See plate 7.

"The goal is to enrich architecture with modern geometries," Robbin contends. "Buildings need to embody the intricate, multiply connected, fluid, and subtly ordered spaces that we know and feel to be here."

In Penrose tilings and quasicrystal geometry, mathematicians, physicists, artists, and architects share the experience of seeing in its complexity a pattern that is subtle yet powerful, and a symmetry that is elusive yet enthralling. Physicists see in these patterns hints of how nature may organize matter under certain circumstances. They invent and invoke special rules to

create models that appear to mimic the behavior of real-life quasicrystals.

Mathematicians enjoy the opportunity to explore the diversity of forms that can arise from simple rules and principles. They look for links between these patterns and other types of mathematics. They try to enumerate the geometric possibilities in any given situation. They sense the mystery. "The pentagon and the icosahedron are figures full of mysteries," de Bruijn says. "Again and again, you get these surprises. You get this harmony—a very beautiful harmony that we really do not deserve."

Artists usually don't appreciate this mathematical beauty, he continues. "Many of them know very little mathematics, and they are very easily impressed by things that we think ordinary," de Bruijn says. "They build structures and change them a little bit—by taste or predilection rather than by mathematical principle or necessity—so the structures lose their mathematical essence."

Nonetheless, in quasicrystal geometry, artists and architects have gained an aesthetically and structurally challenging way of dividing and organizing space, even though they generally use only arbitrary fragments of quasicrystals. "Normally, we work with repetitive grids and lattices," Lalvani says. "A different underlying grid—a different way of organizing space—changes things radically."

One may wonder what Escher might have made of nonperiodic plane- and space-filling patterns. "It is one of my very great regrets that Escher did not live to make use of these tiles," Penrose notes. "One cannot adequately speculate on the fascinating designs that he might have produced."

Escher did find inspiration in the work of mathematicians. For instance, he gleaned ideas and images from the work of the University of Toronto geometer H. S. M. Coxeter, whose mathematical research focused on symmetry and shapes. "It is fascinating how artists can take mathematical ideas and play with them," Coxeter remarks.

Visualizing mathematical objects such as polytopes (polyhedra such as cubes and tetrahedra in any dimension), infinite periodic and nonperiodic tilings, and chaotic algebraic systems requires deep insight. In chaos, where very simple algebraic ideas have limitless artistic applications, one literally has access to an infinity of abstract art, Coxeter notes. "It makes it almost embarrassing for abstract artists to do abstract art because these are things that are so varied and so beautiful that one doesn't need to go any further."

Robbin, more than most artists, seeks inspiration in mathematics and science. He tries to weave together mathematical, physical, and aesthetic threads into compelling works of art. "If you want to be creative, it's essential for an artist to know about geometries and space," Robbin says. "Physics and mathematics describe spaces far richer than any artist has yet imagined, spaces needed for the definition of inner experience, and for the completion of our aesthetic sensibility."

At the same time, he insists that scientists and mathematicians can benefit from new modes of expression created by artists. With their highly developed capabilities of visualization, artists introduce new viewpoints that contribute to the development of science and culture as a whole. While artists mine the territory and exploit the riches that mathematicians stake out, Robbin says, they also serve as the provisioners and bankers of these prospector mathematicians.

7 Strange Sides

R esembling a pair of wings boldly sketched in the sky, an eight-foot-high, stainless-steel sculpture perches atop a tall pedestal in front of the National Museum of American History in Washington, D.C. As it revolves slowly on its base, the swooping, twisted loop glints strangely in the sun. Designed in 1967 by sculptor José de Rivera (1904–1985), who titled the piece simply *Infinity,* the sculpture is based on an intriguing mathematical form known as the Möbius strip.

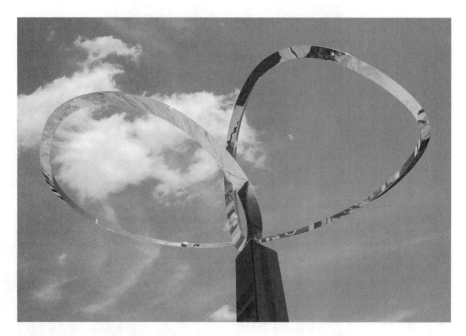

Infinity by José de Rivera.

A product of purely mathematical research, the Möbius strip has just one side and one continuous edge. You can make a model of this unusual form by joining the two ends of a strip of paper after giving one end a 180-degree twist. An ant could crawl from any point on the surface to any other point without ever crossing an edge.

Remarkably, de Rivera's sculpture is not the only version of a Möbius strip on display in the area. A short walk away, a more complicated Möbius shape stands guard (and hosts pigeons) at the entrance to the National Air and Space Museum. Created by sculptor Charles O. Perry of Norwalk, Connecticut, it is titled *Continuum*.

Across the Potomac River in a plaza in front of several office buildings in the Crystal City neighborhood of Arlington, Virginia, stands another Möbius strip—a giant, calligraphic loop of twisted, red-painted steel, also created

Möbius strip.

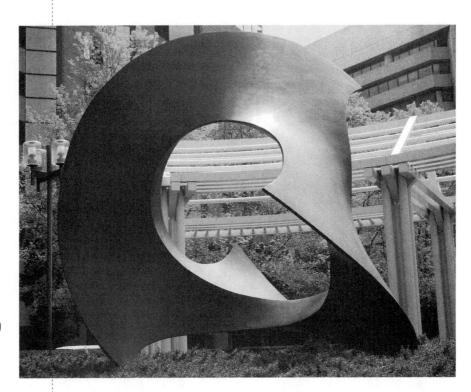

Mace Möbius (right) and *Calligraphic Möbius* (next page) by Charles O. Perry.

by Perry. Much more compact and rounded, a nearby companion piece presents an entirely different perspective on one-sided surfaces.

An hour's drive north of Washington, a granite Möbius strip fashioned by Swiss artist Max Bill (1908–1994) reclines in the sculpture garden of the Baltimore Museum of Art. Bill called his creation *Endless Ribbon*. Additional artful manifestations of the enigmatic, infinitely malleable Möbius strip can be found in many other parts of the world.

□ □ □

The Möbius strip is named for the astronomer and mathematician August Ferdinand Möbius (1790–1868). For much of his life, Möbius was a professor at the University of Leipzig in Germany. He had studied theoretical astronomy with Carl Friedrich Gauss (1777–1855) in Göttingen for two semesters early in his life and became director of the Leipzig astronomical observatory in 1848. His publications spanned a broad range of topics in both astronomy and mathematics.

In 1858, Möbius was deeply immersed in the development of a geometrical theory of the faceted solids known as polyhedra. The Paris Academy had called attention to this area of mathematics research by offering a prize for the solution to a puzzle that had arisen in the classification of polyhedra.

In the eighteenth century, the mathematician Leonhard Euler (1707–1783) had observed that in solids enclosed by plane faces, the number of vertices (V) minus the number of edges (E) plus the number of faces (F) equal 2, or $V - E + F = 2$. A cube, for example, has eight vertices, twelve edges, and six faces: $8 - 12 + 6 = 2$. However, the formula doesn't work for all polyhedra. A polyhedron that looks like a squared-off bagel with a square hole in the middle, for instance, has sixteen vertices, thirty-two edges, and sixteen faces, so $V - E + F = 0$. Clearly, the presence of a hole makes a difference.

Mathematicians were forced to consider how a hole in a solid would affect Euler's formula for polyhedra. If a solid has several holes, how should they be counted? What if the holes comprise a network of tunnels threading the solid's interior? Efforts to answer these and related questions about the fundamental characteristics of surfaces and solids have propelled much mathematical research during the past two hundred years.

Euler's formula that the number of faces plus the number of vertices minus the number of edges equal two doesn't apply to a polyhedron such as this square bagel.

Möbius identified an additional complication. In the course of his investigations, he had started to describe surfaces in terms of flat polygonal pieces glued together in various ways. A cube, for instance, can be created by gluing together six squares. Möbius worked out what would happen if you started with a row of triangles and linked the ends in various ways. An entry Möbius made in his notebook in September 1858 records his discovery that connecting the ends after putting a twist into a strip produces a one-sided surface.

Möbius's discovery of what we now call the Möbius strip was published in 1865, in a paper titled "On the Determination of the Volume of a Polyhedron." His essay on the theory of polyhedra, which summarized his investigations and results, was published after his death in 1868.

In one of those surprisingly frequent quirks of mathematical fate, Möbius was not the first to discover or describe the object named for him. Credit for the discovery of the Möbius strip should probably go to the German mathematician Johann Benedict Listing (1808–1882). Working independently, Listing first encountered the one-sided surface in July 1858. He published his discovery in an 1856 paper devoted to generalizations of Euler's formula for polyhedra.

Nonetheless, it is Möbius rather than Listing whom we now associate with one-sidedness. How and why that came to be appears lost in the mists of mathematical history. It's also a bit surprising that no one seems to have noticed the existence of one-sided surfaces before Möbius and Listing delved into the geometrical theory of polyhedra.

Interestingly, the first known application of the idea outside of mathematics was in the realm of magic. In their unceasing efforts to befuddle, astonish, and mystify their audiences, magicians have long been among the first to adopt new technologies or take advantage of scientific and mathematical advances. A parlor trick involving the Möbius strip appeared in the enlarged 1882 English edition of Gaston Tissandier's *Les Recreations Scientifiques,* first published in Paris in 1881.

In Tissandier's account, the magician gives a spectator three large bands, each formed by joining the ends of a long paper strip. The magician then invites the spectator to divide each strip in half lengthwise, cutting along the strip until he or she returns to the starting point. The results are astonishingly varied. Cutting the first of the three bands produces two separate rings. When the second is cut, it forms a single band twice as long as the original. The third band becomes two interlocking rings.

What happens in each case depends on how the ends of the paper strips were joined. In the first case, there is no twist in the strip before its ends are joined. The second has a half twist, so it is a Möbius strip. The third is formed with a full 360-degree twist. Typically, the bands are so long that spectators don't notice the subtle difference in the number of twists. Nowadays, magicians often use the mysterious term "Afghan bands" when they refer to this trick.

The Möbius strip is an example of the distinctive geometric forms that play important roles in topology. In categorizing surfaces, topologists emphasize the properties of shapes that remain unchanged, no matter how much a shape is bent, stretched, twisted, or otherwise manipulated. Such a transformation of an ideally elastic object is subject only to the condition that nearby points on its surface remain close together in the transformed version. The condition effectively outlaws transformations

Arch of Janus by Charles O. Perry.

involving cutting and gluing, and it preserves certain features such as holes.

Like any topological object, a Möbius strip can take on an infinite variety of forms while still maintaining qualities such as its one-sidedness, which makes it unique in the family of topological surfaces. The Möbius strip's intrinsic malleability means that there is no shortage of ways to represent or depict the object. Some versions of the Möbius strip may be so wildly contorted that they disguise or hide the surface's true topological nature.

Since its discovery in the nineteenth century in a purely mathematical context, the Möbius strip has achieved a life of its own independent of mathematics—not only in magic but also in science, engineering, literature, music, film, and art. An object of continuing fascination, it has shown up in all sorts of unexpected settings: as monumental sculptures, synthetic molecules, knitted scarves, and glittering pendants; in designs on postage stamps and greeting cards; and as the ubiquitous symbol for recycling.

The recycling symbol typically appears as three bent arrows chasing one another around a triangle. The arrows are twisted so that if they were joined in a continuous ribbon, they would form a Möbius strip.

However, a close examination of the recycling logo as it appears in newspapers and magazines and on bottles, envelopes, cardboard cartons, and other containers reveals that there are two versions of the symbol. "There is a distinct topological difference between these two versions," says Cliff Long, a mathematics professor now retired from Bowling Green State University in Ohio.

The standard recycling symbol (left) has the topology of a Möbius strip. An alternative version (right), made up of three identically bent arrows in different orientations, has the topology of a one-sided surface whose edge is a trefoil knot.

> I enjoy the creation of an object whose shape appeals to me for one reason or another—mathematically, artistically, or just for fun.
>
> —*Cliff Long*

Familiar with the standard form of the recycling symbol, Long first noticed the alternative version on the front page of a local newspaper. It differed from the standard version in that all three of the bent arrows were identical in appearance, though each was turned so its tip pointed in a different direction. In the standard version, one of the three arrows is always bent differently, so the symbol doesn't have rotational symmetry.

Long recognized the alternative version as the surface that would result if you bent a piece of wire into a trefoil knot, joined the ends to make a closed loop, dipped this configuration in a soap solution, and examined the soap film that emerges clinging to the wire. Like the standard Möbius strip, this so-called spanning surface has just one side and one edge. However, if you were to lay a string along its edge until the ends met and pull the string taut, you would end up with a knot in the string.

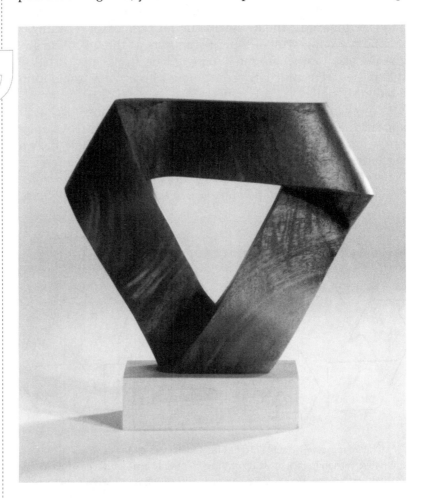

Möbius Band by Cliff Long.

If you did this with a standard Möbius strip, you would not get a knot.

How could the alternative version arise? One possibility is that someone drew just one bent, twisted arrow, made two copies of it, and put the three arrows in a triangle pattern, never realizing how the original symbol was meant to conform to the shape of a standard Möbius strip.

Long's interest in the artistic side of mathematics goes back more than thirty years. One of the first pieces he ever carved out of wood was a sculpture he described as "a bug on a band." Fashioned from a piece of white pine, this Möbius strip had a slot down the middle along which a knob of wood shaped like a ladybug could travel. One trip around the loop would bring the bug back to its starting point, but oriented upside down; a second circuit would bring it back to its starting point in its original orientation.

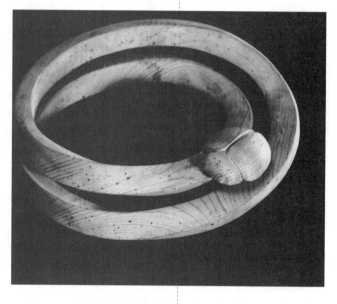

Bug on a Band by Cliff Long.

Over the years, Long has carved a variety of mathematical surfaces, including saddle shapes, knots, and geometric forms modeled on soap films. "I enjoy the creation of an object whose shape appeals to me for one reason or another—mathematically, artistically, or just for fun," Long says. At the same time, he adds, the carvings "have significantly improved my understanding of various surfaces—and the mathematics behind them."

Max Bill was a pioneer in sculpting Möbius strips. Starting in the 1930s, he created a variety of "endless ribbons" out of metal, granite, and other materials.

When Bill first made a Möbius strip, in 1935 in Zurich, he thought he had invented a completely new shape. The artist had been invited to craft a piece of sculpture to hang above a fireplace in an avant-garde house in which everything was to be electric. The idea was to add some sort of dynamic element to increase the attractiveness of an electric fireplace that would need to glow without a mesmerizing dance of flames. One possibility was a sculpture that would rotate from the upward flow of hot air. Bill's design experiments included twisting paper strips into different

configurations. "After many experiments, I came up with a solution that seemed reasonable," he noted in a 1972 essay.

"Not long afterwards, people began to congratulate me on my fresh and original interpretation of the Egyptian symbol for infinity and the Möbius ribbon," Bill recalled. "I had never heard of either of them. My mathematical knowledge had never gone beyond architectural calculations, and I had no great interest in mathematics."

Over the years, Bill nonetheless became a strong advocate of using mathematics as a framework for art. "I am convinced it is possible to evolve a new form of art in which the artist's work could be founded to quite a substantial degree on a mathematical line of approach to its content," Bill argued in a 1949 essay.

As a sculptor, Bill firmly believed that geometry is the principal mechanism by which we try to understand our physical surroundings and learn to appraise relations and interactions between objects in space. Mathematical art is best defined as "the building up of significant patterns from ever-changing relations, rhythms, and proportions of abstract forms, each one of which, having its own causality, is tantamount to a law unto itself," Bill insisted.

Bill went on to enumerate some of the perplexities that arise in mathematics and their implications for the artist. One such mathematical conundrum was what he described as the "inexplicability of space." As an example, he cited the Möbius surface as one "that can stagger us by beginning on one side and ending in a completely changed aspect on the other, and somehow manages to remain that self-made side." He cited other mathematical perplexities: the peculiar notion of the remoteness or nearness of infinity, depending on your perspective, and such counterintuitive, paradoxical concepts as parallel lines that intersect and limitations without boundaries. In tangling with such ideas, he maintained, mathematical thinking widens the scope of human vision, and art has fresh territories to explore.

Some of the same issues and themes that Bill tackled in his topological sculptures also were important to M. C. Escher. Escher, too, thought deeply about the puzzle of depicting infinity on a finite, flat surface and sought to capture infinity in visual images. In a famous 1963 engraving, Escher showed an endless procession of ants treading the looped surface of a Möbius strip—a finite number of ants on a twisted ladder that doesn't go anywhere yet never ends.

A variety of other artists have followed the twisting paths blazed by Bill, Escher, and other pioneers of mathematical art.

Traversing the route through the topological wonderland of the Möbius strip in his or her own distinctive way, each artist discovers anew the remarkable attraction and immense power of this enigmatic construct.

Charles Perry's monumental sculptures can be found in many cities around the world. A close look reveals that an astonishingly large proportion of them incorporate the Möbius strip in some way.

Perry first encountered the Möbius strip in 1958, when he was studying architecture at Yale University in New Haven, Connecticut. At that time the head of Yale's design department was Josef Albers (1888–1976), who had taught at the famous Bauhaus school of design in Weimar, Germany, during the early 1930s.

As an artist and a teacher, Albers had considerable influence on many American painters and designers. His own art generally consisted of simple, carefully constructed forms that could be used as frames to explore color and the ambiguities of visual and spatial perception. In such stark settings, color by itself could introduce deception and produce unpredictable effects. His explorations of color and shape appear in their purest form in a series of paintings called *Homage to the Square,* which Albers started in 1950 and continued into the 1970s. Each painting typically consists of nested, variously colored squares whose proportions are determined by a progression of mathematical ratios.

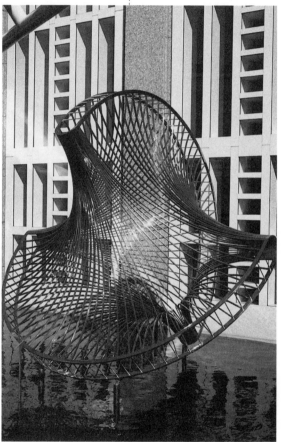

Early Mace by Charles O. Perry. The basis for this twelve-foot stainless-steel sculpture is the form created when the arcs on the face of a sphere are inverted, along the lines of the stitching on a baseball.

Albers believed strongly that students need to develop an understanding of materials through direct experience. His students built structures out of all kinds of unusual materials, from wire netting and matchboxes to phonograph needles and razor blades. They visited workshops where master craftsmen shaped metal, wood, and other natural and industrial materials into products. They learned the properties of materials and played with shapes. "I thought it was the most wonderful play in the world and went crazy with it," Perry recalls.

Born in 1929 in Helena, Montana, and raised from age eleven in Berkeley, California, Perry can't remember a time when he wasn't making something. At Yale he could indulge that passion without guilt, following up his lifelong curiosity about structures and materials. Inevitably, he ended up making and playing with Möbius strips.

As a practicing architect in San Francisco, Perry attracted attention for his graceful designs. He received the prestigious Prix de Rome in Architecture in 1964 and moved to Rome, where he took up sculpture. When he returned to the United States in 1977, Perry settled in Norwalk, Connecticut, and continued to create artworks, filling his studio with a wild jumble of geometric models—the concrete results of his evolving geometric visions, stepping from one shape and structure to the next.

Fascinated by the science of morphology, Perry refers to these transformations as "investigations of nature's variables." Strongly influenced by the notion expressed nearly a century ago in D'Arcy W. Thompson's book *On Growth and Form* that the designs of nature follow from the laws of mathematics, Perry applies the same idea to his geometric sculptures. "*On Growth and Form* was my bridge from real life to art," Perry explains. "Somehow the structures of shells, leaves, bubbles, and bones depicted in this book had far more natural beauty to me than did the sculpted bronze buttocks of a horse."

For Perry, the starting point is often a simple shape—an octagon, a cube, an ellipsoid, a pyramid, or a spiral. The question he asks is "What if?" The geometric musings that arise out of the question inevitably become a lengthy daydream, sometimes ending up solid, in the form of a twenty-foot structure elegantly posed in front of a major edifice somewhere in the world.

Perry's precisely engineered sculptures embody natural and logical progression. Some of them twist provocatively through the air or writhe powerfully across the ground in sinuous curves. In others, glistening ribs fan out in precisely orchestrated explosions of form, like multiple exposures capturing a dramatic metamorphosis of one strangely transparent shape into another. Motion and change are captured in gigantic skeletal structures fashioned from metal, mysteriously frozen in time, yet with interior and exterior, past and future exposed for all to see.

"Just as it sets my brain off to hear Bach, so the exquisite natural laws of form strike a chord in me," Perry says. "My pieces are ordered unto themselves, as if space had a set of rules similar to the counterpoint of music. They are, therefore, compositions of

Da Vinci by Charles O. Perry is an example of a geometric implosion.

the interplay of their own logic, the making process and their ambient."

In *Continuum*, installed at the National Air and Space Museum in 1976, Perry used the Möbius strip in a particularly convoluted guise to symbolize the universe. "In this case, the edge of the sculpture portrays the path of a star as it flows through the

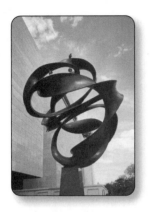

Continuum by Charles O. Perry. See plate 19.

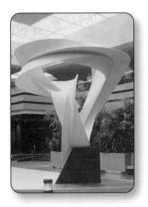

Enigma by Charles O. Perry. See plate 20.

center of the sculpture's 'black hole' into negative space-time and on again into 'positive' space," Perry explains.

Like many of his sculptures, *Continuum* reflects Perry's desire to explore the paradoxes and enigmas posed by scientific discovery and to express the solemn beauty of scientific ideas and the attendant quest for knowledge. "The difference between the artist and the scientist is that the scientist uses intuition to look toward finding the facts, while the artist uses intuition to intrigue others," Perry contends. "Thus, I remain here on the edge of science, encouraged to make these sculptures that attempt to speak of the orders of our universe."

Möbius surfaces appear again and again in Perry's sculptures, sometimes in barely recognizable form. At times a sculptural form can be so complex or its various surfaces so intertwined that it's difficult to identify whether the sculpture as a whole can truly be considered one-sided. Perry still finds topological puzzles written in the forms that have emerged, seemingly unbidden, from his creative mind. What happens, for example, when two Möbius surfaces come together, then intertwine?

"The breadth of expression possible with mathematics as a discipline is almost endless," Perry insists.

Soaring into the sky like a medieval cathedral, the twin towers of the structure known as Wilson Hall dominate the flat countryside surrounding the Fermi National Accelerator Laboratory (Fermilab) in Batavia, Illinois. Named for the physicist and accelerator builder Robert Rathbun Wilson (1914–2000), the building celebrates Wilson's vision and skill, not only as a scientist but also as an artist. As leader of the effort begun in 1967 to build a world-class proton synchrotron and founding director of Fermilab, Wilson played a central role in designing the entire laboratory. He was also widely recognized as an accomplished sculptor.

The Fermilab grounds feature several of Wilson's sculptures. One of the most striking examples is a tubular form eight feet in diameter, which sits in the middle of a circular pool atop the Norman F. Ramsey Auditorium in front of Wilson Hall. Having spent part of his youth on a Wyoming cattle ranch, Wilson was no stranger to the blacksmith shop, and he welded together the sculpture from three-by-five-inch pieces of stainless steel.

Wilson called the sculpture *Möbius Strip,* but it isn't the usual twisted rectangular strip. It's a three-dimensional version of this one-sided surface. The tube's cross section is essentially an equilateral triangle, and this triangle is rotated through 120 degrees along the tube. Wilson used the same Möbius form as the basis

for a gleaming bronze sculpture, called *Topological III,* installed near an entrance to the Science Center at Harvard University in Cambridge, Massachusetts.

It's possible to create a variety of three-dimensional variants of the Möbius surface. Thickening a standard Möbius strip so that

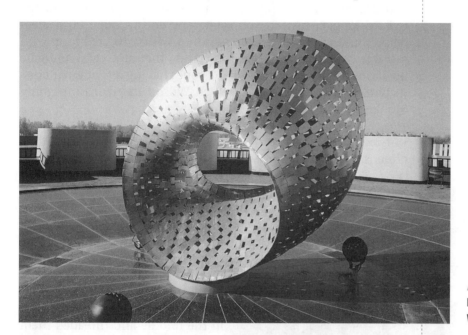

Möbius Strip by Robert Rathbun Wilson at Fermilab.

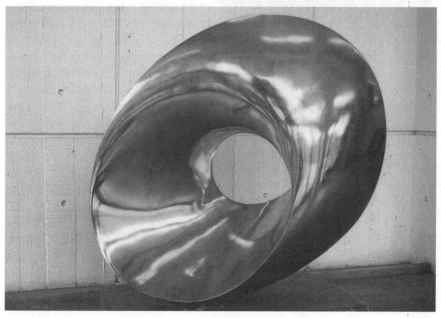

Topological III by Robert Rathbun Wilson at the Harvard Science Center in Cambridge, Massachusetts.

149

its edge becomes as wide as the strip's side produces a three-dimensional object with a square cross section. The resulting form has two edges and two faces.

You can construct a model of this surface from a length of foam rubber with a square cross section. After rotating one end 180 degrees, you simply fasten the ends together to form the twisted loop. If instead you rotate one end through 90 degrees before linking the ends, you wind up with a twisted loop with just one edge and one face! You can do the same twist-and-glue operation with a length of foam rubber having a triangular cross section to get the shape on which Wilson based his intriguing Möbius sculptures.

Wilson was not the only sculptor to experiment with three-dimensional variants of Möbius strips. Such forms appear in the work of Charles Perry, for example. Moreover, in the early 1980s, English sculptor John Robinson independently discovered and created several versions of the same three-dimensional form that had inspired Wilson.

"I prepared one hundred equilateral triangles, each with a hole in the middle and threaded them onto a ring," Robinson recounts. Following the faces around the loop, he saw that he had a surface with three edges and three bands. "By changing one of the edges to meet another, I found I was left with only one edge and one band," he says. "It was a magical moment when I realized that I had created *Eternity*." Polished bronze versions of *Eternity* can be seen in Canberra, Australia, and at the Center for Physics in Aspen, Colorado.

Born in London, England, in 1935, Robinson came to sculpture at age thirty-five. When he was sixteen, he had run away from a stultifying experience at an Eng-

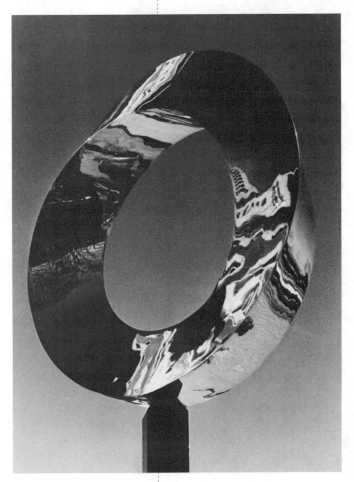

Eternity by John Robinson.

lish boarding school and joined the merchant navy. A stop in Australia led to a lengthy sojourn in that country, where he traveled and worked at various jobs, from policing to cattle handling in the outback, finally becoming a sheep farmer. His belated success at molding modeling clay into likenesses of his friends encouraged the leap to full-time sculpting, with a return to England.

Over the years, Robinson has explored a variety of mathematical themes in his series of "symbolic" sculptures. Several involve one-sided surfaces. His *Immortality* bronze, for instance, is a Möbius band twisted into a trefoil knot. Another sculpture, named *Journey*, is at Macquarie University in Sydney, Australia. This tall, angular form, made of polished stainless steel, is derived from the so-called Brehm model of the Möbius strip.

Immortality by John Robinson. This sculpture features a Möbius strip in the form of a trefoil knot.

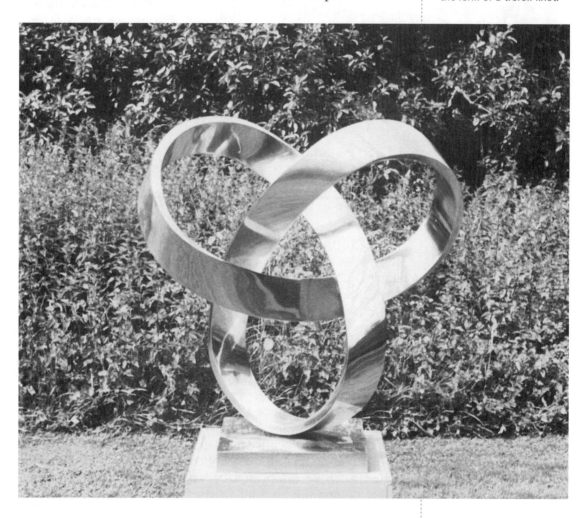

John Robinson's *Journey* sculpture (left) is an interpretation of the so-called Brehm model of a Möbius strip, which can be constructed from three identical polygonal pieces (below).

One of the most intriguing interpretations of the Möbius strip occurs in the work of Benigna Chilla, an artist at Berkshire Community College in Pittsfield, Massachusetts. Chilla has focused on hidden images: planar patterns that are visible only from certain angles. Typically, an artwork consists of several layers: a painted canvas backdrop combined with a number of transparent fabric screens, each printed with its own pattern, hung in front of the canvas.

What a viewer sees depends on the viewer's eye level and distance from the combined surfaces. By moving forward or backward or from side to side, the viewer interacts with the piece, experiencing an evocative overlapping of color and pattern and a three-dimensional illusion of ephemeral form in space. "New formations can be discovered by varying the distance from the object or just the amount of time spent interacting with it,"

Chilla says. "The surfaces, as concrete as they are alone, together convey images with constantly changing focus and appearance."

In 1993 Chilla created *Interrupted Möbius,* a three-layered artwork six feet high and twenty-four feet wide, which extended one foot from the wall when it was installed. It featured equally

Two views of *Interrupted Möbius* by Benigna Chilla.

> "The application of geometry pervades and forms the visual world we move through.
>
> —*Benigna Chilla*

spaced, horizontal undulating lines in seven contrasting columns—a pattern repeated on each of the three surfaces. Optical interference between the patterns printed on the layers produced an eye-popping moiré effect, creating a visual illusion of ebb and flow and wavelike motion—like electromagnetic waves undulating into space. The metaphoric reference in the artwork's title to the Möbius strip, in its guise as an endless loop, emphasizes how the wavy swaths could go on forever.

"The application of geometry pervades and forms the visual world we move through," Chilla maintains. "It allows us to remember and reconstruct formations and gives artists the freedom of scale and combination of different dimensions."

Fabric also plays an important role in the Möbius creations of Shiela Morgan, a spinner and weaver in the town of Lighes Hill in New South Wales, Australia. Morgan first encountered the Möbius strip many years ago when she was in her twenties. Her vivid impressions of the Möbius strip's remarkable one-sidedness and the equally fascinating properties of its topological kin, the Klein bottle, stayed with her. That eventually led her to investigate ways of weaving these surfaces out of ribbons.

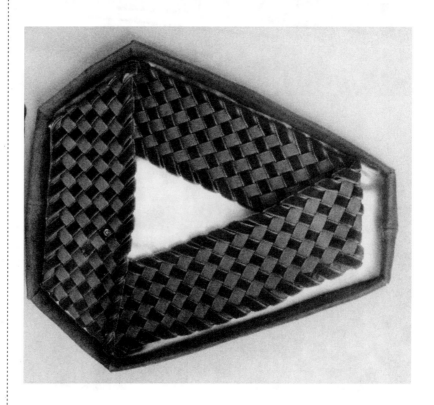

Shiela Morgan can weave a Möbius strip from a single ribbon. A small bead marks the point where the ribbon's ends meet.

The inspiration for her invention of topological weaving came when she saw a jumper with a complex pattern that had been made by knitting one surface through the stitch holes of another knitted surface. "I realized that a Klein bottle could be brought into being by the same method," Morgan says. "The integrity of the fabric is not compromised." After that insight, the key step in weaving threads or ribbons into a Möbius strip or a Klein bottle of given dimensions was her discovery of an ingenious diagonal weaving technique to accomplish the feat.

Consider the usual way of making a Möbius strip from a long strip of paper by joining the two short ends after giving the strip a half twist. In Morgan's weavings, ribbons pass back and forth and over and under at forty-five degrees to the sides of the desired rectangular strip to produce a Möbius surface. Each ribbon closes upon itself exactly, and it is always reversed when it crosses itself.

So, relative to the sides, a woven ribbon of finite width forms little diamonds as it intersects itself. Morgan calls each such diamond a mesh space. She determines the weaving "frame" by specifying the width and length of the desired rectangular strip in

In weaving a Möbius strip, Morgan may use several ribbons to fill out the surface.

155

terms of the number of mesh spaces across the short side and along the long side. Before she tried it with fabric, paper models demonstrated to her that different proportions of mesh space widths and mesh space lengths require different numbers of ribbons to weave the whole figure.

To aid and explain her weaving efforts, Morgan compiled tables that show the number of mesh spaces required to weave different topological objects—a torus, a twisted torus, a Möbius strip, and a Klein bottle—with different proportions. Remarkably, the numbers in the table appear to represent unsuspected symmetries of the various surfaces and exhibit a complex pattern that involves primes.

"It is my reasonably confident hope that someone with more skill than I have will be able to discern a formula from that structure which will be used to economically explicate the primes," she ventures. Indeed, her work has attracted the attention of some mathematicians who are intrigued by the numerical patterns and apparent symmetries that Morgan has discovered.

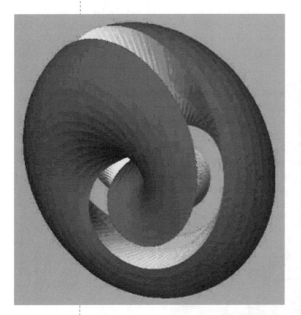

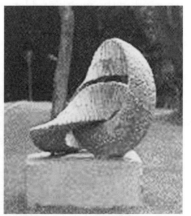

A cut that makes a 180-degree twist during its travel around a ring creates a "Möbius" space, as seen in this computer-generated illustration (above). Sculptor Keizo Ushio stands beside a stone sculpture that features such a cut (bottom right). A cut that makes a 360-degree twist splits a stone torus into two interlocking parts (top right).

Japanese sculptor Keizo Ushio has devised his own, spectacular way to create a Möbius surface. He starts with a massive granite ring having a hole width equal to the thickness of the ring. He then drills into the granite to slice it longitudinally, not the way you would normally slice a bagel to get two halves, but with a cut that makes a 180-degree twist during its travel around the ring. If he makes a 360-degree twist, the twisting cut separates the torus into two equal, but interlocked parts.

The examples in this chapter represent just a sampling of the numerous artistic efforts that have been devoted to the Möbius strip. Indeed, new designs based on this motif continue to appear every year.

The amazingly diverse ways in which artists have depicted or incorporated a Möbius surface in their work offer potent testimony to the power of the mathematical notion of a topological form. Such a form retains its essential character—in the Möbius strip case, its one-sidedness—no matter how much the figure is deformed, just as long as it isn't punctured or torn. In effect, topology offers a vast playground for the creative reconfiguration of fascinating shapes.

8 Minimal Snow

In the gray light of a wintry day, the giant, sleekly curved figure reclining on its icy couch appeared ready for slumber. From some angles, the snow sculpture resembled a strangely contorted bell; from other angles, a piece of surreal plumbing or an ancient urn worn smooth by time. Its curious system of tunnels echoed the work of British sculptor Henry Moore.

The setting was the ski resort town of Breckenridge in the Rocky Mountains of Colorado. The occasion was the 1999 International Snow Sculpture Championships. In this annual event held in January, teams from around the world compete by carving sculptures out of twelve-foot-high, twenty-ton blocks of densely packed, machine-made snow. In 1999 one team, headed by Helaman Ferguson, dared to put forward a purely mathematical form as its entry in this prestigious competition.

The chosen shape was the central portion of the Costa surface, named for the Brazilian mathematician Celso J. Costa, who had discovered the equations for this particular figure in 1983. The Costa surface belongs to the family of geometric shapes known as minimal surfaces.

A minimal surface is one for which any distortion, no matter how small, increases its area. A soap film serves as a convenient physical model of such a mathematical surface. A ring dipped into a basin of soapy water, for example, comes out spanned by an iridescent film in the form of a thin, flat disk. Any other ring-bounded surface would have a larger area, even if it is just barely wrinkled. Mathematically, a flat disk is the minimal surface having a circle as its boundary.

Invisible Handshake. See plate 21.

A loop twisted into some other configuration and dipped into a soap solution emerges with its own glistening, contorted soap film. Each one corresponds to a bounded minimal surface. The endless variety of twisted loops and frameworks that one can fashion from wire or some other material hints at the bounty of minimal forms available to a scientist or an artist keen to study or mimic nature's stinginess and elegance.

At every point, a minimal surface either is flat, like a disk, or has a saddle shape. In the latter case, its curvature resembles that of a potato chip, which typically starts out as a flat, thin slice of moist potato. As a chip dries during frying, it shrinks. Minimizing its area, it curls into a saddle shape.

The disklike soap film clinging to a ring emerging from soapy water is part of an idealized mathematical object called the plane. In a sense, the plane is like a giant soap film that extends so far over the horizon that its boundary can't be seen. In fact, it is an example of a minimal surface that is infinite in extent and unbounded, rather than bounded.

Until the 1980s, mathematicians knew of only two other unbounded minimal surfaces that don't curl around to intersect themselves. Two rings dipped in a soap solution can emerge with a soap film connecting the two rings, creating a minimal surface that looks like a pinched cylinder smoothly taken in at its waist. This hourglass form is the middle piece of an unbounded minimal surface called a catenoid. Its two open mouths, one at each end, stretch out infinitely far into space. Mathematically, a catenoid can be defined in terms of the curve formed by a hanging chain fixed at both ends. This chain represents a segment of a mathematical curve called a catenary. Rotating it around a horizontal straight line delineates the "hourglass" section of a catenoid.

A loose coil of wire twisted into the form of a helix supports a spiraling soap film. If a person were to slide along an infinitely long helix, it would whirl the plummeting rider along its surface into a dizzy spin. This unbounded minimal surface is called a helicoid.

Topologists had reasons to suspect that the plane, catenoid, and helicoid were not the only unbounded minimal surfaces that don't intersect, or fold back on, themselves. The trouble was that potential candidates for this highly selective minimal-surface hall of fame are typically expressed in complicated equations that mask more than they reveal. Determining from the equations whether a surface folds back on itself was a particularly vexing problem.

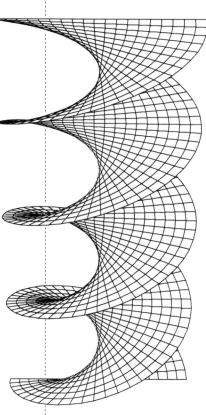

A catenoid (left) and a helicoid (right).

As a graduate student in mathematics, Celso Costa found inspiration for his geometric studies in the sweeping curves of skirts and hats worn by dancers in Rio de Janeiro's famous Carnival. He discovered a particularly promising set of equations and, in his thesis, proved that these equations represented an unbounded minimal surface threaded by several tunnels. It wasn't clear from the equations, however, whether Costa's newly discovered surface intersects itself.

In 1983 David Hoffman and Bill Meeks, then at the University of Massachusetts, took up the quest for an answer. Mathematical clues already hinted that the surface contained a plane and a pair of catenoids that somehow sprouted from the figure's center, but it was hard to see what was happening in the middle. For assistance in his search, Hoffman turned to James Hoffman (no relation), a graduate student at the university who happened to be working on a new computer program and language for generating graphic images. Together, they spent hours tinkering with the equations and the software necessary to bring the surface to life on a computer screen, all in the hope of catching Costa's surface in intimately revealing poses.

The first portraits presented a mathematical surprise. The Costa surface appeared not only to be free of self-intersections but also to have a high degree of symmetry. "Extended staring," in Hoffman's words, led him to conclude that the surface consisted of eight identical building blocks that fit together to make up the whole figure—a pattern not evident from the bare equations themselves. In an early triumph for computer visualization in mathematics, this striking symmetry allowed Hoffman and Meeks to demonstrate conclusively the absence of self-intersections. The Costa surface could now join the exclusive company formed by the plane, catenoid, and helicoid.

Computer visualization allowed the entranced mathematicians to explore the surface graphically—in effect, to clamber about and map its graceful contours and intriguing tunnels. Many views later, the true form of this beautiful minimal surface began to emerge. The figure had the splendid elegance of a gracefully spinning dancer flinging out her full skirt so it whirled parallel to the ground. A gentle wave ruffled the skirt's hem. Two holes pierced the skirt's lower surface and joined to form a tunnel that swept upward. Another pair of holes, set at right angles to the first pair, led from the top of the skirt downward into a second tunnel.

Computer-generated diagram of the Costa surface.

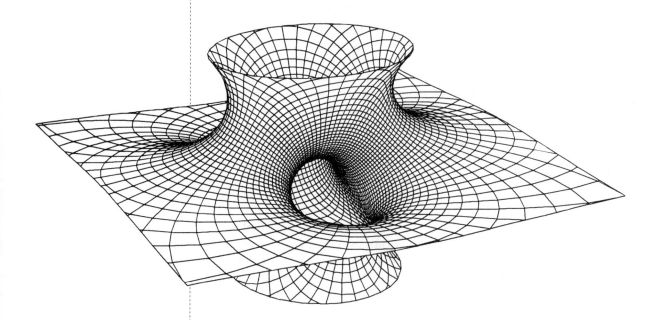

The group learned that the Costa surface is just one of an infinite number of such unbounded minimal surfaces, each with a different number of tunnels penetrating the form's interior and opening up into wide mouths, like trumpet bells.

The Costa surface and its siblings proved to have immense aesthetic appeal. Attracted by James Hoffman's colorful, computer-generated images, mathematicians and artists alike responded strongly to these graceful shapes. Computer graphics showed its value in opening up for artistic exploration a hitherto unseen realm of geometric forms.

One of those who fell under the Costa surface's spell was Helaman Ferguson (see also Chapter 2). In 1994, officials at the Maryland Science Center in Baltimore invited him to create a mathematically accurate model of the Costa surface for an exhibit about modern mathematics. Ferguson envisioned fabricating a model that would be ten feet tall—one that children could touch and even slide through. "Wouldn't you like a seat-of-the-pants understanding of minimal surfaces?" Ferguson asks. "You would get to feel a minimal surface that doesn't go pop when you touch it."

To learn what he would need to know about the surface, Ferguson started on a modest scale by fashioning a sixteen-inch-tall version out of bronze and aluminum, then completing a fiberglass model that was three feet in diameter. The next challenge he set for himself was to carve a three-foot-tall Costa surface directly out of a gleaming chunk of white Carrara marble. For the project, Ferguson used special equipment that could translate geometric forms on a computer screen directly into instructions on how much material the sculptor had to chip away at any point on a stone's surface to reveal the object beneath.

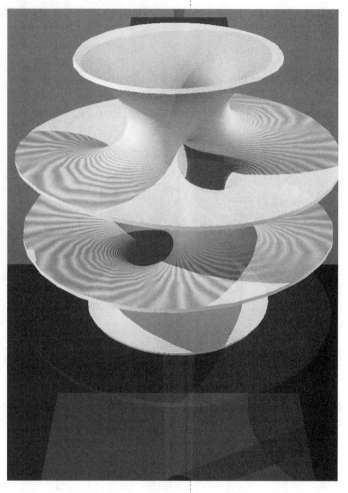

Stewart Dickson's rendering of a member of the Costa surface family.

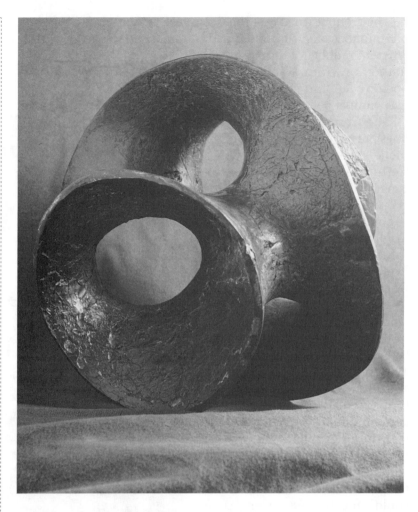

A Costa surface fashioned from bronze by Helaman Ferguson.

"With this exotic studio apparatus, I can learn new surfaces, mathematical forms that have never before seen the light of day, never before been touched by human hands," Ferguson contends.

Getting the right equations to prime his apparatus wasn't a simple matter, however. Using Costa's original equations for the surface, Hoffman and his colleagues initially took many hours to generate even a single graphic image of the form. To speed up the process, Ferguson got some help from Alfred Gray (1939–1998), an expert on differential geometry. Gray had found a way of rewriting the equations in terms of a different mathematical expression. Using this new formula and a computer program called Mathematica, Gray could produce images of the Costa surface from just a few lines of instructions in minutes.

Ferguson then adapted Gray's formula for use with the relatively modest computer that provided data to his sculpting apparatus. Working with his son Samuel, then a graduate student in mathematics at the University of Michigan, Ferguson refined the computer algorithm and wrote a program for speedily computing the parameters defining the figure. The new program took just a few seconds to produce a picture.

This meant that Ferguson could carve the Costa surface without waiting interminable intervals for his computer to calculate the necessary distances. Interestingly, Ferguson's desire to do this particular sculpture had resulted in the development of new mathematics—a new way of mathematically representing the Costa surface.

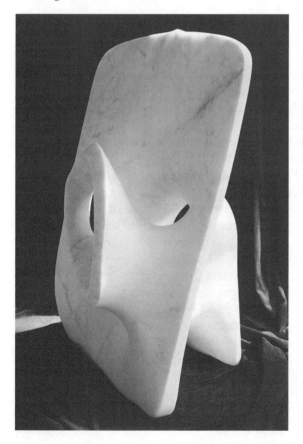

Helaman Ferguson created this bronze version of the Costa surface as a memorial to Alfred Gray.

A marble Costa surface by Helaman Ferguson.

In a sense, each Costa surface that Ferguson created is the same object. To be a minimal surface, the vicinity of every point on the surface must have the proper saddle shape. So the basic form is set. The artist, however, has to make decisions about how to present this precisely defined object. The Costa equations specify a form of infinite extent, so the sculptor must decide where to truncate it to create a visually appealing shape. More artistry arises from the choice of materials and techniques and the selection of scale and orientation.

Intriguingly, Ferguson's sculptures of the Costa surface in bronze and marble represent the culmination of an exploration that started more than two centuries ago with scientific observations of soap films in nature. In the years that followed, mathematicians developed equations to describe such surfaces. Costa probed those generic equations to uncover a novel minimal surface no one had seen before. Inspired by this form, Ferguson's creations completed a cycle back to nature, making concrete what was initially just equation and computer-generated picture.

It was Stan Wagon, a mathematician at Macalester College in St. Paul, Minnesota, who persuaded Ferguson to tackle the Costa surface in snow. In 1998 Wagon happened to witness that year's edition of the Breckenridge International Snow Sculpture Championships and came away immensely impressed with what he had seen. He decided that a snow sculpture inspired by mathematics could succeed in this setting, and he set about selecting a design and assembling a team to enter the competition.

When Wagon first approached Ferguson with the idea of submitting a proposal to the by-invitation-only contest, Ferguson was initially skeptical and reluctant to get involved. "I do granite; I don't do snow," Ferguson insisted. "My idea of mathematical sculpture combines timeless conceptual content with timeless-as-possible materials, such as billion-year-old granite," he said. "Snow? Here today, evaporated tomorrow."

Ferguson's interest increased, however, as he and Wagon began to discuss which of Ferguson's many sculptures would look best in snow. The discussion forced Ferguson to think about what snow and stone have in common. Stone can carry weight. It has compressive strength. On the other hand, it can't be stretched very much; it has significantly less tensile strength than compressive strength. Hence, it's possible to make an arch out of stone but not an unsupported ceiling. Snow has similar characteristics. An igloo is a system of arches, and a minimal surface can be thought of in terms of arches.

> It seemed that a Costa form could be carved in snow, and without special equipment.
>
> —*Helaman Ferguson*

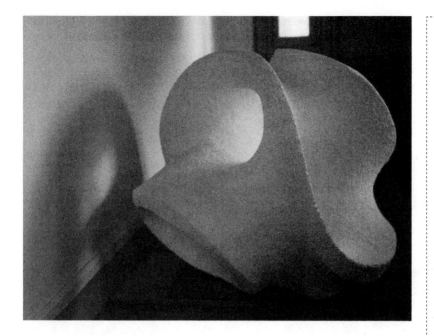

A Costa surface carved by Helaman Ferguson out of Styrofoam hints at the appearance of one made from snow.

Technically, every point of a minimal surface has what mathematicians call a negative Gaussian curvature—where the surface curves up in one direction and down in a perpendicular direction, like the seat of a saddle. In effect, any point of a minimal surface is the keystone of a cluster of arches. So, if the object to be sculpted were a Costa surface, could compacted snow be carved as thinly as marble can, to create a seemingly delicate sculpture that still manages to support itself?

Ferguson wanted to test the feasibility of carving snow into the required shape, but there was a dearth of snow in the month of May in Maryland, where Ferguson lives. He ended up retrieving several cubic feet of high-consistency snow—actually, shaved ice—dumped by a Zamboni ice-smoothing machine outside a local rink. On a warm afternoon, using a giant kitchen spoon and spatula, Ferguson carved a minimal-surface form with several tunnels. As it melted in the late afternoon sun, he watched its walls get thinner and thinner. The snow sculpture maintained its basic structure, however. "It seemed that a Costa form could be carved in snow, and without special equipment," Ferguson says.

Wagon and Ferguson formulated a proposal to create a sculpture based on the Costa surface with the title *Invisible Handshake*. The title refers to the fact that the intertwining tunnels of the Costa surface roughly correspond to the orientations of two hands about to grasp each other. The Costa surface itself represents the

empty space between the hands at the instant before the consummation of a handshake.

This interpretation gives the mathematical surface a distinctly human touch. Two people can each extend a hand through an opening in the surface as if to shake hands, and only the thin material of the sculpture keeps their hands from grasping each other in a true handshake. Each can touch the figure's walls but not the other hand.

The Ferguson-Wagon proposal to create *Invisible Handshake* was accepted. The 1999 international competition featured fifteen four-member teams representing ten countries. The team consisting of Ferguson, Wagon, and Macalester professor Dan Schwalbe and student Tamas Nemeth was the only group in the contest with no prior snow-sculpting experience.

The snow-sculpting team of (from left to right) Stan Wagon, Tamas Nemeth, Helaman Ferguson, and Dan Schwalbe stands in front of the block of snow that would, after 4½ days, become *Invisible Handshake*.

To work out the technical details of carving snow into the Costa surface, Ferguson got permission from the manager of an ice arena to get additional Zamboni snow at various times between summer and the competition date in January. The technical details included determining the types of tools to use, what sort of clothing to wear for the anticipated long days of snow carving under potentially blizzard conditions, and how best to coordinate the work of team members who are mathematicians, not sculptors.

The anticipated conditions would be tough. At nearly ten thousand feet above sea level the mountain air is thin, and biting blizzard winds are a constant threat. The packed, manufactured snow is hard (five times more dense than natural snow and about half as dense as ice), and the contestants have a strictly limited amount of time available to remove the excess material. They can use only hand tools and are not allowed to incorporate any sort of support structure.

Ferguson could not rely on a computer to help him shape the snow sculpture. "Fortunately, I had learned all I needed to complete this piece from my prior experience carving the various other Costa surfaces," Ferguson remarks. His assistants, though inexperienced in sculpting, were all mathematicians and understood the language of algorithms and differential geometry. "Our common mathematical language helped tremendously in my communicating my prior experience in carving the other Costas," Ferguson says.

Remarkably, it all came together in 4½ days of intensive labor. On the first day, the team removed enough snow to produce a rough sphere. The second day's labor was devoted to drilling the figure's two main tunnels. By the end of the competition's third day, the rough Costa shape was visible, just in time for the arrival of a class of kindergarten children, who crawled and slid along the surface's intriguing tunnels. The

At work on *Invisible Handshake*.

team continued to shave the outside walls until they were only four inches thick. Altogether, about fourteen tons of snow were removed from the original block to reveal the ultimate shape.

"It was a real thrill to learn the rudiments of sculpting as we progressed," Wagon observes. "Our piece was ugly at first, slowly became less ugly, and then emerged all at once in all its curvaceous glory."

The choice of tools—a four-foot logging saw, a large wood chisel, masonry tools, and small hatchets and shovels—proved critical. An auger designed for drilling holes through three feet of ice for fishing turned out to be particularly effective for removing large quantities of material during the early stages. Its razor-sharp blades readily chewed through the snow, performing much the same function that diamond drill bits do in carving stone.

The final day of the competition was warm, bringing with it the threat of melting. Although it didn't win a prize, the Costa surface held up nicely. A week after the event, the other sculptures had all lost detail, and one of them had even imploded. The only significant change in *Invisible Handshake* was that its walls had become thinner still.

Ferguson was used to creating sculptures from granite, marble, and other materials in the expectation that they could last for millennia. His creation in snow, in contrast, melted away in days,

The completed *Invisible Handshake* at night.

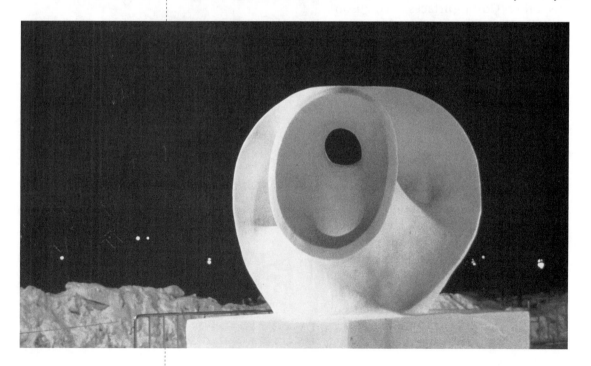

remaining only in memory. Nonetheless, Ferguson prized his newfound knowledge of the surprising structural strength of negative Gaussian curvature as a sculptural fabric, even when the material is as flimsy as snow. The power of a minimal surface—both structurally and aesthetically—resides in this curvature.

A year later, Wagon was back with a new team and a new design for a snow sculpture—again based on a minimal surface.

Wagon and several colleagues conduct a summer program in the Breckenridge area called "Rocky Mountain Mathematica," where they teach courses on how to use Mathematica software. In the summer of 1999, one of the participants was John Bruning of Tropel Corporation in Fairport, New York. Knowing Wagon's interest in sculpted mathematical forms, Bruning showed him a postcard of an elegant, swooping structure crafted from wood by Robert Longhurst. It was just the sort of design that Wagon had been looking for, and he immediately telephoned Longhurst, an experienced wood and stone carver, to see if he would be willing to sculpt in snow.

Arabesque XXIX by Robert Longhurst. See plate 22.

Trained as an architect, Longhurst has been carving since 1976. His studio is on a farm in the Adirondack Mountains, near Chestertown, New York. Longhurst's patiently crafted, sinuous, abstract sculptures emerge from his imagination rather than from mathematics, even though they often bear an uncanny resemblance to the types of shapes that soap films or minimal surfaces can display. "Curvilinear works, whether they fall into the categories of art, architecture, or design, have always held a fascination for me beyond that of straight lines," Longhurst says.

Loop IL by Robert Longhurst.

Creating each piece is a demanding, labor-intensive, time-consuming process. Longhurst typically begins with a conceptual sketch, which he then translates into a wax, wire, or aluminum-foil model. Once he is satisfied with the result, he selects an appropriate type of wood, carefully kiln-dried and seasoned to give the material the stability necessary for an envisioned sculpture's delicate passages and ornate curves. Longhurst's main tool is not a chisel but a die grinder whose carbide bit spins at twenty-two thousand rotations per minute, enabling him to cut away wood with great precision on both interior and exterior surfaces.

Over the years, Longhurst has developed a distinctive, recognizable style. Lately he has been stretching his artistic vision to encompass works that incorporate granite. Using stone now allows him to create pieces that can survive outdoors.

Wagon, Longhurst, and Schwalbe considered a number of possible designs for a snow sculpture but soon settled on the form depicted on the Longhurst postcard—a piece that Longhurst had titled in his usual understated fashion *Arabesque XXIX*.

Heart of Stone by Robert Longhurst.

172

In this particular case, Longhurst had taken his inspiration from mathematics.

Longhurst had learned about this intriguingly curved shape from Nat Friedman, a mathematician and sculptor at the State University of New York in Albany. When visiting David and James Hoffman at the University of Massachusetts, Friedman had seen a video they had made depicting variants of a mathematical form called Enneper's surface. Friedman snapped photos of frames from the video and sent them to Longhurst. Fascinated by these shapes, Longhurst ended up fashioning a graceful, twelve-inch-high model of one that he found particularly appealing from bubinga wood.

Enneper's surface is an example of a minimal surface discovered in 1864 by Alfred Enneper (1830–1885), a mathematics professor at the University of Göttingen in Germany. The equation defining the surface looks very simple, but the highly symmetric, complicated form is hard to visualize because it curls around and, unlike the Costa surface, intersects itself.

Two views of the central portion of the infinite Enneper minimal surface, showing the surface just before (above) and just after (left) its lobes intersect.

173

The team's design effort involved the use of computer graphics to decide where to truncate what is mathematically an infinite surface, and how to orient the result to create an aesthetically pleasing sculpture. "Truncating the surface just before the self-intersections leads to a very pleasing design," Wagon says. "It is very open and invites the viewer to explore it."

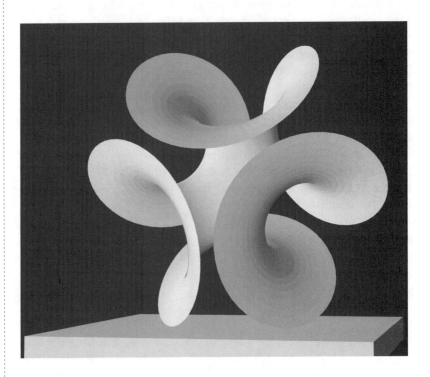

Dan Schwalbe's design, generated and rendered using Mathematica software, for *Rhapsody in White*, based on Longhurst's *Arabesque XXIX* version of a variant of the Enneper minimal surface.

Adding Macalester student Andy Cantrell to the team and using Bruning as a nonsculpting team manager and photographer, Wagon, Longhurst, and Schwalbe submitted a proposal just before the September 1 deadline. Seventeen designs were chosen from twenty-four proposals submitted from around the world. Wagon's team made the cut and arrived in Breckenridge on January 16, 2000, to work on a small practice block in preparation for the snow-sculpting event.

Having learned from the 1999 effort, the team came prepared with a variety of hand tools, from the ice-fishing auger that had been so helpful the previous year to various chippers, axes, and shovels. Longhurst also brought along some specialized tools that he had devised to help with shaping the snow. Details mattered. Cantrell spent a day and a half toward the end crawling up and down the snow sculpture removing little bits of dirt from exposed

surfaces and patching those spots with snow to give the sculpture a crisp, clean finish.

"It all went quite smoothly," Wagon notes. "This snow is very strong, and I think some of the other teams underestimate its strength." Wagon named the result *Rhapsody in White*, reflecting the sculpture's graceful curves, dramatic overhangs, and harmonious repeating pattern in the swooping clarinet solo

> "Truncating the surface just before the self-intersections leads to a very pleasing design. It is very open and invites the viewer to explore it."
>
> —*Stan Wagon*

Robert Longhurst working on the snow sculpture at night.

that starts off George Gershwin's musical composition *Rhapsody in Blue*. About ten thousand people came to view the results on the final weekend, and many more showed up earlier in the week to see the snow sculptors at work.

The team captured second place in the elite international competition, losing only to a team from Russia that had created a soaring tribute to the new millennium. The sculpture of Enneper's surface also received two other prizes. It was voted the Artists' Choice Award by the participating snow sculptors and the People's Choice Award by the event spectators. "It is very satisfying to use a purely mathematical object and sculpt it in a way that looks beautiful," Wagon says.

A week after the competition, Enneper's surface was still standing in its pristine glory. "Our piece had no fine detail—no positive curvature anywhere," Wagon notes. "There was no detail to melt out or to get overwhelmed by new snow."

In his award acceptance speech, Wagon remarked that even for mathematicians, true understanding can be obtained only by interacting with a geometric form in a truly three-dimensional way. "This is what snow allows us to do," he added. "In a very

The snow-sculpting team of (from left to right) John Bruning, Andy Cantrell, Dan Schwalbe, Stan Wagon, and Robert Longhurst poses with the completed, award-winning *Rhapsody in White*.

short period of time and with a minimum of tools, we can sculpt a complicated shape and so learn more about it. It's a glorious opportunity and tremendous fun."

More than a century earlier, mathematicians fascinated by the shapes and curves of minimal surfaces had drawn pictures, constructed models, and written manuals on how to visualize these forms. They commissioned sculptors and craftsmen to create elegant wooden and plaster models. Whether rendered in stone, wood, or snow, the sculptures of Ferguson and Longhurst, along with the creations of other sculptors such as Brent Collins, are now bringing that sense of mathematical wonder to a larger audience.

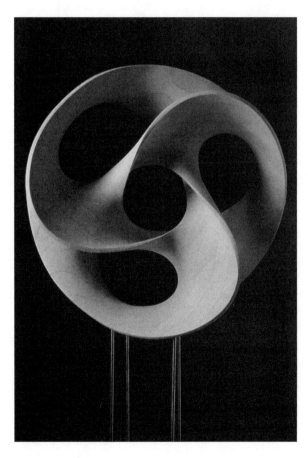

Saddle Trefoil by Brent Collins.

9　Points of View

A fractal stone print by Nat Friedman.

Arectangular slab of polished granite gives an impression of solemn immutability. With its straight lines and smooth surface, it is an elegant, humanmade artifact meant to stand as a monument or serve as skin for a sleek skyscraper. Breaking a granite slab produces jagged fragments. The fractal geometry of the granite's fractured edges bears witness to the raw stone's natural history and contrasts sharply with the classical geometry of its manufactured facade.

In working with stone, a sculptor inevitably confronts breakage. When mathematician and sculptor Nat Friedman first looked at the shards of a broken granite slab, he saw something more than an unfortunate accident. Friedman had become aware of how twentieth-century sculptors such as Henry Moore had opened up the solid form to create space so they could revel in the interplay of form and light created by that opening. Friedman envisioned how he could create space by leaving gaps between the fragments when he reassembled

a broken slab. He then developed a technique for making prints from the granite assemblage.

The resulting images, made with deep-blue or black ink on sheets of thin, porous paper, leave a vivid impression of jagged lightning bolts slashing across an otherwise dark sky. Some resemble drawings of crumpled coastlines edging unknown land-masses on an explorer's map. The stark contrasts in form and color tease the eye.

"Visual thinking leads to seeing that mathematical forms can also generate art forms," Friedman maintains. An artist can look at a mathematical shape and envision unlimited possibilities, even from a shape as seemingly simple as a tetrahedron, a trefoil knot, a Möbius strip, or a fractal surface. An artist can transform a mathematical idea into an evocative artwork.

The works of artist Sol LeWitt represent one approach to cap-

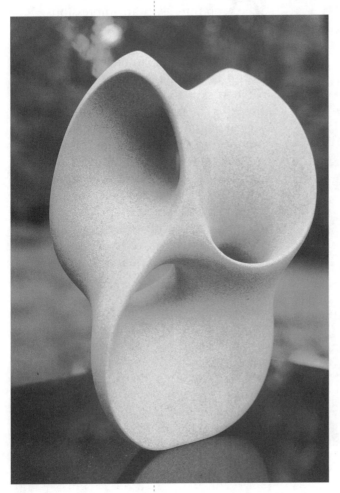

turing mathematical logic in visual form. Born in Hartford, Connecti-cut, in 1928, LeWitt has often fea-tured geometric and combinatorial themes in his numerous creations. His frequent use of simple grids and modular structures and his choice of a palette of bright primary colors plus black and white reflect a strong back-to-basics approach to design.

"I will refer to the kind of art in which I am involved as conceptual art," LeWitt once wrote. "In concep-tual art the idea or concept is the most important aspect of the work. When an artist uses a conceptual form of art, it means that all of the planning and decisions are made beforehand and the execution is a perfunctory affair. The idea becomes a machine that makes the art."

A recent "shell" sculpture carved by Nat Friedman out of limestone was inspired by the graceful, geometric shapes of seashells.

Four-Sided Pyramid by Sol LeWitt.

That approach is evident in many of LeWitt's sculptures, paintings, and drawings. His *Four-Sided Pyramid,* installed in 1997 in a sculpture garden at the National Gallery of Art in Washington, D.C., consists of concrete blocks precisely stacked to form a stark, eye-catching pyramid. In bright sunlight, the blindingly white blocks and deep shadows play curious visual tricks on the eye as the viewer gazes at the structure from different angles.

LeWitt's large-scale drawings, painted directly on walls, represent the logical outcome of his desire to create artworks that are as two-dimensional as possible. For the National Gallery's *Wall Drawing No. 681 C,* for instance, LeWitt divided a wall's surface into four panels, each painted with broad stripes oriented in a different direction. Another example of his wall drawings features large triangles that fit together to suggest a pyramid.

Many of LeWitt's earlier artworks were explicitly combinatorial. In 1973 he composed *Straight Lines in Four Directions and All Their Possible Combinations.* This study consists of a grid of fifteen squares, each inscribed with one or more horizontal, vertical, and diagonal lines in different orientations.

Simple mathematical recipes for creating geometric figures also can inspire artistic endeavors. One way to describe a geometric figure is in terms of the path generated by a moving point. For example, instead of defining a square as a four-sided polygon with equal sides and angles, one can call it the path generated by the following rule: Go in a straight line for a distance s, turn ninety degrees to the right, and repeat until the path returns to its starting point.

Using the computer language LOGO, children can produce a list of commands to govern the motion of a "turtle" and trace out a geometric track on a computer screen. Indeed, they can program such a turtle to generate any one of an endless variety of patterns. Mathematicians can use similar algorithms to generate fractals and other forms.

Certain sequences of moves produce patterns known as spirolaterals. In general, the first line is one unit long, and each successive line is one unit longer than the previous one. Three factors determine the spirolateral's geometry: the turning angle, the number of segments (or turns), and the number of repetitions.

For example, a turtle could crawl a distance of one unit, turn ninety degrees right, crawl a distance of two units, turn ninety degrees right, crawl a distance of three units, turn ninety degrees right, then repeat the sequence. In this case the turning angle is ninety degrees, the number of turns is three (so the number of segments and the so-called order of the spirolateral also is three), and the number of repetitions is four before the pattern closes up.

One can use the rules for spirolaterals "to generate artistic forms of unexpected complexity and beauty" says Robert J. Krawczyk of the College of Architecture at the Illinois Institute of Technology in Chicago. By setting different rules, one can create different patterns. Some of these patterns remain open, while others close up after a certain number of repetitions. Incorporating occasional changes in direction—reversals—into the rules enlarges the repertoire of patterns in intriguing ways.

The rule "go a distance one unit, turn ninety degrees right, go two units, turn ninety degrees right, go three units, turn ninety degrees right, then repeat the sequence" generates this simple spirolateral.

Different rules produce different spirolateral designs.

Such exercises in design can serve as idea generators for architects, Krawczyk suggests. They also lead to mathematical investigations—from the development of formulas for predicting when a pattern will be closed to the enumeration of all the different possibilities for a given order and turning angle, with and without reversals.

183

Krawczyk has written a computer program to generate and display spirolaterals. The user can set the parameters, specify line thickness, add a contrasting center line to each segment of the pattern, or add contrasting edge lines where thickened lines intersect. In effect, the artist (as programmer) creates the environment, and the subsequent user develops his or her own version of the artwork. Echoing LeWitt, Krawczyk says, "The idea is the main thing, and the computer does the drawing."

Users can investigate all sorts of variants. "Depending on the time spent and the individual interest of the viewer, the viewer is able to see particular instances that the artist never encountered," Krawczyk says.

The tetrahedron appears to be a rather humble geometric figure. Any four points in space that are not all on the same plane mark the corners of four triangles. The triangles in turn are the faces of a tetrahedron. It's the simplest of all polyhedra—solids bounded by polygons.

Embellishing a spirolateral design creates an aesthetically pleasing rendition of a rule-generated form.

A tetrahedron has four triangular faces, four vertices, and six edges.

To sculptor Arthur Silverman of New Orleans, however, tetrahedra are very special. He has been investigating variations of tetrahedral forms for more than two decades through his sculptures, many of which are displayed in public spaces in New Orleans and other cities from Florida to California. "The tetrahedron is very exciting visually," Silverman insists. "It's very difficult to anticipate what you are going to see."

We are accustomed to thinking about orientation in space in terms of three perpendicular axes defining left and right, up and down, and forward and backward. A tetrahedron has no right angles, so a tetrahedral structure jars us out of spatial complacency. It has so few faces compared to other polyhedra that its aspect changes abruptly as the observer moves around to view it from different angles.

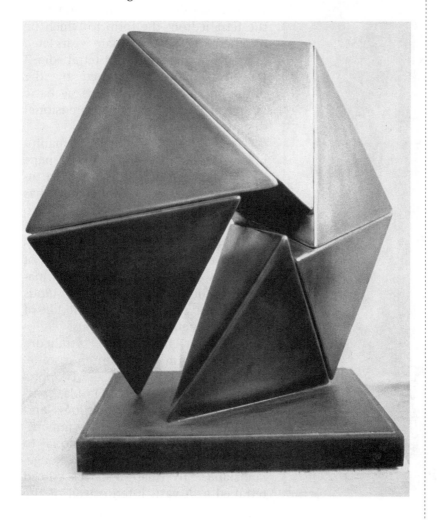

Almost Hexagon by Arthur Silverman is composed of tetrahedra joined at common triangular planes.

Until age fifty, Silverman had been a highly successful surgeon, practicing medicine with considerable enthusiasm and skill. Then he encountered an ailing colleague near death, who advised Silverman that if there was anything he might really want to do, then he ought to do it right away, before the chance slips away. The encounter changed Silverman's life. He returned to interests that had captured his attention when he was a teenager. He had visited museums to gaze at statues, and had tried his own hand at carving wood. Then, when studying medicine at Tulane University, he had met a sculpture teacher who had invited him to classes and taught him how to see, in the artistic sense.

Arthur Silverman's *Echo* features a pair of elongated tetrahedra, each balanced on one edge.

During these early explorations, Silverman had discovered the wonders of the tetrahedron, the form to which he returned with a passion many years later. "When I first encountered tetrahedra, I was immediately fascinated by the notion of using these forms as basic building blocks for three-dimensional designs," Silverman recalls.

Over the years, Silverman has manipulated the tetrahedron's familiar shape into myriad forms that are often virtually unrecognizable as tetrahedra. He has elongated it, stretching several edges to create a slim, stainless-steel tower sixty feet high, then twinned it with an identical tower to produce an elegant pair of structures, which seem to soar in formation into the sky. Such a sculpture stands as Silverman's signature in the middle of a plaza fountain in New Orleans.

Silverman has joined tetrahedra together to form an aluminum cascade. The water wall at the Lee County Sports Complex in Fort Meyers, Florida, spotlights such geometric playfulness and activity. He has stacked them symmetrically to produce a solemn memorial to Martin Luther King, Jr., in Baton Rouge, Louisiana. Silverman also has sliced tetrahedra. A vast, interior wall of the

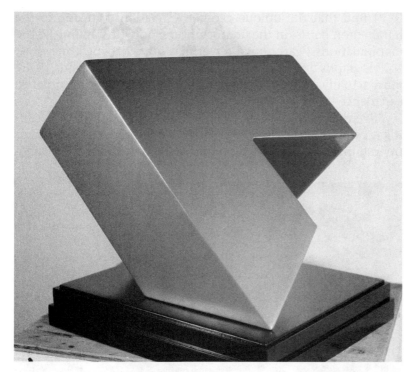

About twenty inches high, this recent sculpture of a tetrahedral form by Arthur Silverman looks startlingly different from different viewpoints. Changing the sculpture's orientation gives an observer additional views.

Equitable Center in New Orleans is covered with aluminum tiles based on such a cross section.

Silverman has divided tetrahedra, then rejoined them in various ways. He has looked at what's left when tetrahedra are cut out of a column or from inside a cube. He has stretched a tetrahedron and turned it inside out. He has stood the shape on edge, and he has balanced it on a vertex.

"I find that the unique geometric relations intrinsic to the tetrahedron persist in the final sculpture, notwithstanding all the manipulations I carry out," Silverman notes. At the same time, "photographs do not do these works justice," he contends. "One must actually see, feel, and walk around these works in order to experience them in their totality."

Silverman fabricates nearly all his pieces in his studio by welding together metal plates. Altogether he has produced more than three hundred sculptures based on the tetrahedron, from large-

A sculpture based on tetrahedral forms by Arthur Silverman.

scale outdoor works to diminutive studio models. "When I get an idea, I play with it as long as I can," he says.

Silverman is not alone in his interest in the tetrahedron. When its four faces are all equilateral triangles, the tetrahedron counts as one of the five Platonic solids. Among these five special polyhedra "there is nothing to compare with the tetrahedron," says Bathsheba Grossman of Santa Cruz, California, who describes herself as a digital sculptor. The tetrahedron, she says, is "the simplest (therefore the best) Platonic solid, the only one that is its own dual, its vertices and faces a hymn to the divine Three, while being Four in number, thus giving rise to harmonious Twelveness. . . ." For Grossman, the attraction is not so much the bare tetrahedron itself but its tetrahedral symmetry, which can serve as a framework that can be bent and embellished in myriad ways to create intricately intriguing, sinuous, and lacy forms.

Flame Beta Eleven Stripes by Bathsheba Grossman.

In the late 1980s, when Grossman was an undergraduate studying mathematics, she had found herself wanting to step from thinking about geometric abstractions to working with physical objects. Sculpture showed her the way, and she ended up studying art with Robert Engman at the University of Pennsylvania in Philadelphia in the early 1990s.

Nowadays Grossman designs her sculptures on a computer, using computer-aided design software. She employs rapid-prototyping technology to convert a design into a physical model, built up layer by layer into the full, three-dimensional figure. Usually the model is made from wax, resin-impregnated starch, or plastic. To create a metal casting of the sculpture, she typically turns to the ancient lost-wax method, which destroys the model and mold to leave a metal sculpture. "So the process moves, as it were, backward in time: from virtual idea to hand-finished metal," Grossman notes.

Another enthusiast of the tetrahedron is Philadelphia-based artist Robinson Fredenthal, who was trained as an architect. His large, angular structures take advantage of the tetrahedron's amazing rigidity and its ability to resist an incredible amount of force from the outside. "I can't think of anything more perfect than a tetrahedron," Fredenthal once remarked. If visitors came

> I can't think of anything more perfect than a tetrahedron.
> —Robinson Fredenthal

189

Black Forest by Robinson
Fredenthal.

from outer space, "I'd hand them a tetrahedron, and they would understand."

Like Silverman, Fredenthal has manipulated tetrahedra in a variety of ways. He has created peculiarly balanced, leaning towers of tetrahedra, vertical forests of sprouting tetrahedra, and great bridges of these remarkable forms.

For Italian artist Carlo Roselli, the tetrahedron serves a somewhat different purpose. It frames a particular geometric curve and the beginnings of a theory that has become the focus of Roselli's attention in recent years.

Born in Milan in 1939, Roselli moved to Rome when he was an adolescent. Later, after sojourns in Paris and elsewhere to pur-

sue theater and art, he returned to Rome to paint. His voluptuous paintings often show huddled buildings or thick crowds of people in the street, at the circus, or in cafés. The decadently bewitching tones of red that dominate these pictures leave an impression of perpetual sunset. Most striking of all, the eyes of Roselli's painted figures all stare as if startled out of intimate reveries.

Throughout the 1970s and 1980s Roselli spent brief periods studying aspects of philosophy and mathematics to satisfy his curiosity about metaphysical issues, but he remained dedicated to his painting. That changed in 1995, when Roselli turned away from painting to investigate new forms of expression. He began to fashion abstract sculptures out of flexible plastic and other materials. "I had no specific program in mind," he says. "I wanted to reflect on the two concepts of empty space and matter, and to consider their reciprocal relationship."

Of the various structures that Roselli created, the most interesting to him was one based on a gracefully lobed curve with a beguiling symmetry. It was a geometric curve that had characteristics of both the tetrahedron and the sphere. "After a few sleepless nights, things became clear and I decided to take pen to paper and think in geometrical terms," he says.

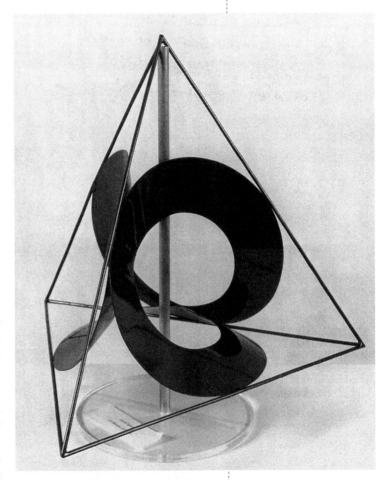

Odin's Coin by Carlo Roselli. This sculpture is named after the ancient Norse god Odin, who was associated with magic and poetry.

The sphere has the property of appearing identical from any angle. It has an infinite number of symmetries. The tetrahedron, on the other hand, has the fewest symmetries of all the Platonic solids. The tetrahedron also is its own dual. Possessing self-duality means that the centers of a tetrahedron's four triangular faces constitute the vertices of another tetrahedron. In contrast, the centers of a cube's six square faces constitute the vertices of an

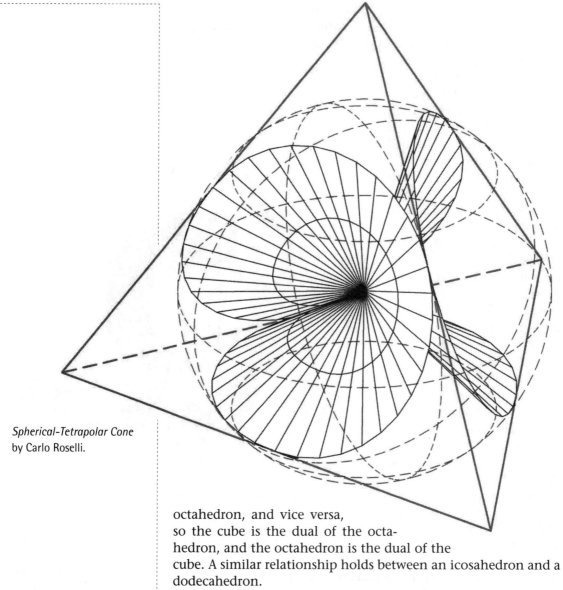

Spherical-Tetrapolar Cone
by Carlo Roselli.

octahedron, and vice versa,
so the cube is the dual of the octa-
hedron, and the octahedron is the dual of the
cube. A similar relationship holds between an icosahedron and a
dodecahedron.

Roselli has produced a variety of images of his basic geomet-
ric shape, rendering the form in different ways to highlight vari-
ous features. He also has used computer animation to study its
transformations and rotations. To Roselli, the images he creates
are so rich in intriguing symmetries that he can't help but won-
der if this particular geometric shape may represent an overarch-
ing physical theory—a simple form that can serve as a model of
how all the forces of nature are unified within a single mathe-
matical framework.

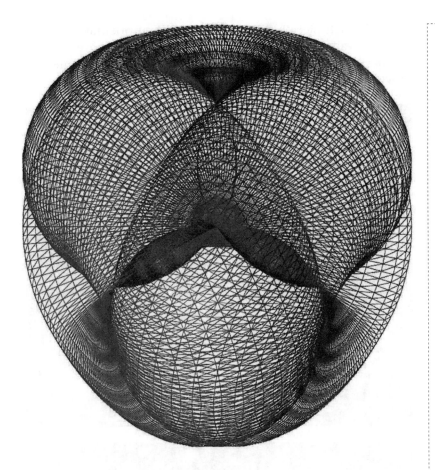

"The ultimate aim in physics is to find the simplest objects in nature and to understand their properties," Roselli suggests. "In Euclidean geometry, the sphere and the tetrahedron seem to be the simplest forms to define parts of three-dimensional space." Perhaps a geometric shape that combines the simplicity of the sphere and the tetrahedron may yet serve as the model for the ultimate physical object, he muses.

So Roselli's painting waits in the wings as he continues his center-stage explorations of tetrahedral spaces and curves.

One of the most intriguing of Arthur Silverman's tetrahedral creations is an ensemble of sculptures he calls *Attitudes*. The six pieces are spread across a grassy area at the Elysian Fields Sculpture Park in New Orleans.

All the pieces have the same geometry. Each one is made up of two identical tetrahedrons, having faces in the form of tall isosceles triangles that are welded together to form a single object. In

the park, each piece has a strikingly different orientation. As an observer walks from piece to piece, "it's hard to believe they are all the same structure," Silverman remarks. "Every time you move, you see something different."

Arthur Silverman uses small models to study the different ways in which a geometric sculpture can be oriented. The strikingly different appearance of a model consisting of two elongated tetrahedra stuck together to form a single shape suggested the idea of creating an ensemble sculpture made up of a set of identical, differently oriented pieces.

To Nat Friedman, Silverman's creation is an example of a hypersculpture. Its ensemble arrangement represents a way of seeing a three-dimensional form from many different viewpoints at once. To see every part of a two-dimensional painting, you have to step away from it in the third dimension. To see a three-dimensional sculpture in its totality, you need a way to slip into the fourth dimension. Friedman calls this hypothetical process "hyperseeing." A hypersculpture consisting of a set of several related sculptures provides one way to approximate that experience. Silverman's *Attitudes,* for instance, presents multiple views of an object from a single viewpoint, because copies of the same object lie in different orientations.

Another set of related sculptures is *Rashomon* by Charles Ginnever. The basic piece is an angular steel framework that stands about eleven feet tall and weighs sixty-seven hundred pounds. The piece can stand stably in fifteen different orientations, and in each position it looks startlingly different and tells a unique story. By having several copies of the same sculpture in the same setting, each positioned differently, the artist can tell a remarkably complex, multidimensional tale.

Hyperseeing is easiest when a sculpture is highly symmetrical. For example, if the front and back views of a sculpture are identical, you can readily reconstruct from one view what the entire sculpture looks like. Simplest of all, a featureless sphere can be understood with just one glance.

Placing a model of Charles Ginnever's *Rashomon* sculpture in different orientations demonstrates its many stable positions. The artist can then select those he would like to use full scale in a particular setting.

195

Another strategy to encourage hyperseeing is to make the form at least partly transparent or to create a ribbed structure, as seen in many sculptures by Ginnever and Charles Perry. Such approaches are somewhat reminiscent of the X-ray and time-lapse presentations of artists such as Pablo Picasso and Marcel Duchamp, who used multiple, fractured images of the same object in their paintings to convey a sense of three-dimensional space and time in a two-dimensional medium. The result, says Friedman, can be bewildering to our conventionally conditioned eyes.

For English artist Henry Moore, a sculpture was a composition in both form and space. He considered it important to see all around the sculpture as well as into and through it. Moore could develop such a vision of a sculpted form by initially working with a small plaster model, or maquette. "You can turn it around as you shape it and work on it without having to get up and walk around it, and you have a complete grasp of its shape from all around the whole time," Moore once remarked. "But all the time that I'm doing this small model, in my mind it isn't

Three-Way Piece No. 2, or *The Archer,* by Henry Moore.

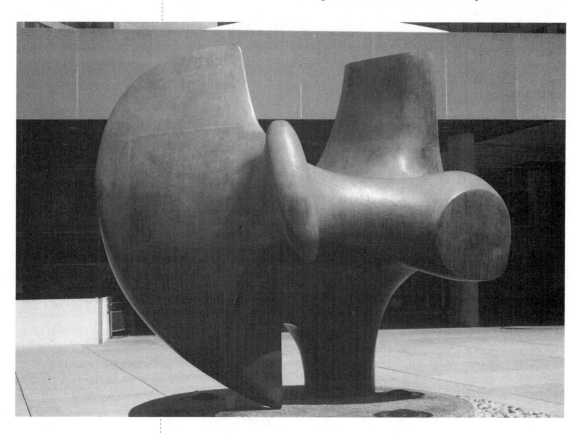

the small model that I'm doing, it's the big sculpture that I intend to do."

By handling and manipulating a hand-sized model, a sculptor gets a solid shape inside his head, whatever the sculpture's ultimate intended size. "This is what the sculptor must do," Moore insisted. "He must strive continually to think of, and use, form in its full spatial completeness."

Experience with hypersculptures, like those created by Silverman and Ginnever, increases appreciation of sculpture in general, Friedman contends. "You learn to look harder and more closely from all angles," he says. When you hypersee a three-dimensional object, you begin to visualize the form from all sides, including the top—a view of a sculpture that is often neglected or unavailable.

Interestingly, the mathematical field of knot theory provides an ideal source of three-dimensional shapes that have no preferred front, back, top, or bottom. As open forms, mathematical knots are wonderful subjects on which to practice hyperseeing, Friedman says. In effect, you can see all the points of a knot from any one view except for a finite number of points where the strand crosses itself.

In mathematics, a knot is a curve that winds through itself in three-dimensional space and catches its own tail to form a loop. Typically, mathematicians examine two-dimensional shadows cast by knots rather than actual three-dimensional knots. Even the most tangled configuration can be shown as a continuous loop whose shadow sprawls across a flat surface. In drawings of knots, tiny breaks in the lines are often used to signify underpasses or overpasses.

The continuous loop of a three-dimensional mathematical knot constructed from copper tubing casts an interesting shadow.

However, just as a suspended wire frame, caught in a breeze on a sunny day, casts an ever-changing shadow on the ground, so a rigid knot illuminated from different angles can display different projections on a flat surface. Mathematicians usually work with the simplest projection they can find for a given knot. Usually it's the shadow (or diagram) that has the smallest possible number of crossings.

Truly appreciating a knot, however, requires having a three-dimensional model of it. "You make a knot sculpture," Friedman says. He has used strips of aluminum foil and embedded wires, plastic aquarium tubing, and copper pipe for his artful experiments. "A knot can look completely different when viewed from different directions," he notes. At the same time, the infinitely malleable shape of a given knot allows you to create innumerable space-form variants of the same knot, which also can serve as raw material for artistic creativity.

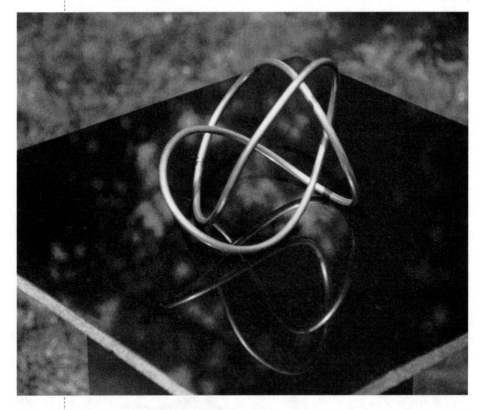

A physical model of a mathematical knot can have any one of an infinite variety of possible forms. The artist can select a configuration that has symmetries or other features that may make it particularly pleasing to the eye.

A number of artists, including English sculptor John Robinson, have taken advantage of this elastic versatility to create fascinating knot-based sculptures. José de Rivera made a career out of sculptures based on simple loops—beautiful tubes of polished metal with round or triangular cross sections winding gracefully through space.

A knotted loop also can serve as the edge of a surface. An example of such a surface appears when a wire model of a knot is dipped in a soap solution and emerges with a soap film clinging to the wire. Mathematically the result is known as a minimal surface—the surface of least possible area that spans the looped wire. If the wire is in the form of a circle, the resulting minimal surface is a flat disk. Experiments show that the minimal surfaces associated with different knotted loops can take on a variety of shapes. Some of these surfaces feature the peculiar one-sidedness characteristic of Möbius strips. Sculptors such as Robert Longhurst and Brent Collins have carved a variety of forms reminiscent of such minimal surfaces.

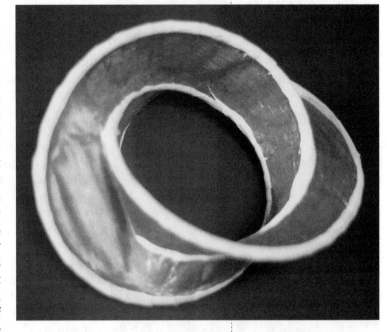

Filling in a knot produces interesting surfaces that share properties of mathematical shapes such as Möbius strips.

Collins has spent more than two decades carving gracefully curved sculptures out of wood. Born from his imagination, rendered in wire and wax, then painstakingly realized in wood in his Gower, Missouri, workshop, each creation demands many weeks of labor. He uses common shop tools—a handheld router or a small, electric chain saw—to carve the abstract curvaceous shapes out of blocks of cedar.

Collins is not a mathematician, yet his intuition and aesthetic sense have led him to explore patterns and shapes that have an underlying mathematical logic. His creations exude a strong sense of natural economy, like that of a soap film spanning a twisted wire frame, and, to his mind, the artworks reflect the logic of the natural world. Indeed, many of his sculptures display the characteristic curves of a minimal surface, as observed in

saddle-shaped soap films spanning wire frameworks. They also surprise the viewer by dramatically changing in appearance with changes in viewing angle.

Quiet-spoken and self-effacing, Collins is a self-taught artist. In the early 1970s he studied social science and biology at Illinois State University. As a student, he never quickened to the intellectual challenge or beauty of mathematics. Paging through a book about sculpture, however, would stop him in his tracks. "Sculpture immediately spoke to me," Collins says. Soon after graduation, he settled into life with his grandmother in her modest home in the small rural community of Oakland, Illinois. That living arrangement, along with odd jobs doing carpentry, allowed Collins to meet his expenses and pursue his passion for sculpture. He also gained a palpable sense of history from his grandmother, who lived to be nearly a hundred years old.

Initially, Collins worked with stone, carving sculptures reminiscent of biological forms. One of his series portrays prehistoric humanity. Over the long haul, however, his creations became increasingly abstract, evolving from human figures to the fundamental forms that he envisioned underlying visible nature. His strategy was to take simple geometric ideas that are easy to visualize in isolation and weave them into an increasingly complex tapestry. Wood became his medium of choice, and he would work logically through a particular geometric motif to create a series of carvings representing successive levels of increasing abstraction.

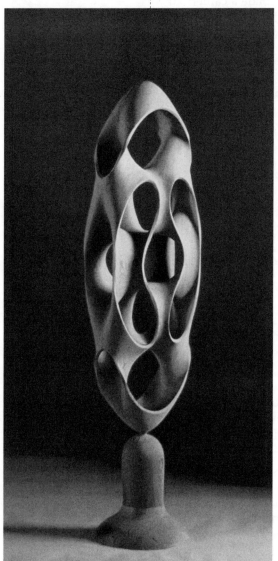

Wood sculpture by Brent Collins.

By the early 1980s Collins was intuitively trying to minimize the surface area between edge constraints, in effect approximating soap-film economy without knowing it. He also found himself dealing with surfaces that are continuously touchable without crossing an edge (like the one-sidedness of a Möbius strip) and with surfaces having edges that correspond to mathematical knots. At the same time, the minimal surfaces, Möbius strips, and mathematical knots that appeared in Collins's

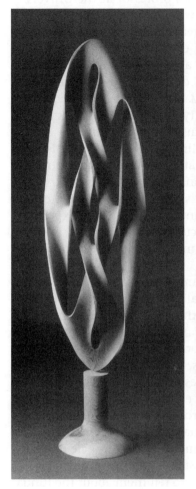 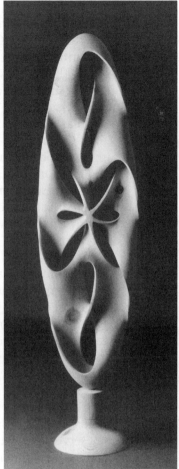 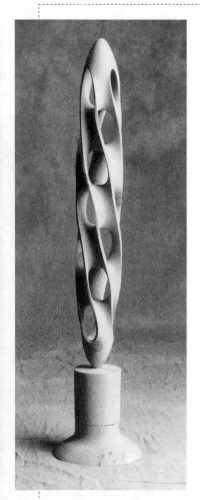

A series of wood sculptures created by Brent Collins.

carvings were not intended but arose naturally as unforeseen consequences of the structural logic he followed.

"I've always tended in my work to distill form—pare it down to its essentials," Collins says. "And those essentials are basically minimal mathematical relationships. It's a language of nature I've appropriated for aesthetic purposes."

Obstinately pursuing his distinctive vision of organic form, Collins worked virtually alone for many years. Desperate for recognition but unwilling to compromise, he persevered in carving one sculpture after another despite the insecurity of his position. When a modicum of recognition finally came in the late 1980s for Collins's efforts, it was from scientists and mathematicians.

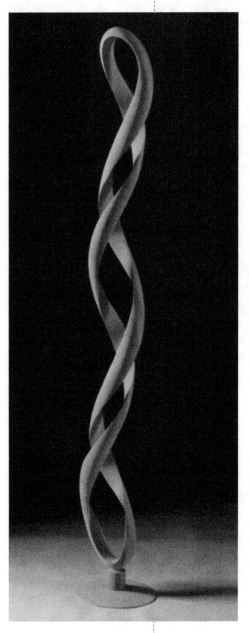

Genesis by Brent Collins. This wood sculpture, with its spiral motif representing DNA, was later cast in bronze.

George K. Francis, a mathematics professor at the University of Illinois at Urbana-Champaign, was one of those fascinated by what Collins had achieved and created. Francis was particularly struck by the fact that, without extensive scientific training, Collins had arrived intuitively at abstract geometric forms that mathematicians had themselves discovered by rational argument. Francis could also describe with considerable precision what type of mathematical surface a particular Collins sculpture represented.

For Collins, the link between his carved sculptures and specific mathematical ideas was a revelation. The connection gave him a vocabulary with which to describe his artworks and elucidate their mathematical content. "It was a heady experience to learn that [my sculptures] are in fact intuitive apprehensions of mathematical relationships," Collins says.

Interestingly, Francis himself has helped revitalize the art of visualizing mathematics. A century ago, geometers and their assistants frequently used elegant diagrams to illustrate their ideas and even created plaster or wooden models of mathematical curves and surfaces. Such models and drawings were not only sources of pleasure but also valuable tools for probing exotic geometric structures. The illustrations brought together the logically abstract and the visually concrete in mathematics. They served as landmarks in the struggle by mathematicians to understand what seemingly isolated examples were trying to tell them about the fundamental principles of geometry. By the early twentieth century, pictures began to disappear from the study of geometry and to be replaced by more abstract constructs. Concerned that pictures could sometimes lead to misunderstandings and false proofs, mathematicians turned to algebra, group theory, and calculus to express geometric notions. Francis and others have been instrumental in reviving the art of drawing mathematical pictures, from colorful chalk drawings on a blackboard to vivid representations on the computer screen.

In the 1990s, Collins also began to collaborate with Carlo H. Séquin, a computer scientist at the University of California at Berkeley who creates

three-dimensional art as a hobby. His professional specialty is the computer-assisted design of objects such as complicated machine parts, and the production of plastic or ceramic proto-types using stereolithography and other computer-driven fabri-cation techniques. His test pieces are often small sculptures or interesting mathematical forms.

When he first met Séquin, Collins was working on a series of sculptures in which each piece consists of a punctured ring of intertwined saddle surfaces. These sculptures can be described as different ways of warping pieces of an infinite mathematical shape called Scherk's second minimal surface, named for the

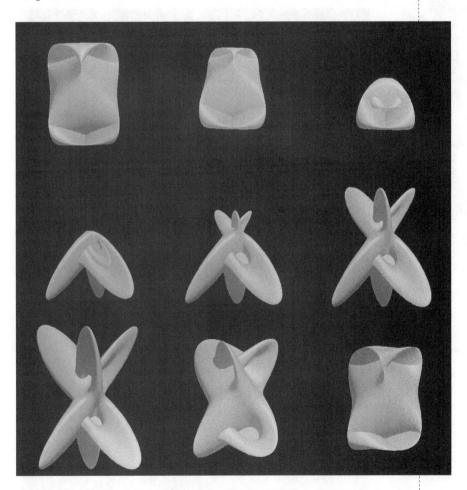

Mathematician George Francis worked with artist Donna Cox and computer pro-grammer Ray Idaszak to create a computer-drawn film showing the transformation of a mathematical surface from one topological form to another, revealing inter-esting shapes along the way.

mathematician Heinrich Ferdinand Scherk (1798–1885). Intrigued by Collins's artwork, Séquin worked with his students to develop an innovative computer program for creating prototypes of such sculptures, allowing a sculptor to try out new designs without having to spend several weeks making physical prototypes.

Using Séquin's sculpture generator, a sculptor can specify the number of holes and saddles in a unit based on a piece of a Scherk surface. That unit can then be stretched, twisted, bent into an arc, or joined end-to-end to form a

Central portion of Scherk's second minimal surface.

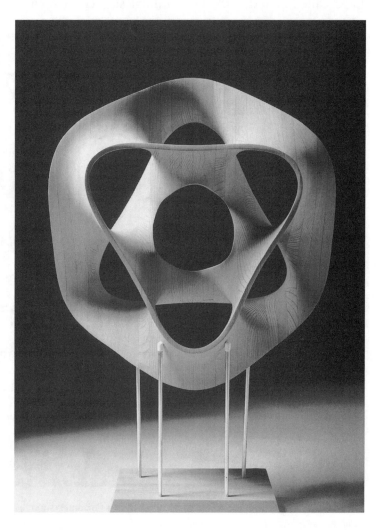

Hyperbolic Hexagon by Brent Collins. This shape can be understood as a six-level Scherk minimal surface bent into a ring.

ring. The artist also can adjust the color, surface texture, and edge thickness and even add a background scene to see how the resulting sculpture would look in a particular setting.

The sculpture generator is meant to be a research tool, not a commercial product. "Students who work on it learn many techniques applicable to other [computer-aided design] software," Séquin says. "They learn a lot about how these programs have to be structured to make them fast, interactive, and easy and enjoyable for people to use." Séquin and his students have continued to improve and develop variants of the original sculpture generator. Newer versions allow a designer to play with a greater variety of structures and deformations. They can also deliver blueprints—in the form of slices through a sculpture—that an artist can use to fashion a full-scale model.

In the meantime, Collins has ventured in new directions, working on airy sculptures made from concave ribbons of bronze or wood that spiral through space—like the ephemeral patterns that participants in rhythmic gymnastics set by twirling long ribbons.

Collins can see himself, in some sense, as a visual mathematician. He keenly values his connections and collaborations with mathematicians and scientists, yet he continues to go his own way, remaining relentlessly faithful to his visions and dreams, and forever fascinated by curvilinear elegance. "In the beginning I had no real concept of visual mathematics as a possible art form," Collins says. "Now I understand that pursuing this vision was also to practice mathematics as the science of patterns. It therefore seems inevitable that patterns would eventually emerge in my work."

Visual mathematics offers infinite possibilities. It is for the aesthetic mind and eye to pluck the true wonders from this plenitude.

Music of the Spheres by Brent Collins. See plate 23.

10 Fragments

A drawing of a tiling of the hyperbolic plane similar to the one that inspired M. C. Escher to create his *Circle Limit* series of prints.

Mathematics is a vast enterprise. It is a discipline practiced at many different levels and in many different ways. Its practitioners range from the researcher probing the secrets of random matrices and the Wall Street financial analyst trying to make sense of the stock market's fluctuations to the amateur who enjoys poking into mysterious patterns among integers, playing with novel tiling arrangements, or pondering sports statistics. It has a place in the classroom, the home, the business office, the research laboratory, and the art studio.

Art, too, is a vast enterprise. Its practitioners range from the celebrity artist, hailed in the media as an innovator and perhaps social commentator, to the artisan crafting decorative ceramics for sale at a local market. It, too, has a place in the classroom, the home, the business office, and the research laboratory.

Given the scale and the variety of both artistic and mathematical endeavors, it should come as no surprise that mathematics can inspire art and that art can inspire mathematics. When searching for such interactions between mathematics and art, it turns out to be surprisingly easy to find examples.

In 1957, M. C. Escher found himself staring at a diagram in a mathematical article about symmetry. The illustration showed a curious tiling of black-and-white triangles with curved sides. Enclosed within a circle, the alternately colored triangles became progressively smaller as they approached the circle's perimeter. The diagram gave Escher what he later described as "quite a shock." It also inspired him to create four artworks: the *Circle Limit* series of prints.

The concept of infinity had long captivated Escher, and he had sought to depict this elusive notion in visual images. One strategy he employed was to create repeating patterns of interlocking figures. Although Escher could imagine how such arrays could extend to infinity, the actual patterns he drew represented only a fragment of an infinite expanse.

In another approach, Escher tried to fit together replicas of a figure, such as a fish, that diminish in size as they spiral into or recede from a point in the middle of a square or a circular frame. However, he wasn't entirely satisfied with these efforts.

The mathematical drawing that had so startled Escher—an illustration of the so-called hyperbolic plane—offered him a precise, aesthetically pleasing solution for depicting diminishing figures within a circle. The article containing the drawing had been written by H. S. M. Coxeter, whose mathematical work on symmetry, tilings, kaleidoscope patterns, and higher-dimensional objects called polytopes has, over the years, inspired many artists and amateur mathematicians (see Chapter 6).

Coxeter had sent Escher a copy of his symmetry article as a thank you for permission to reproduce several of Escher's periodic drawings as illustrations. The men had met in 1954 in Amsterdam at the International Congress of Mathematicians, where there was an exhibition of Escher's work. That encounter led to correspondence between the two, which continued until Escher's death in 1972.

In 1958 Escher mailed Coxeter a print of *Circle Limit I*—the first fruit of the artist's venture into hyperbolic geometry, inspired by Coxeter. In the decades since Escher's initial foray, the *Circle Limit* prints themselves have motivated many mathematical investigations and artistic efforts.

All this diverse activity stems from the same basic principles of curved geometry. For example, if you draw any triangle on a sheet of paper and add up its three angles, the result is always 180 degrees. When you draw a triangle on a saddle-shaped surface, however, the angles invariably add up to fewer than 180 degrees.

Just as a flat surface is a piece of the infinite mathematical surface known as the Euclidean plane, so a saddle-shaped surface can be thought of as a small piece of the hyperbolic plane. Picturing what the hyperbolic plane looks like on a larger scale, however, requires some mind-bending ingenuity.

Mathematicians Bill Thurston of the University of California at Davis and Jeff Weeks of Canton, New York, suggest making "hyperbolic paper" from a large number of equilateral triangles as one way to get a feel for the hyperbolic plane. Taping together equilateral triangles so that precisely six triangles meet at each vertex produces a flat sheet. In contrast, assembling equilateral triangles so seven triangles meet at each vertex produces a floppy, bumpy surface. The more triangles you use and the larger the resulting sheet, the more closely it resembles the hyperbolic plane.

A similar construction is possible with pentagons. Mathematician and sculptor Helaman Ferguson has fashioned a persistently wrinkly hyperbolic quilt by sewing together pentagonal patches

Helaman Ferguson's unruly hyperbolic quilt, sewn together from pentagons of cloth, refuses to lie flat.

of a leatherlike material or some other fabric so that four pentagons meet at each corner. He describes his creation as an unruly quilt that simply refuses to lie flat.

Such constructions are not the only way to visualize the hyperbolic plane. More than a century ago, the French mathematician Henri Poincaré introduced a method for representing the entire hyperbolic plane on a flat, disk-shaped surface. In Poincaré's model, the hyperbolic plane is compressed to fit within a circle. The circle's circumference represents points at infinity. In this context, a straight line, meaning the shortest distance between two points, is a segment of a circular arc that meets the Poincaré disk's circular boundary at right angles.

Although this model distorts distances, it represents angles faithfully. The hyperbolic measure of an angle is equal to that measured in the disk representation of the hyperbolic plane. A repeating pattern made up of identical geometric shapes in the hyperbolic plane, when represented in a Poincaré model, transforms into an array of shapes that diminish in size as they get closer to the disk's bounding circle.

For his *Circle Limit* prints Escher worked out the underlying

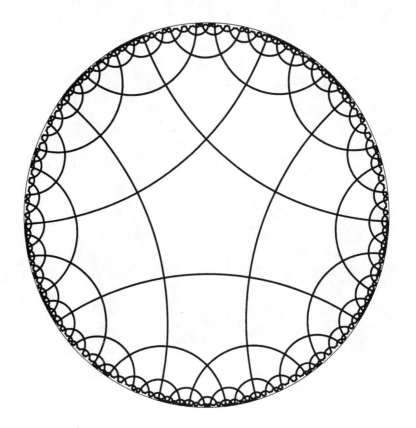

A pentagonal tiling of the hyperbolic plane in which four pentagons meet at each vertex.

rules of these disk models and developed his own method for constructing a hyperbolic grid, relying on his skill and intuition to create the geometric scaffolding he needed. Coxeter's "hocus pocus" mathematical text wasn't much help, Escher later remarked in a letter to Coxeter. Nonetheless, Escher executed the drawings with extraordinary accuracy, Coxeter comments.

In addition to its beauty, *Circle Limit III* presents a puzzle. For some reason, in this particular case, Escher drew a somewhat different pattern of lines than that in Coxeter's original diagram. The main arcs seen in *Circle Limit III* meet the circumference at a specific angle very close to eighty degrees rather than precisely

Circle Limit III by M. C. Escher. © 2001 Cordon Art B.V.–Baarn–Holland. All rights reserved.

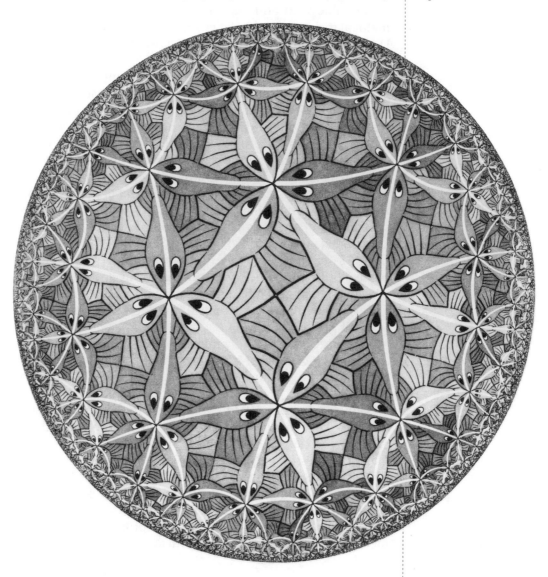

ninety degrees. Coxeter was able to demonstrate that each arc is of a type known to mathematicians as an equidistant curve. It bears the same relationship to a hyperbolic straight line as a line of latitude does to the equator on the surface of a sphere. When Coxeter worked out trigonometrically what the proper angle of such a curve in Escher's print should be, he obtained seventy-nine degrees, fifty-eight minutes, again confirming the accuracy of Escher's draftsmanship.

Escher's mathematically intriguing *Circle Limit* prints and their repeating patterns also prove to be useful vehicles for becoming comfortable with and teaching hyperbolic geometry. "Even to mathematicians, hyperbolic geometry is not that familiar," says Douglas J. Dunham of the computer science department at the University of Minnesota at Duluth.

Dunham and his students have written computer programs to generate hyperbolic patterns, particularly those made up of repeating motifs colored in various ways. Mathematicians use a standard notation for describing a mosaic made up of identical tiles, where each tile is a polygon with a given number of edges of the same length and the same number of vertices. Written in the form $\{p,q\}$, the first entry, p, is the number of sides in each polygon, and the second entry, q, is the number of polygons that meet at each vertex when the tiles are laid out. A tiling in which six equilateral triangles meet at each intersection is designated $\{3,6\}$, for example.

The same notation applies to regular tilings of the hyperbolic plane. A tiling in which four pentagons meet at each vertex is labeled $\{5,4\}$. In general, for polygons with p sides, meeting q at a vertex, the result is a hyperbolic tiling when $(p-2)$ multiplied by $(q-2)$ is greater than 4.

Escher's *Circle Limit IV*, which features interlocking devils and angels, is an example of a $\{6,4\}$ hyperbolic tiling. In other words, the underlying grid consists of hexagons that meet 4 at each vertex.

Dunham has developed a computer program that transforms a hyperbolic Escher design from one tiling pattern to another. For example, he can transform the $\{8,3\}$ pattern of crosses in *Circle Limit II* into a strikingly different $\{10,3\}$ tiling, where the repeated figure is a five-pointed star. The same pattern can be transformed into an array of starbursts with any number of rays. Indeed, there is an infinite number of hyperbolic tilings available for such transformations. The use of different motifs and color schemes increases the possibilities even further.

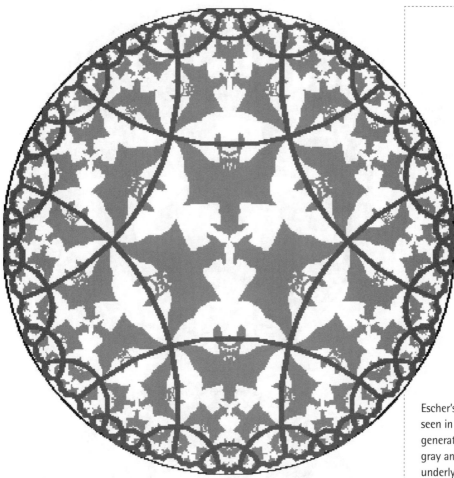

Escher's *Circle Limit IV*, as seen in this computer-generated rendition in gray and white, has an underlying tiling pattern in which four hexagons meet at each vertex.

Dunham has extended some of these ideas to Celtic knot patterns, used centuries ago in Ireland and elsewhere to decorate religious texts. Such knots are formed by weaving a ribbon into an alternating over-and-under pattern, then joining the two ends to form a continuous band. Dunham's new computer program generates hyperbolic versions of these ancient designs. He also can construct examples in which rings interlock in the over-and-under pattern of Celtic knots.

Interestingly, Escher himself incorporated an intricate pattern of interlocking rings in his last woodcut, *Snakes*. Dunham can show that this pattern is closely related to a hyperbolic variant of a Celtic weaving. Although Escher and Dunham approached these patterns from different perspectives, their intellectual common ground is apparent.

Douglas Dunham has developed a computer program that can transform one hyperbolic tiling pattern into another. In this case he has used the program to convert the crosses of his rendition of Escher's *Circle Limit II* pattern (top) into stars (bottom).

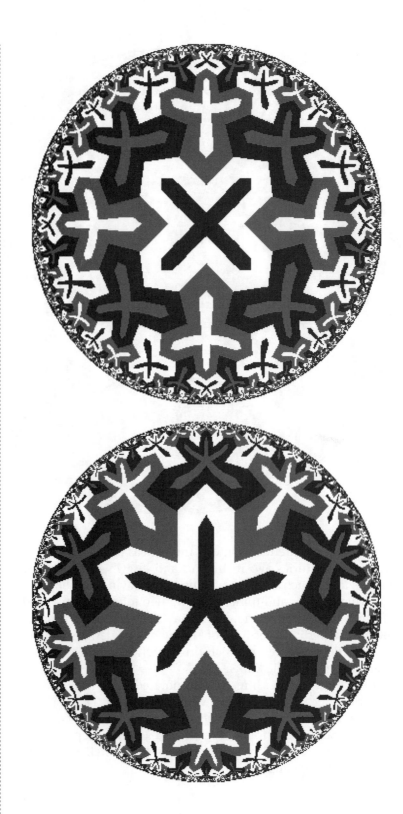

In a 1960 essay later translated into English and published in the book *The Graphic Work of M. C. Escher,* Escher noted, "The ideas that are basic to [my art] often bear witness to my amazement and wonder at the laws of nature which operate in the world around us. . . . By keenly confronting the enigmas that surround us, and by considering and analyzing the observations that I have made, I ended up in the domain of mathematics. Although I am absolutely without training or knowledge in the exact sciences, I often seem to have more in common with mathematicians than with my fellow artists."

A simple Celtic knot pattern (above). Such a woven pattern can be converted into an array of interlocking rings, then depicted using hyperbolic geometry (below).

Square Root of a Tree by John Sims. Both a mathematician and an artist, Sims teaches at the Ringling School of Art and Design in Sarasota, Florida. "The mathematical art that I seek to develop combines mathematical language and analysis with the expressiveness and creativity of the process to make expressive visual theorems," Sims says. In this example he uses images of a real tree and a fractal tree to show the tree-root relationship between mathematics and art. In different orientations the artwork becomes *Tree Root of a Fractal*, *Mathematics-Art Brain*, and *Art-Brain Mathematics*.

Such sentiments are not uncommon among mathematically oriented artists. The wonders and enigmas of nature, the power of geometry for visualizing and understanding the world, the intricacies and perplexities of perception, and the role of mathematics as the language of form are recurring themes. So, too, is the frequent lack of recognition for this sort of creativity in an art world that, more often than not, takes a surprisingly narrow, self-centered view of what constitutes art and fails to appreciate and encompass the full scope of visual creativity.

The term "mathematical art" usually conjures up images of Escher's endless staircases, Möbius ants, and other creations, or the intimate intertwining of mathematics and art during the

Limits of Infinity III by John Safer. "I carved the interior shape while groping for a shape which would seem fulfilling, internally harmonious, and perhaps inspiring," Safer explains. "When that part of the sculpture was complete, I realized that it was a three-dimensional rendition of the symbol for infinity." Safer chose to orient his sculpture vertically rather than horizontally and mounted it within an elliptical frame—in effect, confining infinity.

> "Mathematicians and artists are engaged in the ultimate creative activity—creating something out of nothing.
>
> —*Howard Levine*

Renaissance with the development of perspective painting and eye-teasing stagecraft. However, the realm of mathematical art is far wider and more diverse than most people realize. A surprising number of contemporary artists recognize mathematics—from Fibonacci numbers and the digits of pi to tetrahedra and Möbius strips—as the inspiration for their creations. In *Fragments of Infinity*, I could highlight just a small sampling of such endeavors.

Mathematician, writer, and educator Howard Levine of Berkeley, California, put it this way in a 1994 essay published in *Leonardo:* "Mathematicians and artists are engaged in the ultimate creative activity—creating something out of nothing. We need to do more than simply understand the affinity these two disciplines share for each other. We need to incorporate their *modus vivendi* into our lives. For how else are we to define the good life and live it with grace if we leave the creative act and appreciation of beauty to specialists?"

A visit to an art gallery or a walk in a sculpture garden is one way to start. Viewing art with a mathematical eye can be immensely illuminating and rewarding. There is much to see and experience anew.

Further Readings

Visit the Web site of the International Society for the Arts, Mathematics, and Architecture at *http://www.isama.org/* to find an updated, expanded version of this bibliography, along with links to other sites devoted to various aspects of the interaction between art and mathematics.

General

Albers, Donald J. and G. L. Alexanderson, eds. *Mathematical People: Profiles and Interviews*. (Boston: Birkhäuser, 1985).

Albers, Donald J., Gerald L. Alexanderson, and Constance Reid. *More Mathematical People: Contemporary Conversations*. (San Diego, CA: Academic Press, 1990).

Burger, Edward B. and Michael Starbird. *The Heart of Mathematics: An Invitation to Effective Thinking*. (Emeryville, CA: Key College Publishing, 2000).

Devlin, Keith. *The Language of Mathematics: Making the Invisible Visible*. (New York: W. H. Freeman, 2000).

_____. *Life by the Numbers*. (New York: Wiley, 1998).

Hilton, Peter, Derek Holton, and Jean Pedersen. *Mathematical Reflections: In a Room with Many Mirrors*. (New York: Springer, 1997).

Peterson, Ivars. *The Mathematical Tourist: New and Updated Snapshots of Modern Mathematics*. (New York: W. H. Freeman, 1998).

_____. *Islands of Truth: A Mathematical Mystery Cruise*. (New York: W. H. Freeman, 1990).

Sarhangi, Reza, ed. *Bridges: Mathematical Connections in Art, Music, and Science Conference Proceedings*. 2000. See http://www.sckans.edu/~bridges/

_____. *Bridges: Mathematical Connections in Art, Music, and Science Conference Proceedings*. 1999. See http://www.sckans.edu/~bridges/

_____. *Bridges: Mathematical Connections in Art, Music, and Science Conference Proceedings*. 1998. See http://www.sckans.edu/~bridges/

Steen, Lynn Arthur, ed. *On the Shoulders of Giants: New Approaches to Numeracy*. (Washington, DC: National Academy Press, 1990).

Chapter 1. Gallery Visits

Bliss, Anna Campbell. "Architectural extents." In *First Interdisciplinary Conference of the International Society of the Arts, Mathematics, and Architecture (ISAMA 99)*, Nathaniel Friedman and Javier Barrallo, eds. (San Sebastián, Spain: University of the Basque Country, 1999).

Emmer, Michele, ed. *The Visual Mind: Art and Mathematics*. (Cambridge, MA: MIT Press, 1995).

Field, J. V. *The Invention of Infinity: Mathematics and Art in the Renaissance*. (New York: Oxford University Press, 1997).

Friedman, Nathaniel and Javier Barrallo. *First Interdisciplinary Conference of the International Society of the Arts, Mathematics, and Architecture (ISAMA 99)*. (San Sebastián, Spain: University of the Basque Country, 1999).

Gardner, Martin. "Minimal sculpture." In *Fractal Music, Hypercards and More . . . Mathematical Recreations from* Scientific American *Magazine*. (New York: W. H. Freeman, 1992).

Hargittai, István and Magdolna Hargittai. *Symmetry: A Unifying Concept*. (Bolinas, CA.: Shelter Publications, 1994).

Ivins, William M., Jr. *Art and Geometry: A Study in Space Intuitions*. (New York: Dover, 1964).

Kapraff, Jay. *Connections: The Geometric Bridge between Art and Science*. (New York: McGraw-Hill, 1991).

Singer, Clifford. "On visual mathematics in art." In *Bridges: Mathematical Connections in Art, Music, and Science Conference Proceedings*, Sarhangi, Reza, ed. 2000. See http://www.sckans.edu/~bridges/

_____. "The conceptual mechanics of expression in geometric fields." In *Bridges: Mathematical Connections in Art, Music, and Science Conference Proceedings*, Sarhangi, Reza, ed. 1999. See http://www.sckans.edu/~bridges/

_____. "Geometrical fields." In *First Interdisciplinary Conference of the International Society of the Arts, Mathematics, and Architecture (ISAMA 99)*, Nathaniel Friedman and Javier Barrallo, eds. (San Sebastián, Spain: University of the Basque Country, 1999).

Chapter 2. Theorems in Stone

Albers, D. "Carving mathematics." *Math Horizons* (November 1994): 14–17.

Cannon, J. W. "Mathematics in marble and bronze: The sculpture of Helaman Rolfe Pratt Ferguson." *Mathematical Intelligencer* 13 (No. 1, 1991): 30.

Cipra, Barry A. "Quod granite demonstrandum." *SIAM News* 30 (December 1997): 1.

_____. "Mathematical ideas shape sculptor's work." *SIAM News* 23 (May 1990): 24.

Ferguson, Claire. *Helaman Ferguson: Mathematics in Stone and Bronze*. (Erie, PA: Meridian Creative Group, 1994).

Ferguson, Helaman. "Duality in mathematical sculpture: Linking Klein bottles in granite." *International Journal of Shape Modeling* 5 (No. 1, 1999): 55–68.

_____. "Equations to stone sculpture." In *First Interdisciplinary Conference of the International Society of the Arts, Mathematics, and Architecture (ISAMA 99)*, Nathaniel Friedman and Javier Barrallo, eds. (San Sebastián, Spain: University of the Basque Country, 1999).

_____. "Two theorems, two sculptures, two posters." *American Mathematical Monthly* 97 (August–September 1990): 589–610.

Peterson, Ivars. "The song in the stone." *Science News* 149 (Feb. 17, 1996): 110–112.

_____. "Equations in stone." *Science News* 138 (Sept. 8, 1990): 152–154.

Stewart, Ian. "Glass Klein bottles." *Scientific American* (March 1998):101.

Chapter 3. A Place in Space

Abbott, Edwin A. *Flatland: A Romance of Many Dimensions by A Square*. (London: Seeley & Co., 1884).

Albers, D. J. "Tom Banchoff: Multidimensional mathematician." *Math Horizons* (February 1996): 18–22.

Asimov, Daniel. "There's no space like home." *The Sciences* (September–October 1995): 20–25.

Banchoff, Thomas F. *Beyond the Third Dimension*. (New York: Scientific American Library, 1990).

Brisson, Harriet E. "Aesthetic geometry." In *First Interdisciplinary Conference of the International Society of the Arts, Mathematics, and Architecture (ISAMA 99)*, Nathaniel Friedman and Javier Barrallo, eds. (San Sebastián, Spain: University of the Basque Country, 1999).

Coxeter, H. S. M. *Regular Polytopes*, 3rd. ed. (New York: Dover, 1973).

Dewdney, A. K. "A program for rotating hypercubes induces four-dimensional dementia." *Scientific American* (April 1986): 14–23.

Gardner, Martin. "The wonders of a planiverse." In *The Last Recreations: Hydras, Eggs, and Other Mathematical Mystifications*. (New York: Copernicus, 1997).

_____. "Hypercubes." In *Mathematical Carnival*. (Washington, DC: Mathematical Association of America, 1989).

_____. "The church of the fourth dimension." In *The Unexpected Hanging and Other Mathematical Diversions*. (New York: Simon and Schuster, 1969).

_____. "Flatlands." In *The Unexpected Hanging and Other Mathematical Diversions*. (New York: Simon and Schuster, 1969).

Henderson, Linda Dalrymple. *Duchamp in Context: Science and Technology in the* Large Glass *and Related Works*. (Princeton, NJ: Princeton University Press, 1998).

_____. *The Fourth Dimension and Non-Euclidean Geometry in Modern Art*. (Princeton, NJ: Princeton University Press, 1983).

Kemp, Martin. "Dali's dimensions." *Nature* 391 (Jan. 1, 1998): 27.

Ouspensky, P. D. *A New Model of the Universe: Principles of the Psychological Method in Its Application to Problems of Science, Religion, and Art*. (Mineola, NY: Dover, 1997).

Pickover, Clifford A. *Surfing through Hyperspace: Understanding Higher Universes in Six Easy Lessons*. (New York: Oxford University Press, 1999).

Rucker, Rudy. *The Fourth Dimension: Toward a Geometry of Higher Reality*. (New York: Houghton Mifflin, 1984).

Stewart, Ian. "One hundred and one dimensions." *New Scientist* (Oct. 11, 1995): 28–31.

Chapter 4. Plane Folds

Demaine, Erk D., Martin L. Demaine, and Anna Lubiw. "Polyhedral sculptures with hyperbolic paraboloids." In *Bridges: Mathematical Connections in Art, Music, and Science Conference Proceedings,* Sarhangi, Reza, ed. 1999. See http://www.sckans.edu/~bridges/

Gardner, Martin. *The Universe in a Handkerchief: Lewis Carroll's Mathematical Recreations, Games, Puzzles, and Word Plays*. (New York: Copernicus, 1996).

_____. "Pascal's triangle." In *Mathematical Carnival*. (Washington, DC: Mathematical Association of America, 1989).

_____. "Origami." In *The 2nd Scientific American Book of Mathematical Puzzles & Diversions*. (New York: Simon and Schuster, 1961).

Gurkewitz, Rona and Bennett Arnstein. *3-D Geometric Origami: Modular Polyhedra*. (New York: Dover, 1995).

Lang, Robert J. *Origami in Action: Paper Toys That Fly, Flap, Gobble, and Inflate!* (New York: St. Martin's Griffin, 1997).

Miura, Koryo, ed. *Origami Science & Art: Proceedings of the Second International Meeting of Origami Science and Scientific Origami*. (Otsu, Japan: Seian University of Art and Design, 1997).

Montroll, John. *Teach Yourself Origami*. (New York: Dover, 1998).

Neale, Robert, Thomas Hull, and Lionel Delevingne. *Origami, Plain and Simple*. (New York: St. Martin's Press, 1994).

Stewart, Ian. "Origami tessellations." *Scientific American* (February, 1999): 100–101.

Verrill, Helena. "Origami tessellations." In *Bridges: Mathematical Connections in Art, Music, and Science Conference Proceedings,* Sarhangi, Reza, ed. 1998. See http://www.sckans.edu/~bridges/

Chapter 5. Grid Fields

Blatner, David. *The Joy of* π. (New York: Walker, 1997).

Crutchfield, James P., J. Doyne Farmer, Norman H. Packard, and Robert Shaw. "Chaos." *Scientific American* 255 (December 1986): 46–57.

Dewdney, A. K. "Wallpaper for the mind: Computer images that are almost, but not quite, repetitive." *Scientific American* 255 (September 1986): 14–23.

_____. "A computer microscope zooms in for a look at the most complex object in mathematics." *Scientific American* 255 (August 1986): 16–24.

Gardner, Martin. "The transcendental number pi." In *New Mathematical Diversions*. (Washington, DC: Mathematical Association of America, 1995).

_____. "Mandelbrot's fractals." In *Penrose Tiles to Trapdoor Ciphers*. (New York: W. H. Freeman, 1989).

_____. "Anamorphic art." In *Time Travel and Other Mathematical Bewilderments*. (New York: W. H. Freeman, 1988).

_____. "Rep-tiles: Replicating figures on the plane." In *The Unexpected Hanging and Other Mathematical Diversions*. (New York: Simon and Schuster, 1969).

Mandelbrot, Benoit B. *The Fractal Geometry of Nature*. (New York: W. H. Freeman, 1983).

McGuire, Michael. *An Eye for Fractals: A Graphic & Photographic Essay by Michael McGuire*. (Reading, MA: Addison-Wesley, 1991).

Peden, Douglas D. "Bridges of mathematics, art, and physics." In *Bridges: Mathematical Connections in Art, Music, and Science Conference Proceedings,* Sarhangi, Reza, ed. 1998. See http://www.sckans.edu/~bridges/

Pickover, Clifford A., ed. *The Pattern Book: Fractals, Art, and Nature.* (Singapore: World Scientific, 1995).

_____. *Keys to Infinity.* (New York: Wiley, 1995).

_____. *Mazes for the Mind: Computers and the Unexpected.* (New York: St. Martin's Press, 1992).

_____. *Computers and the Imagination: Visual Adventures Beyond the Edge.* (New York: St. Martin's Press, 1991).

_____. *Computers, Pattern, Chaos and Beauty: Graphics from an Unseen World.* (New York: St. Martin's Press, 1990).

Stewart, Ian. *Does God Play Dice? The Mathematics of Chaos.* (Cambridge, MA: Basil Blackwell, 1989).

Chapter 6. Crystal Visions

Gailiunas, Paul. "Spiral tilings." In *Bridges: Mathematical Connections in Art, Music, and Science Conference Proceedings,* Sarhangi, Reza, ed. 2000. See http://www.sckans.edu/~bridges/

Gardner, Martin. "Penrose tiling." In *Penrose Tiles to Trapdoor Ciphers.* (New York: W. H. Freeman, 1989).

_____. "Penrose tiling II." In *Penrose Tiles to Trapdoor Ciphers.* (New York: W. H. Freeman, 1989).

_____. "Tiling with convex polygons." In *Time Travel and Other Mathematical Bewilderments.* (New York: W. H. Freeman, 1988).

Grünbaum, Branko and G. C. Shephard. *Tilings and Patterns.* (New York: W. H. Freeman, 1987).

La Breque, Mort. "Opening the door to forbidden symmetries." *Mosaic* 18 (Winter 1987): 2–23.

Penrose, Roger. *The Emperor's New Mind: Concerning Computers, Minds, and the Laws of Physics.* (New York: Oxford University Press, 1989).

_____. "Pentaplexity: A class of non-periodic tilings of the plane." *Mathematical Intelligencer* 2 (No. 1, 1979): 32–37.

Robbin, Tony. *Engineering a New Architecture: How New Engineering Materials and Techniques Are Influencing Architectural Design.* (New Haven, CT: Yale University Press, 1996).

_____. *Fourfield: Computers, Art, and the Fourth Dimension.* (Boston: Little, Brown and Company, 1992).

_____. "Painting and physics: Modeling artistic and scientific experience in four spatial dimensions." *Leonardo* 17 (No. 4, 1984): 227–233.

Schattschneider, Doris. "In praise of amateurs." In *Mathematical Recreations: A Collection in Honor of Martin Gardner,* David A. Klarner, ed. (Mineola, NY: Dover, 1998).

Senechal, Marjorie. *Quasicrystals and Geometry.* (Cambridge, England: Cambridge University Press, 1995).

Venters, Diana and Elaine Krajenke Ellison. *Mathematical Quilts: No Sewing Required!* (Emeryville, CA: Key Curriculum Press, 1999).

Chapter 7. Strange Sides

Barr, Stephen. *Experiments in Topology.* (New York: Dover, 1989).

Brown, Ronald. "John Robinson's symbolic sculptures, knots and mathematics." In *First Interdisciplinary Conference of the International Society of the Arts, Mathematics, and Architecture (ISAMA 99),* Nathaniel Friedman and Javier Barrallo, eds. (San Sebastián, Spain: University of the Basque Country, 1999).

Emmer, Michele. "Mathematics and art: Bill and Escher." In *Bridges: Mathematical Connections in Art, Music, and Science Conference Proceedings,* Sarhangi, Reza, ed. 2000. See http://www.sckans.edu/~bridges/

Fauvel, John, Raymond Flood, and Robin Wilson, eds. *Möbius and His Band: Mathematics and Astronomy in Nineteenth-Century Germany.* (New York: Oxford University Press, 1993).

Gardner, Martin. "Möbius bands." In *Mathematical Magic Show.* Washington, DC: Mathematical Association of America, 1989).

Isaksen, Daniel C. and Alabama P. Petrofsky. "Möbius knitting." In *Bridges: Mathematical Connections in Art, Music, and Science Conference Proceedings,* Sarhangi, Reza, ed. 1999. See http://www.sckans.edu/~bridges/

Perry, Charles O. "Continuum, broken symmetry, and more." In *Bridges: Mathematical Connections in Art, Music, and Science Conference Proceedings,* Sarhangi, Reza, ed. 1998. See http://www.sckans.edu/~bridges/

Séquin, Carlo H. ". . . to build a twisted bridge . . ." In *Bridges: Mathematical Connections in Art, Music, and Science Conference Proceedings,* Sarhangi, Reza, ed. 2000. See http://www.sckans.edu/~bridges/

Chapter 8. Minimal Snow

Bruning, John, Andy Cantrell, Robert Longhurst, Dan Schwalbe, and Stan Wagon. "Rhapsody in White: A victory of mathematics." *Mathematical Intelligencer* 22 (No. 4, 2000): 37–40.

Gray, Alfred. *Modern Differential Geometry of Curves and Surfaces with* Mathematica®, 2nd. ed. (Boca Raton, FL: CRC Press, 1998).

Hildebrandt, Stefan and Anthony Tromba. *The Parsimonious Universe: Shape and Form in the Natural World.* (New York: Springer-Verlag, 1996).

Hoffman, David and William H. Meeks, III. "Minimal surfaces based on the catenoid." *American Mathematical Monthly* 97 (October 1990): 702–730.

Chapter 9. Points of View

Casselman, Bill. "Pictures and proofs." *Notices of the American Mathematical Society* 47 (November 2000): 1257–1266.

Collins, Brent. "Visualization: From biology to culture." In *Bridges: Mathematical Connections in Art, Music, and Science Conference Proceedings,* Sarhangi, Reza, ed. 2000. See http://www.sckans.edu/~bridges/

_____. "Merging paradigms." In *Bridges: Mathematical Connections in Art, Music, and Science Conference Proceedings,* Sarhangi, Reza, ed. 1999. See http://www.sckans.edu/~bridges/

_____. "Finding an integral equation of design and mathematics." In *Bridges: Mathematical Connections in Art, Music, and Science Conference Proceedings,* Sarhangi, Reza, ed. 1998. See http://www.sckans.edu/ ~bridges/

_____. "Evolving an aesthetic of surface economy in sculpture." *Leonardo* 30 (No. 2, 1997): 85–88.

_____. "Topological sculptures." *Interdisciplinary Science Reviews* 18 (No. 1, 1993): 9–12.

Francis, George K. *A Topological Picturebook.* (New York: Springer-Verlag, 1987).

Francis, George K. and Brent Collins. "On knot-spanning surfaces: An illustrated essay on topological art. With an artist's statement by Brent Collins." *Leonardo* 25 (No. 3/4, 1992): 313–320.

Friedman, Nathaniel A. "What do you see?" In *Bridges: Mathematical Connections in Art, Music, and Science Conference Proceedings,* Sarhangi, Reza, ed. 2000. See http://www.sckans.edu/~bridges/

_____. "Geometric sculpture for K-12: Geos, hyperseeing, and hypersculpture." In *Bridges: Mathematical Connections in Art, Music, and Science Conference Proceedings,* Sarhangi, Reza, ed. 1999. See http://www.sckans.edu/~bridges/

_____. "Form, space, and light." In *First Interdisciplinary Conference of the International Society of the Arts, Mathematics, and Architecture (ISAMA 99),* Nathaniel Friedman and Javier Barrallo, eds. (San Sebastián, Spain: University of the Basque Country, 1999).

_____. "Hyperseeing, hypersculptures and space curves." In *Bridges: Mathematical Connections in Art, Music, and Science Conference Proceedings,* Sarhangi, Reza, ed. 1998. See http://www.sckans.edu/~bridges/

Gardner, Martin. "The topology of knots." In *The Last Recreations: Hydras, Eggs, and Other Mathematical Mystifications.* (New York: Copernicus, 1997).

_____. "Worm paths." In *Knotted Doughnuts and Other Mathematical Entertainments.* (New York: W. H. Freeman, 1986).

_____. "The five Platonic solids." In *The Second* Scientific American *Book of Mathematical Puzzles and Diversions.* (New York: Simon and Schuster, 1961).

Krawczyk, Robert J. "Spirolaterals, complexity from simplicity." In *First Interdisciplinary Conference of the International Society of the Arts, Mathematics, and Architecture (ISAMA 99)*, Nathaniel Friedman and Javier Barrallo, eds. (San Sebastián, Spain: University of the Basque Country, 1999).

Levine, Howard. "See-duction: How scientists and artists are creating a third way of knowing." *Humanistic Mathematics Network Journal* (No. 15, 1997): 41–45.

Moretti, Ugo. *Carlo Roselli*. (Rome: Edizioni S. I. R. I. S., 1984).

Peterson, Ivars. "Twists through space." *Science News* 154 (Aug. 29, 1998): 143.

_____. "Plastic math." *Science News* 140 (Aug. 3, 1991): 72–73.

Séquin, Carlo H. "Analogies from 2D to 3D: Exercises in disciplined creativity." In *Bridges: Mathematical Connections in Art, Music, and Science Conference Proceedings*, Sarhangi, Reza, ed. 1999. See http://www.sckans.edu/~bridges/

_____. "Computer-augmented inspiration." In *First Interdisciplinary Conference of the International Society of the Arts, Mathematics, and Architecture (ISAMA 99)*, Nathaniel Friedman and Javier Barrallo, eds. (San Sebastián, Spain: University of the Basque Country, 1999).

_____. "Art, math, and computers: New ways of creating pleasing shapes." In *Bridges: Mathematical Connections in Art, Music, and Science Conference Proceedings*, Sarhangi, Reza, ed. 1998. See http://www.sckans. edu/~bridges/

Wenninger, Magnus J. *Polyhedron Models*. (London, England: Cambridge University Press, 1971).

Chapter 10. Fragments

Coxeter, H. S. M. "Angels and devils." In *Mathematical Recreations: A Collection in Honor of Martin Gardner*, David A. Klarner, ed. (Mineola, NY: Dover, 1998).

_____. *Introduction to Geometry*. (New York: Wiley, 1961).

Coxeter, H. S. M., M. Emmer, R. Penrose, and M. L. Teuber, eds. "M. C. Escher Art and Science: Proceedings of the International Congress on M. C. Escher, Rome, Italy, 26–28 March, 1985." (Amsterdam: North-Holland, 1986).

Dunham, Douglas. "Hyperbolic Celtic knot patterns." In *Bridges: Mathematical Connections in Art, Music, and Science Conference Proceedings*, Sarhangi, Reza, ed. 2000. See http://www.sckans.edu/~bridges/

_____. "Artistic patterns in hyperbolic geometry." In *Bridges: Mathematical Connections in Art, Music, and Science Conference Proceedings*, Sarhangi, Reza, ed. 1999. See http://www.sckans.edu/~bridges/

Escher, M. C. *The Magic of M. C. Escher*. (New York: Abrams, 2000).

_____. *The Graphic Work of M. C. Escher*. (New York: Meredith Press, 1967).

Gardner, Martin. "Non-Euclidean geometry." In *The Last Recreations: Hydras, Eggs, and Other Mathematical Mystifications*. (New York: Copernicus, 1997).

_____. "H. S. M. Coxeter." In *New Mathematical Diversions*. (Washington, DC: Mathematical Association of America, 1995).

_____. "The art of M. C. Escher." In *Mathematical Carnival*. (Washington, DC: Mathematical Association of America, 1989).

Hofstadter, Douglas R. *Gödel, Escher, Bach: An Eternal Golden Braid*. (New York: Basic Books, 1979).

Hollist, J. Taylor. "M. C. Escher's association with scientists." In *Bridges: Mathematical Connections in Art, Music, and Science Conference Proceedings*, Sarhangi, Reza, ed. 2000. See http://www.sckans.edu/~bridges/

Levine, Howard. "The art of mathematics, the mathematics of art." *Leonardo* 27 (No. 1, 1994): 87–89.

Maor, Eli. *To Infinity and Beyond: A Cultural History of the Infinite*. (Boston: Birkhäuser, 1987).

Schattschneider, Doris. *Visions of Symmetry: Notebooks, Periodic Drawings, and Related Works of M. C. Escher*. (New York: W. H. Freeman, 1990).

Seckel, Al. *The Art of Optical Illusions*. (London, England: Carlton Books, 2000).

Weeks, Jeffrey R. *The Shape of Space: How to Visualize Surfaces and Three-Dimensional Manifolds*. (New York: Marcel Dekker, 1985).

Credits

Frontmatter
v (chapter 1) Photo by I. Peterson; (chapter 2) Photo by Claire Ferguson; (chapter 3) I. Peterson; (chapter 4) Chris K. Palmer. *Whirl Spools—Pinwheel Path*, uncut silk 26" × 63", © 1999. © 2001 by Chris K. Palmer; (chapter 5) Arlene Stamp. *Sliding Pi*, 1993. Photo by I. Peterson; (chapter 6) Courtesy of Tony Robbin; (chapter 7) José de Rivera. *Infinity*, 1967. Photo by I. Peterson; (chapter 8) Photo by Claire Ferguson; (chapter 9) Courtesy of Nat Friedman; (chapter 10) Courtesy of Douglas Dunham.

Chapter 1. Gallery Visits
1, 7 (right) Photos by I. Peterson; 2 I. Peterson; 3 Henry Moore. *Knife Edge Mirror Two Piece*, 1977/78, bronze. National Gallery of Art, Washington, D. C. Photo by I. Peterson; 4 Bob Brill. *Cloud Garden*. Courtesy of Bob Brill; 5 Bob Brill. *Sweeping Gesture*. Courtesy of Bob Brill; 6 Courtesy of Nat Friedman; 7 (left) *Pythagorean Fractal Tree*. Design by Koos Verhoeff, bronze by Anton Bakker and Kevin Gallup. Photo by I. Peterson; 8 Robert Engman. *The Triune*, 1975, bronze. Photo by I. Peterson; 9 Clifford Singer. *The Geometry Lesson*, acrylic on plexiglass, 36" × 36". © 1998 by Clifford Singer.

Chapter 2. Theorems in Stone
11 Photo by Claire Ferguson; 12, 29, 31 Photos by I. Peterson; 14 Helaman Ferguson. *Torus with Cross-Cap*, silicon bronze, polished, 10" by 3" by 7", 1989. Photo by Terry Klough; 15, 23, 28 I. Peterson; 18 Helaman Ferguson. *Eine Kleine Rock Musik III*, Skull Valley honey onyx, carved and polished, 14" × 18" × 8", 1986. Collection of the artist. Photo by Jon Ferguson; 19 Helaman Ferguson. *Double Torus Stonehenge*, silicon bronze, a group of twenty-eight individual bronzes arranged in a circle on an oak disk, 6" × 32" × 32". Collection of the artist. Photos by I. Peterson; 20 Helaman Ferguson. *Whaledream II*, White Carrara marble, satin surface. Photo by Helaman Ferguson; 21 Helaman Ferguson. *Wild Sphere I*, silicon bronze, 12" × 12" × 5", 1987. Photo by Terry Klough; 22 (top) Helaman Ferguson. *Umbilic Torus NC*, silicon bronze, antique green patina, 24" × 24" × 7", 1988. Photo by Terry Klough; 22 (bottom), 24, 30 Courtesy of Helaman Ferguson; 26 Helaman Ferguson. *Four Canoes*. Photo by Sam Ferguson; 27 Computer rendering of transparent Klein bottle by John M. Sullivan, University of Illinois at Urbana-Champaign. Glass Klein bottle by Cliff Stoll (www.kleinbottle.com). Photo by I. Peterson; 32 Helaman Ferguson. *Torus with Cross-Cap and Vector Field II*, Col-

orado Yule marble, carved with polished grooves, 23" × 29" × 9", 1986. Collection of artist. Photo by I. Peterson.

Chapter 3. A Place in Space
35, 37, 41, 46–49, 50 (top), 51 I. Peterson; 39, 40 Courtesy of Thomas F. Banchoff, Brown University; 43 Courtesy of Thomas F. Banchoff, Brown University. Image rendered by Davide Cervone, Union College; 44 Model constructed by I. Peterson from instructions by Thomas F. Banchoff. Photos by I. Peterson; 45 Photo by I. Peterson; 50 (bottom) David W. Brisson. *16 Hypercubes That Fit around a Point in 4D*. 36" × 15" × 72". Courtesy of Harriet E. Brisson; 52 Thomas F. Banchoff. *Math Horizon*. Image rendered by Davide Cervone; 53 David W. Brisson. *Hyperstereogram*, drawing. Courtesy of Harriet E. Brisson; 54 Harriet E. Brisson. *Magic Box*, neon, wood, plexiglass, 22" × 22" × 22", 1978. Courtesy of Harriet E. Brisson; 55 (right) Harriet E. Brisson. *Great Rhombicubooctahedra and Octagonal Prisms*, tensegrity structure of plexiglass, aluminum tubes, and nylon cord, 24 × 24 × 24 in., 1975. Courtesy of Harriet E. Brisson; 55 (left) Harriet E. Brisson. *Pentahedroid*, blue neon tubes with transformer encased in two-way glass mirror on wood base, 30" high, 1994. Courtesy of Harriet E. Brisson; 56 Thomas F. Banchoff. *Triple-Point Twist*. Image rendered by Davide Cervone; 57 Charles O. Perry. *Solstice (2/3rd Twist Triangular Torus Moebius)*, stainless steel, 28' high, 1985. Barnett Plaza, Tampa, Florida. Photo by Charles O. Perry; 59 Thomas F. Banchoff. *Z-Squared Necklace*. Image rendered by Davide Cervone; 60 Harriet E. Brisson. *Truncated 600-Cell*, 12 fluorescent tubes in the shape of an octahedron placed within a mirrored tetrahedron, 9 × 9 × 9 ft., 1989. Courtesy of Harriet E. Brisson.

Chapter 4. Plane Folds
61 Chris K. Palmer. *Whirl Spools—Pinwheel Path*, uncut silk 26" × 63", © 1999. © 2001 by Chris K. Palmer; 62, 63, 70, 71, 73, 77, 78 Courtesy of Tom Hull; 65 Photo by Robin Macey. Courtesy of Robert J. Lang; 66, 67, 68(top) Courtesy of Robert J. Lang; 68 (bottom) Photo by Robert J. Lang; 69 Chris K. Palmer. *Whirl Spools—Hexagon, Triangle and Square Twists*. Folded separately in paper by Shuzo Fujimoto c. 1980. Patterns combined and executed as Shadowfold in uncut silk 25" × 33" by Chris K. Palmer, 1995. © 2001 by Chris K. Palmer; 72 Courtesy of Helena Verrill; 74 Chris K. Palmer. *Shadowfold Whirl Spools—Dodecagon Twists*, uncut silk, backlit, 25" × 34", © 1997. © 2001 by Chris K. Palmer; 75, 79 (top) Photos by I. Peterson; 76 I. Peterson; 79 (bottom) Courtesy of Erik Demaine; 81 Model by William Webber, photos by I. Peterson; 82 Chris K. Palmer.

Whirl Spools—Watering Fujimoto's Garden—Kites. Folded separately in paper by Shuzo Fujimoto c. 1980. Patterns combined and executed as Shadowfold in uncut silk 25" × 33" by Chris K. Palmer, 1995. © 2001 by Chris K. Palmer.

Chapter 5. Grid Fields
85 Arlene Stamp. *Sliding Pi*, 1993. Photo by I. Peterson; 87(top), 90(bottom) Photos by I. Peterson; 87 (bottom), 88, 90 (top), 92 (top), 95, 105 I. Peterson; 92 (bottom), 93 Arlene Stamp. *Sliding Pi*, detail, 1993. Photos by I. Peterson; 97 Image by John Sullivan, University of Illinois at Urbana-Champaign. Courtesy of John Sullivan; 98 Courtesy of Cliff Pickover, www.pickover.com; 100 Algorithm by Bob Brill. Image by I. Peterson; 101, 102 Courtesy of Bob Brill; 103 Bob Brill. *Vortex*. Courtesy of Bob Brill; 104 Douglas Peden. *Transfiguration*, acrylic on canvas, 32" × 61", 1999. Courtesy of Douglas Peden; 106, 107 Courtesy of Douglas Peden; 108 (top) Douglas Peden. *Serenade for a Lone Figure*, detail, acrylic on canvas, 12" × 72", 1997. Photo by I. Peterson; 108 (bottom) Douglas Peden. *Come Together*, acrylic on canvas, 18" × 89", 1998. Courtesy of Douglas Peden.

Chapter 6. Crystal Visions
111, 112, 131 (bottom) Courtesy of Tony Robbin; 113, 115, 117, 121, 122 (top), 131 (top) I. Peterson; 114 M. C. Escher. *Symmetry Drawing E137*. © 2001 Cordon Art B.V.–Baarn-Holland. All rights reserved; 116, 118 Courtesy of Donald L. D. Caspar and Eric Fontano, Florida State University; 119, 120, 122 (bottom) *Mathematica* notebook for generating illustrations courtesy of Stan Wagon; 123 Image by Paul Hildebrandt, Zome System (zomesystem.com, 888-966-3386); 125 Photos by I. Peterson; 126 Eleni Mylonas. *All Stars CMYK 295*, digital output, variable size, 1999/2000. © 2000 by Eleni Mylonas. All rights reserved; 127 Eleni Mylonas. *Gray Bed Revisited*. © 2000 by Eleni Mylonas. All rights reserved; 128 Helaman Ferguson. *Aperiodic Penrose Torus, Alpha*. Department of Mathematics, Smith College. Photo by Helaman Ferguson; 129 Tony Robbin. *Untitled*, 1970, acrylic on canvas, 70" × 56". Courtesy of Tony Robbin. 130 (top) Tony Robbin. *Simplex #9, 1983*. 5' × 7' × 1'. Courtesy of Tony Robbin. 130 (bottom) Tony Robbin. *Untitled #3, 1987*. 70" × 70" × 15". Courtesy of Tony Robbin; 132 (top) Tony Robbin. *COAST Canopy*, 1994. Erik Reitzel, engineer; RCM Precision, fabricator of components. Located at the Center of Art, Science, and Technology, Technical University of Denmark. Courtesy of Tony Robbin; 132 (bottom) Tony Robbin, *Untitled #6, 2000*. Courtesy of Tony Robbin.

CREDITS

Chapter 7. Strange Slides

135 José de Rivera. *Infinity*, 1967. Photo by I. Peterson; **136 (top)**, 138, 139 I. Peterson; **136 (bottom)**, 137 Charles O. Perry. *Helix Moebius Mace*, 8', bronze, and *Calligraphic Moebius*, aluminum, 20', 1988. Crystal City, Arlington, Virginia. Photos by I. Peterson; **140** Charles O. Perry. *The Arch of Janus*, granite, 1994. 14' × 14' × 10', private collection. Photo by Charles O. Perry; **141** Courtesy of Cliff Long; **142** Cliff Long. *Möbius Band*. Courtesy of Cliff Long; **143** Cliff Long. *Bug on a Band*. Photo by David Hampshire, Instructional Media Services, Bowling Green State University. Courtesy of Cliff Long; **145** Charles O. Perry. *Early Mace*, stainless steel, 12 feet, 1971. Peachtree Center, Atlanta, Georgia. Photo by I. Peterson; **147** Charles O. Perry. *Da Vinci*, steel, 24'. Photo by Balthazar Korab. Courtesy of Charles O. Perry; **148(top)** Charles O. Perry. *Continuum*, bronze, 15', 1976. National Air and Space Museum, Smithsonian Institution, Washington, D.C. Photo by I. Peterson; **148 (bottom)** Charles O. Perry. *Enigma*, steel, 20' high. Lynnhaven Mall, Virginia Beach, Virginia. Photo by Charles O. Perry; **149 (top)** Robert R. Wilson. *Möbius Strip*. Photo by Fred Ullrich, Fermilab; **149 (bottom)** Robert R. Wilson. *Topological III*. Photo by I. Peterson; **150** John Robinson. *Eternity*. Image by Ben Dickins. © John Robinson/Edition Limitée, Geneva; **151** John Robinson. *Immortality*, height 6', polished bronze, 1982. School of Mathematics, University of Wales, Bangor. Image by Ben Dickins. © John Robinson/Edition Limitée, Geneva; **152** John Robinson. *Journey*. Image by Ben Dickins. © John Robinson/Edition Limitée, Geneva; **153** Benigna Chilla. *Interrupted Möbius*, 1993, 6' × 24' × 1'. Installation at Berkshire Museum, Pittsfield, Mass. Courtesy of Benigna Chilla; **154, 155** Courtesy of Shiela Morgan; **156 (left)** Carlo H. Séquin. *Moebius Space*. Sculpture model/image by C. H. Séquin; **156 (right)** Courtesy of Keizo Ushio.

Chapter 8. Minimal Snow

159, **168–170** Photos by Claire Ferguson; 161, 162, 173 I. Peterson; 163 Image by Stewart Dickson from mathematical data by David Hoffman and James Hoffman; **164, 165 (right)** Courtesy of Helaman Ferguson; **165 (right)**, 167 Photos by I. Peterson; **171 (top)** Robert Longhurst. Arabesque XXIX, bubinga, 12" × 10½" × 9½". Courtesy of Robert Longhurst; **171(bottom)** Robert Longhurst. Loop IL, bubinga, 30" × 8" × 8". Courtesy of Robert Longhurst; **172** Robert Longhurst. *Hearts of Stone*. Courtesy of Robert Longhurst; **174** *Mathe-matica* notebook for generating the image courtesy of Dan Schwalbe; **175** Photo by John Bruning; **176** Courtesy of John Bruning; **177** Brent Collins. *Saddle Trefoil*, wood sculpture, 20 × 20 × 8 in., 1996. Photo © Phillip Geller.

Chapter 9. Points of View

179, 180 Courtesy of Nat Friedman; **181** Sol LeWitt. *Four-Sided Pyramid*, concrete blocks and mortar, 180 × 398 × 382 in., first installation 1997, fabricated 1999. National Gallery of Art. Photo by I. Peterson; **182, 183** Courtesy of Robert J. Krawczyk; **184 (top)** Robert J. Krawczyk, 2000; **184(bottom)** I. Peterson; **185** Arthur Silverman. *Almost Hexagon*. Courtesy of Arthur Silverman; **186** Arthur Silverman, *Echo*, stainless steel, 60' tall, 1984. Energy Centre Building, New Orleans, Louisiana. Courtesy of Arthur Silverman; **187, 188** Courtesy of Arthur Silverman; **189** Bathsheba Grossman. *Flame Beta Eleven Stripes*, bronze, 4¼" diameter. Collection of Nat Friedman. Photo by I. Peterson; **190** Robinson Fredenthal. *Black Forest*, 1977. University of Pennsylvania, Philadelphia. Photo by I. Peterson; **191** Carlo Roselli. *Odin's Coin*, iron and copper, 1998. On permanent display at the Galleria Lombardi, via del Babuino, Rome. Courtesy of Carlo Roselli; **192** Carlo Roselli. *Spherical-Tetrapolar Cone*, 1997. © 2001 by Carlo Roselli; **193** Carlo Roselli. *Spherical-Tetrapolar Torus*, 1997. © 2001 by Carlo Roselli; **194** Model by Arthur Silverman. Photos by I. Peterson; **195** *Rashomon* model by Charles Ginnever. Photo by I. Peterson; **196** Henry Moore. *Three-Way Piece No. 2 (The Archer)*, bronze, 1966. Toronto City Hall. Photo by I. Peterson; **197** Knot sculpture by Nat Friedman. Photo by I. Peterson; **198, 199** Courtesy of Nat Friedman; **200** Photo © Phillip Geller; **201** Courtesy of Brent Collins; **202** Brent Collins. *Genesis*. Photo © Phillip Geller; **203** © Donna Cox, George Francis, and Ray Idaszak, University of Illinois at Urbana-Champaign/National Center for Supercomputing Applications. Courtesy of George Francis; **204 (left)** Seven-story Scherk tower. Computer model by C. H. Séquin; **204 (right)** Brent Collins. *Hyperbolic Hexagon*, wood, 20 × 20 × 8 in., 1995. Photo © Phillip Geller; **205** Brent Collins. *Music of the Spheres*, 1999, wood lamination, sugar pine pattern for bronze edition, 30" × 30" × 20". Photo © Phillip Geller.

Chapter 10. Fragments

207, 213–215 Courtesy of Douglas Dunham; 209 Quilt by Helaman Ferguson. Photo by I. Peterson; 210 Courtesy of Helaman Ferguson; 211 M. C. Escher. *Circle Limit III*. © 2001 Cordon Art B.V.–Baarn-Holland. All rights reserved; 216 John Sims. *Square Roots of a Tree*. Courtesy of John Sims; 217 John Safer. *Limits of Infinity III*, 15' high. Photo by I. Peterson.

Color Plates

Plate 1 Clifford Singer. *The Geometry Lesson*, acrylic on plexiglass, 36" × 36". © 1998 by Clifford Singer; **Plate 2** Helaman Ferguson. *Umbilic Torus NC*, silicon bronze, antique green patina, 24" × 24" × 7", 1988. Photo by Terry Kloug; **Plate 3** Harriet E. Brisson. *Great Rhombicuboctahedra and Octagonal Prisms*, tensegrity structure of plexiglass, aluminum tubes, and nylon cord, 24 × 24 × 24 in., 1975. Courtesy of Harriet E. Brisson; **Plate 4** Harriet E. Brisson. *Truncated 600-Cell*, 12 fluorescent tubes in the shape of an octahedron placed within a mirrored tetrahedron, 9 × 9 × 9 ft., 1989. Courtesy of Harriet E. Brisson; **Plate 5** Thomas F. Banchoff. *Math Horizon*. Image rendered by Davide Cervone; **Plate 6** Eleni Mylonas. *All Stars CMYK 295*, digital output, variable size, 1999/2000. © 2000 by Eleni Mylonas. All rights reserved; **Plate 7** Tony Robbin, *Untitled #6, 2000*. Courtesy of Tony Robbin; **Plate 8** Arlene Stamp. *Sliding Pi*, 1993. Photo by I. Peterson; **Plate 9** Courtesy of Bob Brill; **Plate 10** Courtesy of Cliff Pickover, www.pickover.com; **Plate 11** Douglas Peden. *Transfiguration*, acrylic on canvas, 32" × 61", 1999. Courtesy of Douglas Peden; **Plate 12** Douglas Peden. *Come Together*, acrylic on canvas, 18" × 89", 1998. Courtesy of Douglas Peden; **Plate 13** Douglas Peden. *Serenade for a Lone Figure*, detail, acrylic on canvas, 12" × 72", 1997. Photo by I. Peterson; **Plate 14** Courtesy of Tony Robbin; **Plate 15** Tony Robbin. *Simplex #9, 1983*. 5' × 7' × 1'. Courtesy of Tony Robbin; **Plate 16** Tony Robbin. *Untitled #3, 1987*. 70" × 70" × 15". Courtesy of Tony Robbin; **Plate 17** Courtesy of Tony Robbin; **Plate 18** Tony Robbin. *COAST Canopy*, 1994. Erik Reitzel, engineer; RCM Precision, fabricator of components. Located at the Center of Art, Science, and Technology, Technical University of Denmark. Courtesy of Tony Robbin; **Plate 19** Charles O. Perry. *Continuum*, bronze, 15', 1976. National Air and Space Museum, Smithsonian Institution, Washington, D.C. Photo by I. Peterson; **Plate 20** Charles O. Perry. *Enigma*, steel, 20' high. Lynnhaven Mall, Virginia Beach, Virginia. Photo by Charles O. Perry; **Plate 21** Photo by Claire Ferguson; **Plate 22** Robert Longhurst. Arabesque XXIX, bubinga, 12" × 10½" × 9½". Courtesy of Robert Longhurst; **Plate 23** Brent Collins. *Music of the Spheres*, 1999, wood lamination, sugar pine pattern for bronze edition, 30" × 30" × 20". Photo © Phillip Geller.

Index

Abbott, Edwin A., 39–40, 42, 52
abstract art, 3, 133
"Afghan bands," 140
Albers, Josef, 145
Albus, James, 25
Alexander, James W., 20
Alexander's horned sphere, 20, *20*, *21*
algorithms
 art, 96, 98–99
 Euclidean, 17–18
 geometric forms generation, 182
 intrinsic shapes of, 18
 paper-folding, 64–65, 79
aluminum alloys, 123, 124
anamorphic picture, 104–5
"—And He Built a Crooked House"
 (Heinlein story), 44
animation, 58
Aperiodic Penrose Torus, Alpha
 (Ferguson), 127–28, *128*
Arabesque XXIX (Longhurst), *171*, 172–73, 174
Archimedean tiling, 115, *115*
architecture, 44, 124–26, 145, 146
 quasicrystal structure, 132
 spirolateral designs and, 183
Arnold's cat map, 95–96
art and mathematics conference
 (1992; Albany), v–vi, 5–7
atomic arrangement, 112, 123–24
Attitudes (Silverman), 193–94, 195

Baer, Steve, 124
baker's transformation, 94, *95*
Bakker, Anton, *7*
Baltimore Museum of Art, 137
Banchoff, Thomas F., 37–52, 56–60, 128, 129
 Math Horizon, 52
 Triple-Point Twist, 56
 Z-Squared Necklace, 59
base 2 numbering system, 89–90
base 10 numbering system, 90
Bauhaus, 145
Bill, Max, 143–44
 Endless Ribbon, 137
binary numbers, 89–91

Black Forest cuckoo clock (Lang
 origami model), 65, *65*
Bliss, Anna Campbell, 8
Braque, Georges, 3
Brehm model (Möbius strip), 151, *152*
brick wall pattern, origami, 71, *71*
Brill, Bob, 96, 99–100, 102, 108, 109
 Lissajous figures, *5*
 Transformation, 102
 Vortex, 103
Brisson, David W., 52–53
 "hyperstereogram," 53, *53*
 sixteen hypercubes, *50*
Brisson, Harriet E., 52–55
 *Great Rhombicuboctahedra and
 Octagonal Prisms,* 55
 Magic Box, 54
 Pentahedroid, 55
 Truncated 600-Cell, 60
Bruning, John, 171, 174, *176*
Bug on a Band (Long), 143, *143*

Calder, Alexander, 2
Cantrell, Andy, 174, *176*
*Captain Marvel Visits the World of
 Your Tomorrow* (comic book),
 38
Carroll, Lewis (Charles L.
 Dodgson), 62
Cartesian coordinate, 46–47
Cartesian grid, 105
catenary, 160
catenoid, 160, 161, *161*
Celtic knot patterns, 213, *215*
Center for Physics (Aspen, Colo.),
 150
Center of Art, Science, and Tech-
 nology (COAST; Denmark),
 131–32
"Chaos" (Sanderson and Crutch-
 field article), 95
chaos, 133
checkerboard pattern, origami, *70*, 71
Chilla, Benigna, 152–54
 Interrupted Möbius, 153–54, *153*
Christian theology, 42

circle, 37, 40, *40*
 hyperbolic plane within, 210, *210*
 minimal surfaces and, 159
 as origami appendages, 65–66, *66*
Circle Limit series (Escher), *207*, 208, 210–12
Circle Limit II (Escher), 212
Circle Limit III (Escher), 211–12, *211*
Circle Limit IV (Escher), 212, *213*
close-packing tensegrity structures, 55
COAST Canopy (Robbin), 131–32, *132*
Collins, Brent, 177, 199–205
 Genesis, 202
 Hyperbolic Hexagon, 204
 Music of the Spheres, 205
 Saddle Trefoil, 177
 wood sculptures, *200, 201, 202*
comic books, 38–39
complex numbers, 96
computer graphics, 4, *5, 22, 23,* 89, 98
 Arnold's cat map, 95–96
 Costa surface, 161–62, 163, 164, 165
 dithering, 102
 fractal art generation, 89–94
 geometric track tracing, 182
 geometry of algorithms, 18
 gridfield studies, 108
 hyperbolic patterns, 212, 213, *214*
 hypercube manipulation, 129
 Mandelbrot set's borders, 96–97
 NIST virtual projector, 25
 quasicrystal geometries, 131
 sculpture generator, 204–5
 spirolateral program, 184
 three-dimensional forms, 45–46, 131
 TreeMaker program, 67–68
 visualization, 58–59, 129–30, 189
computers, binary basis of, 90, 91
*Computers, Patterns, Chaos and
 Beauty: Graphics from an Unseen
 World* (Pickover book), 98

Continuum (Perry), 136–37, 147–48, *148*
coordinate axes, system of, 46–48
Corpus Hypercubicus (Dali), 35, 37, 43
Costa, Celso J., 159, 161, 164
Costa surface, 159–71
 computer-generated diagram, *162*
 mathematical representation, 165
 sculptures, *164*, 165, *165*, 166, *167*
 snow sculpture, 159, 166–71
Cox, Donna, computer-drawn film, *203*
Coxeter, H. S. M., 133, 208, 211, 212
crane (traditional Japanese origami), *63*
creases, origami, *62*, 63–64
 collapsed, 71, 72
 Hull technique, 71–72
 Maekawa's theorem, 63–64
 patterns, 64–66, 68–74
 tessellations, 68–77
cross-caps, 18, 28, *29*
cross-sections, 48–49
Crucifixion, The (Dali), 35, 37, 43
Crutchfield, James P., 95
crystals, 112, 123, 124, 131
cube, 37, *41*, 133, 139, 191–92
 cross sections, *51*
 four-dimensional. *See* hypercube
 reversing pattern, 122
 in three-dimensional coordinate space, 47–48, *47*, 123
curves, 22–24, *23*
 catenary, 160
 fractals and, 86, 88–89
 Gaussian, 167, 171
 hyperbolic line relationship, 208, 212
 knots as, 197
 Lissajous figures, *5*
 pursuit, *103*
cusps, 22, *22*, 23

Dali, Salvador, 2, 35, 36, 37, 38, 42, 59
 The Crucifixion: Corpus Hypercubicus, 35, 37, 43
dart. *See* kite-and-dart patterns
de Bruijn, N. G., 131, 133
decagon tiling pattern, 116, *116*
Deci, Florence, 15

decimal digits pattern, 85, 91–94
Demaine, Erik D., 79–80
Demaine, Martin L., 79–80
de Rivera, José, 135–36, 199
 Infinity, 135, *135*
Descartes, René, 46
Dewdney, A. K., 96
diamond tiling, 120, *120*, *122*, 123, 127, 128
Dickson, Stewart, Costa surface, *163*
differential geometry, 42
diffraction pattern, 123
dimension, 35–60
 broader meaning of term, 57
 etymology of word, 46
 Greek philosophy and, 55–56
 hyperseeing and, 195–96
 in measurement, 46
 progression of, 56–57
 See higher dimensions; *specific dimensions*
distortions, 105, 106, 159
dithering (computer graphics effect), 102
dodecagon, 115
dodecahedron, *78*, 124, 192
Dodgson, Charles L. (Lewis Carroll), 62
dome, quasicrystal, *112*
Double Torus Stonehenge (Ferguson), 19–20, *19*
Downsview subway station (Toronto), 85, 91–94
Duchamps, Marcel, 196
Dunham, Douglas J., 212, 213, 214

E (computer language), 99
Einstein, Albert, 36, 57–58, 128
Eisling, Claire, 16
electronic blackboard, interactive, 45
electronic gallery, 60–61
electrons, 123
Endless Ribbon (Bill), 137
Engel, Peter, 62
Engineering a New Architecture (Robbin), 132
Engman, Robert, 189
 The Triune, 8
Enneper, Alfred, 173
Enneper surface, 173–77, *173*
equilateral triangle, 113, *114*, *115*, 150, 189, 209
Equitable Center (New Orleans, La.), 187
Ernst & Young office building (Toronto), 90–91

E-Run (software), 99
Escher, M. C., vi, 4, *7*, 9, 99, 113–14, 117, 133, 208–16
 Circle Limit series, *207*, 208, 210–12
 Circle Limit II, 214
 Circle Limit III, 211–12, *211*
 Circle Limit IV, 212, *213*
 depiction of infinity, vi, 144, 208
 Snakes, 213
 Symmetry Drawing E137, 114
Eternity (Robinson), 150, *150*
Euclid, 17, 60
Euclidean algorithm, 17–18
Euclidean geometry, 36, 47, 60, 193
Euclidean plane, 209
Euler, Leonhard, 138
Euler's formula, 138
Expo '67, Montreal, *45*
extension definition, 46

Ferguson, Helaman, vii–viii, 11–33, *11*, *12*, 127–28, *168*, 177
 Aperiodic Penrose Torus, Alpha, 127–28, *128*
 Costa surface models, 159, 163–64, *164*, 165, *165*, 166, *167*
 Costa surface snow sculpture, 159, 166–71
 Double Torus Stonehenge, 19–20, *19*
 Eine Kleine Rock Musik III, 18
 Four Canoes, 26–27, *26*, *30*, 31
 hyperbolic quilt, 209–10, *209*
 Invisible Handshake, 159, 167–71, *170*
 Torus with Cross-Cap, 14
 Torus with Cross-Cap and Vector Field, 32
 Umbilic Torus NC, 22, *22*, 24
 Whaledream II, 20, 21
 Wild Sphere I, 21
Ferguson, Samuel, 165
Ferguson-Forcade algorithm, 17
Fermi National Accelerator Laboratory (Fermilab), 148
Fibonacci numbers, 218
fivefold symmetry, 123–24
Flatland: A Romance of Many Dimensions (Abbott book), 39–40, *39*, 42, 52
flat origami, 63, 65–66
Forcade, Rodney, 17
Four Canoes (Ferguson), 26–27, *26*, *30*, 31
Fourfield (Robbin book), 129

Four-Sided Pyramid (LeWitt), 181, *181*
fourth dimension, 3, 35–39, 52
 computer sketchpad, 46
 cubic. *See* hypercube
 innumerable variables of, 58
 as mathematical ideal, 60
 Robbin's art and, 112, 128–29
 theological view of Trinity and, 42
 as time, 57–58
fractals, 2, 86–98, *88*, *216*
 Sierpinski triangle, 76, *76*
 in stone, 6, *7*, 179, *179*
 tessellations, 76, *76*, 77
Francis, George K., 202
 surface transformation, *203*
Fredenthal, Robinson, 189–90
 Black Forest, 190
Friedman, Nat, vii, viii, 5–6, 8, 173, 179–80, 195, 197–98
 fractal stone print, *179*
 knot sculpture, 197, *198*
 limestone sculpture, *6*
 "shell" sculpture, *180*
Fujimoto, Shuzo, 69

Gallup, Kevin, *7*
Gardner, Martin, 121
Gauss, Carl Friedrich, 138
Gaussian curvature, 167, 171
geometric progression, 41
Ginnever, Charles, 195–96, 197
 Rashomon, 195, *195*
Glaucon, 55–56
golden ratio, 120
Graphic Work of M. C. Escher, The (Escher book), 215
graph theory, 64
Gray, Alfred, 164, 165
greatest common divisor, 17
Greek philosophy, 55–56
grids, 47, 99–109, *106*, *107*, 133
Grossman, Bathsheba, 189
 Flame Beta Eleven Stripes, 189
Grünbaum, Branko, 80

Heinlein, Robert A., 44
helicoid, 160, *161*
hexagon, *30*, 69, *69*, *73*, 113, 115, *213*
higher dimensions, 53
 as mathematical ideal, 60
 nonperiodic patterns and, 130
 object visualization, 52, 57, 128–29
 quasicrystals and, 131
Hilbert, David, 23
Hoffman, David, 161–63, 164, 173
Hoffman, James, 161, 163, 173

holes, 2, 138, 141. *See also* torus
Homage to the Square (Albers), 145
horned spheres, 18, 21, *21*
Hull, Thomas C., 62–64, 71–74, 77–78
 Five Intersecting Tetrahedra, 78
 origami tessellation, *73*
 self-similar bird base tiling, *77*
hyparhedron, 79
hyperanaglyph, 53
hyperbolic paraboloid, 15, *15*, 79–80, *79*
hyperbolic plane, 4, 207–15
hyperboloid, 80, 82
hypercube, 35–38, 41–44, 48–55, 128–30
 folding model, 43
 as mathematical ideal, 60
 perspectives of, 50–53, *50*, *51*
 rotation effects, 49, 50, 130
 three-dimensional shadow, 50
 unfolded, 35–37, *35*, *37*, 43, 44, *44*
Hypercube, The: Projections and Slices (Banchoff film), 49
hypergraphics, coining of word, 52–53
Hypergraphics 1984 (art exhibit), 52–53, *57*
hypersculptures, 195–97
hyperseeing, 195–96, 197
hyperspheres, 57
hyperstereogram, 53, *53*
hypocycloid, 2–232, *22*, 23

icosahedron, 192
Idaszak, Ray, computer-drawn film, *203*
Immortality (Robinson), 151, *151*
"impossible" triangle (tribar), 117, *117*
Impressionist painting, 2
independent parameter, 57
infinite processes, 10, 36
 Cartesian coordinates, 47
 Enneper minimal surface, *173*
 fractals, *88*
 geometrical illusions, 54–55
 hyperbolic paraboloid, 79
 images of, 144, 208
 Koch snowflake zigzags, *87*
 particular points on plane, 47
 repeating forms, 4, 21
 Safer sculpture, *217*
 tiling patterns, *115*, 118, 133
 unbounded minimal surface, 160, 163
Infinity (de Rivera), 135, *135*
integer relations, 17

interactive artwork, 121
interlocking units, 113–14
International Congress of Mathematicians (1978; Helsinki), 49
International Snow Sculpture Championships (Breckenridge, Colo.), 159, 166–71, 174–77
Interrupted Möbius (Chilla), 153–54, *153*
Invisible Handshake (snow sculpture), *159*, 167–71, *170*
irrational numbers, 91, 120

joggling feat, 17
Journey (Robinson), 151, *152*

Kanada, Yasumasa, 92
Kandinsky, Wassily, 3
Kepler, Johannes, 115, 116, 117
kite-and-dart patterns, 119–20, *119*, 123, 127
Klein, Felix, 26, 27
Klein bagels, 29, *29*
Klein bottle, 18, 26–30, 155
Knife Edge Mirror Two Piece (Moore), *3*
knots, 197–201, 213, *215*
Koch, Helge von, 87
Koch snowflake, 87
Krawczyk, Robert J., 182–84

Lalvani, Haresh, 124–26, 133
Lang, Robert J., 65–68
 Black Forest cuckoo clock, 65, *65*
lattice reduction, 17
lattices, 124, 130–31, 133
Levine, Dov, 123
Levine, Howard, 218
LeWitt, Sol, 180–81, 184
 Four-Sided Pyramid, 181, *181*
 Straight Lines in Four Directions and All Their Possible Combinations, 181
 Wall Drawing No. 681 C, 181
light, 55, 123, 130
Listing, Johann Benedict, 139
LOGO (computer language), 182
Long, Cliff, 141–43
 Bug on a Band, 143, *143*
 Möbius Band, 142
Longhurst, Robert, 171–77, *176*, 199
 Arabesque XXIX, 171, 172–73, 174
 Heart of Stone, 172
 Loop IL, 171

L-shaped tile, *115*
Lubiw, Anna, 79–80
Lull, Ramon, 37–38

Mackay, Alan, 123
Maekawa, Jun, 63–64
magic trick, 139–40
Magritte, René, 2
Man and His Community
 (Expo '67, Montreal), *45*
Mandelbrot, Benoit B., 86, 88–89,
 94, 98
Mandelbrot set, 96–98, *97*
maquette (sculpture model), 25
Mathematica (software), 164,
 171
mathematical art
 Albany campus as, 7
 Bill's definition of, 144
 diversity of, v–vi, 216, 218
 nonrepeating patterns and, 133
 various forms of, 9–10
 See also specific artists and forms
Meeks, Bill, 161–63, 164
milling machine, 22, 23, 24
minimal surfaces, 159–77,
 200–201
 of knotted loops, 199
 negative Gaussian curvature,
 167, 171
 Scherk's second minimal
 surface, 203–5
Miyazaki, Koji, 124
mobiles, 2
Möbius, August Ferdinand,
 138–39
Möbius strip, 135–57, *136, 137,*
 199, 218
 Bill's works, 143–44
 Collins's works, 200–201
 filled-in knot, *199*
 malleability of, 141
 as recycling symbol, 141–43
Möbius Strip (Wilson), 148–49, *149*
Mondrian, Piet, 3
Moore, Henry, 2, 159, 196–97
 Knife Edge Mirror Two Piece, 3
 Three-Way Piece No. 2, or *The
 Archer, 196*
Morgan, Shiela, 154–56
 ribbon Möbius strip, *154*
morphology, 146
mosaic patterns. *See* tiling
 patterns
mountain creases, *62, 63–64, 63,*
 69, 73
Mylonas, Eleni, 126–27
 All Stars CMYK, 126
 Gray Bed Revisited, 127

National Air and Space Museum,
 136, 147
National Gallery of Art, 1–2, 3,
 181
National Institute of Standards
 and Technology (NIST), 25,
 123
National Museum of American
 History, 135
Nemeth, Tamas, *168*
neon infinity structures, 54, *54,*
 55, 55
non-Euclidean geometrics, 35, 36
nonperiodic (nonrepeating)
 patterns, 111–34
 architectural, 124–26, 132
 artworks, 126–28
 higher dimensions and, 130
 quasicrystals, 112, 123, *123,*
 124, 130–34
 tiling, 111–12, 115, 116–24,
 118, 132
numerical data, visualization of,
 58

occult movement, 36
octagon, 69, 115
octahedron, 54, *54,* 192
one-dimensional object, *41*
one-sidedness. *See* Möbius strip
On Growth and Form (Thompson
 book), 146
"On the Determination of the
 Volume of a Polyhedron"
 (Möbius paper), 139
optical systems, 67
origami, 61–83
 algorithms, 64–65
 appendage strategy, 65–66, *66,*
 71
 crease types, *62, 63–64, 63*
 gluing and cutting, 80
 Maekawa's theorem, *63*
 tessellations, 68–77
 three-dimensional objects, 78,
 80, 82
 "tree method," 66–68, *67*
Ouspensky, P. D., 36

Palmer, Chris K.
 origami tessellation, *69,* 74
 *Whirl Spools—Watering
 Fujimoto's Garden—Kites, 82*
 *Shadowfold Whirl Spools—
 Dodecagon Twists, 74*
 Whirl Spools—Pinwheel Path, 61
paper folding. *See* origami
parallel lines, 36, 113, 127
Pascal, Blaise, 75

Pascal's triangle, 75–77
pastry dough, 94
Peano, Giuseppe, 23
Peano-Hilbert curve, 23–24, *23, 24*
Peden, Douglas D., 104–9
 Come Together, 108
 Serenade for a Lone Figure, 108
 Transfiguration, 104
Pei, I. M., 2, *2*
Penny, James, 16
Penrose, L. S., 117
Penrose, Roger, 112, 116–21, 123
Penrose tilings, 117–28, 132–34
 inflation of, 127
 intersecting line grids, 131
 three-dimensional analogs, 112,
 123–26
pentagon, 133
 hyperbolic plane from, 209–10,
 210
 three dimensional, 123, 124, 126
 tiling pattern, 113, 116–20
periodic lattices, 130–31
periodic pattern, 113–14, *122*
 spatial differences in, 130
Perrin, Jean Baptiste, 88, 89
Perry, Charles O., 136–37,
 145–48, 150, 196
 Arch of Janus, 140
 Calligraphic Möbius, 137
 Continuum, 136–37, 147–48, 148
 Da Vinci, 147
 Early Mace, 145
 Enigma, 148
 Mace Möbius, 136
 *Solstice (2/3rd Twist Triangular
 Torus Moebius), 57*
perspective, 2, 9, 218
 hypercube, 50
 wire-frame cube, *48*
physics, 57–58, 123–24, 132–33,
 134
Picasso, Pablo, 2, 9, 196
Pickover, Clifford A., 98
 Mandelbrot Madness, 98
pi decimal digits, 85, 91–94, 218
plane, 47, *56*
 Euclidean, 209
 minimal surface and, 160
 Möbius strip patterns, 152–54
 tiling patterns filling, 111–15,
 116, 119, 120, 134
plane geometry, 47, 56
Plato, 55–56
Platonic solids, 189
pleats, origami, 68–69, 74
Poincaré, Henri, 2, 95, 210
Poincaré recurrence, 95, 102
point (mathematical), *41*

pointillist painting, 102
pointing machine, 25, 26
Pollock, Jackson, 2
polygons
 Möbius strip from, *152*
 origami creases forming, 63,
 73, 77
 packing on plane, 113, *113*, 115
 rotated, *45*
 tiling pattern, 111, 116, *116*,
 118, 212
polyhedra, 42, 55, 133
 building units, 124
 Euler formula, 138
 Möbius theory of, 138–39
 nonrepeating pattern, 123
 origami, *78*, *79*, *80*, *82–83*
 See also tetrahedra
polytopes, 133, 208
projection, mathematical, 48
proofs, 3–4
Ptolemy (Claudius Ptolemaeus),
 46
pursuit curve, *103*

quadratic polynomial iteration,
 98
quantum mechanics, 38
quasicrystals, 112, *123*, 124, 126,
 128, 130–34
Quasicrystals and Geometry
 (Senechal book), 121
quasiperiodic spaces, 126–27
quilt patterns, 74, *75*, 77, 122
 hyperbolic, 209–10, *209*

random patterns, 93–94
Rashomon (Ginnever), 195, *195*
Recreations Scientifiques, Les
 (Tissandier book), 139–40
rectangle
 decimal digits of pi design, 91,
 92–93
 grid-scrambling
 transformations, 100
 paper folds, 69, 80, *81*
recycling symbol, 141–43, *141*
relativity, theories of, 36, 57–58,
 128
Renaissance painters, 2, 9, 218
repeated operations, 94. *See also*
 fractals; pi decimal digits
Republic (Plato book), 55–56
Rhapsody in White (snow
 sculpture), *174*, 175–76,
 175, *176*
rhombohedra, 123, 124, 126
rhombus, 119–20, *121*, *122*, *123*
Riemann zeta function, 16

rings, 22, 26, *26*, *28*, *156*
 interlocking pattern, 213, *215*
 See also torus
Robbin, Tony, 128–32, 134
 COAST Canopy, 131–32, *132*
 Quasicrystal Dome, 111
 Quasisphere, 131
 Simplex #9, 1983, 130
 Untitled #3, 1987, 130
 Untitled #6, 2000, 132
Robinson, John, 150–51, 199
 Eternity, 150, *150*
 Immortality, 150, *151*
 Journey, 151, *152*
"Rocky Mountain Mathematica"
 (summer program), 171
Rodin, François Auguste René, 9
Roselli, Carlo, 190–93
 Odin's Coin, 191
 Spherical-Tetrapolar Cone, 192
 Spherical-Tetrapolar Torus, 193
Russell, Bertrand, 4

saddle-shaped surface, *15*, *46*, *79*,
 160, 208, 209
Safer, John, *Limits of Infinity III*,
 217
Sagan, Hans, 86
Sanderson, Bill, 95
scale within scale, 126–27
Schattschneider, Doris, 114
Schechtman, Dan, 123
Scherk, Heinrich Ferdinand, 204
Scherk's second minimal surface,
 203–5, *204*
Schultz, Roland, 42
Schwabe, Caspar, 121
Schwalbe, Dan, *168*, 172, 174, *176*
self-duality, 191
self-similar structures. *See* fractals
semiregular tiling (Archimedean),
 115, *115*
Senechal, Marjorie, 121, 127–28
Séquin, Carlo H., 202–3, 204
Seurat, Georges, 102
shadows, 58, 123, 130, 131
 of knots, 197–98, *197*
Sierpinski triangle, 76, *76*
Silverman, Arthur, 185–89, 190,
 193–95, 197
 Almost Hexagon, 185
 Attitudes, 193–94
 Echo, 186
 tetrahedral forms sculpture,
 187, *188*
Sims, John, *Square Root of a Tree*,
 216
Singer, Clifford, *The Geometry
 Lesson, 9*

six-dimensional space, 42, 130
Snakes (Escher), 213
snowflakes, *87*, 88
snow sculpture, 159, 166–77
Socrates, 55–56
solid geometry, 47, 56, 138
space
 inexplicability of, 144
 quasicrystal geometry as
 organizing, 133
 quasiperiodic, 126–27
 See also dimension; *specific
 dimensions*
spanning surface, 142–43
sphere
 horned, 18, 21, *21*
 symmetries of, 191, 193
 three-dimensional, 40, *40*
 with two cross-caps, 28
spiritualism, 36
spirolaterals, 182–84
square, *41*
 grid, 104–5, *105*, 107, *107*
 origami quiltlike patterns, 74, *75*
 Pascal triangle pattern, 76, *76*
 plane-filling tiling pattern, 113,
 115
 pursuit curve, *103*
square cylinders, 42
square twists, paper folds, 69–71,
 69, *70*
Stamp, Arlene, 85–86, 89–94, 109
 Sliding Pi, 85, *92*, *93*
State University of New York,
 Albany, v, 5–7, 173
Steinhardt, Paul, 123, 124, 131
stereoscopy, 58
Stone, Edward Durrell, 7
stone carving, 11–13, 16–18
 fragmented forms, 179–80
straight line, Cartesian
 coordinates on, 46
*Straight Lines in Four Directions
 and All Their Possible
 Combinations* (LeWitt), 181
Strauss, Charles, 37, 45, 58
surface, mathematical
 knotted loop as, 199
 Long's carvings of, 143
 minimal, 159–60
 skeleton of, *46*
 spanning, 142–43
 topological form
 transformations, *203*
 See also Möbius strip
surface-cutting patterns, 23–24
"Surfaces Beyond the Third
 Dimension" (1996 exhibit),
 59

Sylvester, James Joseph, 10
symmetries
 Costa surface, 162
 Coxeter work on, 208
 fivefold, 123, 124
 hyperseeing and, 195
 of pleated translucent paper, 69
 sphere vs. tetrahedron, 191
 tiling patterns, 113, 114
 translational, 115
 of unfolded origami creases,
 63

tessellations, 68–77
 four patterns, 72
 from square modules, 74–77
tetrahedra, 133, 184–94, 184,
 194, 218
 origami, 78
 sculpture, 185, 186, 187, 188,
 190, 194
 self-duality of, 191
theorems, 3–4, 19
 origami creases, 63–64
Thompson, D'Arcy W., 146
three-dimensional objects, 23,
 41, 42, 45, 49–50
 hyperseeing, 195–96, 197
 inferring properties of, 56–57
 knots, 197, 198
 Möbius surface, 148–51
 origami, 78, 80, 81, 82–83
 pentagonal pattern, 123–24,
 123, 126
 quasicrystals, 112, 123–24,
 123, 126
 sphere, 40, 40
three-dimensional space
 coordinate system, 47–48
 geometric forms defining, 193
 independent directions in, 57
 quasi-crystalline lattices, 131
Through the Looking-Glass
 (Carroll), 62
Thurston, Bill, 209
tiling patterns
 Archimedean, 115, 115
 hexagons, 213
 hyperbolic plane, 207, 208,
 210, 211, 212, 213, 214, 215
 "illegal" arrangements, 122

nonperiodic, 111–12, 115–24,
 128, 132–34
 origami, 68–77, 80
 pi decimal digits basis, 85,
 91–94
 [p,q], 212
 quasicrystal, 112, 123
 in Robbin's early work, 128,
 129
 shapes suitable for flat surface,
 113
 substitution, 115
tiling theory, description of,
 112–13
time and space, 9, 57–58
Tissandier, Gaston, 139–40
Topological III (Wilson), 149, 149
topological transformation, 18,
 18, 19, 20
 computer-drawn film of, 203
 Möbius strip and, 140–41, 144
topology, 18, 80
torus, 18, 22, 43
 Aperiodic Penrose Torus, Alpha,
 128, 128
 Klein bottle, 29
 origami, 80, 81, 82–83
 stone Möbius surface ring,
 156
transcendental number, 91
transformations, 94, 95, 99–109,
 146
 grid, 104–5
 See also topological
 transformation
translational symmetry, 115
translucent paper, 68–69
transparency, 196
trapezoid, 2, 104
TreeMaker (computer program),
 67–68
"tree method" (origami), 66–67,
 67
triacontahedron, rhombic, 123
triangle
 curved geometry and, 208
 "impossible" (tribar), 117, 117
 Koch snowflake construction,
 87
 Möbius surface combination of,
 139

paper folds, 69, 73
Pascal's, 75–77
plane-filling tiling, 113, 114,
 115
Sierpinski, 76, 76
See also equilateral triangle
tribar, 117, 117
Trinity, 42
two dimensions, 41
 lattice points projection onto
 line, 131
 numerical coordinates, 47
 unfolded hypercube, 44
 visualization techniques, 58
two-piece propety (geometrical
 objects), 42

Umbilic Torus NC (Ferguson), 22,
 22, 24
unbounded minimal surfaces,
 160–63
Ushio, Keizo, 156, 157

valley creases, 62, 63–64, 63, 69,
 73
variables, 57, 58
Verhoeff, Koos, Pythagorean
 Fractal Tree, 7
Verrill, Helena A., 73, 74, 76
visual absurdities, 117
visual mathematics, 58, 203–5
visual puzzles, 105

Wagon, Stan, 166–77, 168, 176
Wall Drawing No. 681 C (LeWitt),
 181
wave space, 104, 105, 106, 107,
 107
Webber, William T., 80, 82–83
Weeks, Jeff, 209
Whaledream II (Ferguson), 20, 21
Wilson, Robert Rathburn, 148
 Möbius Strip, 148–49, 149
 Topological III, 149, 149
woven Möbius strips, 154–56,
 154, 155
woven-squares pattern (origami),
 71, 71

zero dimension, 41
"zome" building system, 124, 125